HANDMADE

D1363002

First published in 2006 by

GINGKO PRESS INC.
5768 Paradise Drive, Suite J
Corte Madera, CA 94925, USA
Telephone (415) 924-9615
Telefax (415) 924-9608
Email: books@gingkopress.com
www.gingkopress.com

ISBN: 1-58423-223-4
ISBN 13: 978-1-58423-223-0

Book Design: www.andrealuglidesign.com

HANDMADE

Andrea Lugli

GINGKO PRESS

INTRODUCTION by David Lopes

Over the past twenty years computers and design have become irretrievably interdependent. Since the advent of the Macintosh the all-pervading popularity of the "digital" image has created what can only be referred to as a new genre of design. Out of the noise of the abused Photoshop filters, digital "cut + paste" collages, overused "superflat" graphics, and an infinite array of typographic aberrations, an entirely new class of graphic clichés has emerged.

Handmade takes a huge step towards providing an antidote to this out of control phenomenon. Graphics editor, Andrea Lugli, presents an impressive selection of work by artists who actually know what it feels like to pick up a pencil, cutting knife, magic marker, stick of charcoal or can of spray paint and create with their bare hands. These are the artists, designers and illustrators who consider their 'hand work' the distinctive characteristic of their art. Some of the images are entirely handmade, some are computer generated and some are interesting hybrids of both approaches. What all of these works share is the ability to break through the somewhat vacuous conventions of contemporary design culture and elevate the level of craftsmanship in the process.

That the computer has changed our lives forever is indisputable but it is now time to take a step back and consider who the real master is, and who the servant. As artists and designers broaden their perspective and gain greater control over rapidly changing technologies, defining the difference between digital and "analog" will be of lesser importance and graphic language will be stronger for it.

Handmade embraces a wide ranging collection of personalities and styles. It demonstrates the strength of design in the pre-digital era and lights the way for a more conscious merging of the digital and analog realms, a reuniting of the left-brain with the right.

As the guest artists featured in this book can attest, many of us have developed an attachment to our computers that is emotional rather than practical. This attachment (and incredible software such as Photoshop) is what makes it possible to create organic beauty with a lifeless machine.

Computers are now accepted as part of our everyday lives and whether operated commercially or experimentally they are in use 24/7. When creating advertising and promotional material many contemporary designers and illustrators, burdened with the pressure of time, forego the animate world and submit fully to the computer. Andrea Lugli encourages you to forget about all of that for a while, and for just a short time to leave behind the hardware, software, scanners and printers. Go out and grab a pencil, a water color kit, spray paint, and some acrylics and consider for a moment that all are no more than simple mediums, that none are better or worse than others, just different tools with which to achieve different results. Lugli argues that a pencil is a medium closer to humans than the computer, and therefore a better method with which to truly express our humanity.

FOREWORD by Andrea Lugli

One way or another we have all become a little alienated by computers. I had almost finished this book when my Macintosh hard drive crashed causing me 24 hours of terror, uncertain of what might have happened to the files in which I had created the layouts for the very pages you now hold in your hands. Ultimately, only a few files were corrupted including some scans from my original drawings and some paintings I had sprayed. Why does a hard-disk break down for no obvious reason? No computer expert seems able to explain it. They simply say, "It doesn't work anymore, you need to get a new one". When I think about the digital work I've done over the years, I sometimes wonder if all of the CDs on which I've archived the files could somehow degrade. It may be an improbable scenario, but it's a scary one.

Being an artist of our time means seizing the opportunities new technologies offer and using them to become original interpreters of contemporary taste.

Artists of all eras have had to compromise in one way or another and today is no different. Graphic designers and illustrators face ever increasing demands to communicate better with their clients, to problem solve and to constantly acquire new (computer) skills. Technology provides many solutions with which to solve communications problems, but even so, many designers simply use default settings rather than take the time to customize software for optimal efficiency. With a little extra effort at the front-end, the computer can be of greater assistance in an automated way.

On the contrary, working with your hands forces you to a more personal approach. Your hands somehow enable you to do things that other's can't, your brain conceives ideas that other's can't. If you sometimes wonder why experimenting with the computer is not easy, the answer may simply be that handwork offers more opportunities for personal expression. Think about calligraphy for a moment. Isn't it one of the most personal expressions we have? Now think about sketches. Born of a genuine stream of consciousness sketches take you deep inside the artist's soul. They contain both intentional messages and often unintentional mistakes.

Handmade work is vital to those artists who want to convey a meaningful impression of their personalities. For those of us who wish to follow our instincts it certainly helps us to get closer to the core of our being. Isn't that what we all need?

STUDIO / DESIGN FIRM You Are Beautiful (London, UK)
WORK / YEAR The Surf Issue / 2005
ARTIST Kerry Roper
ART DIRECTION, COPY Kerry Roper
DESIGN Kerry Roper
CLIENT Adrenalin magazine
DESCRIPTION Editorial illustration, cover concept.

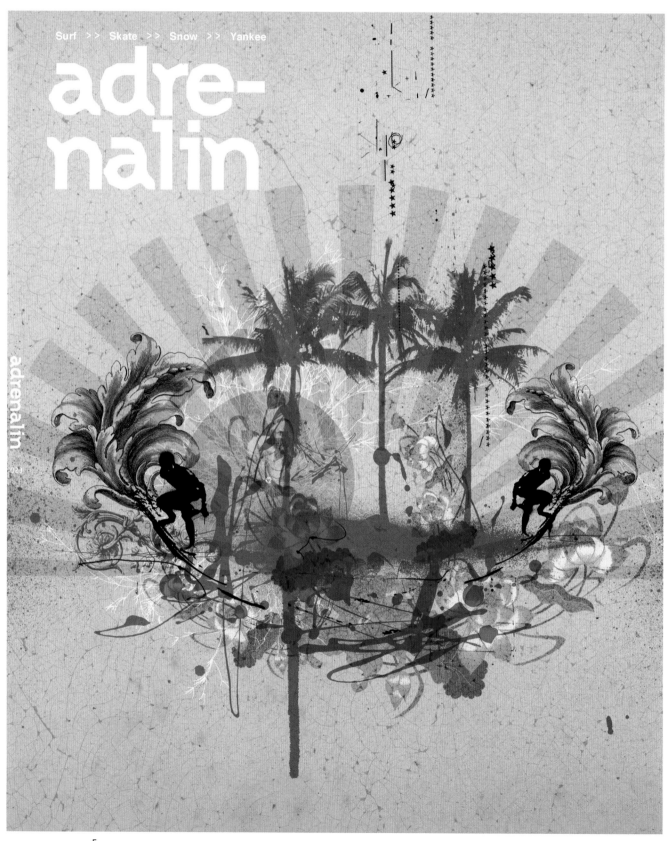

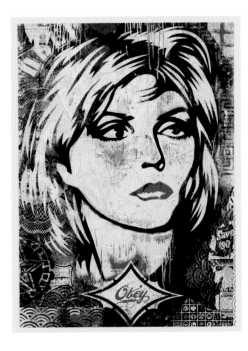

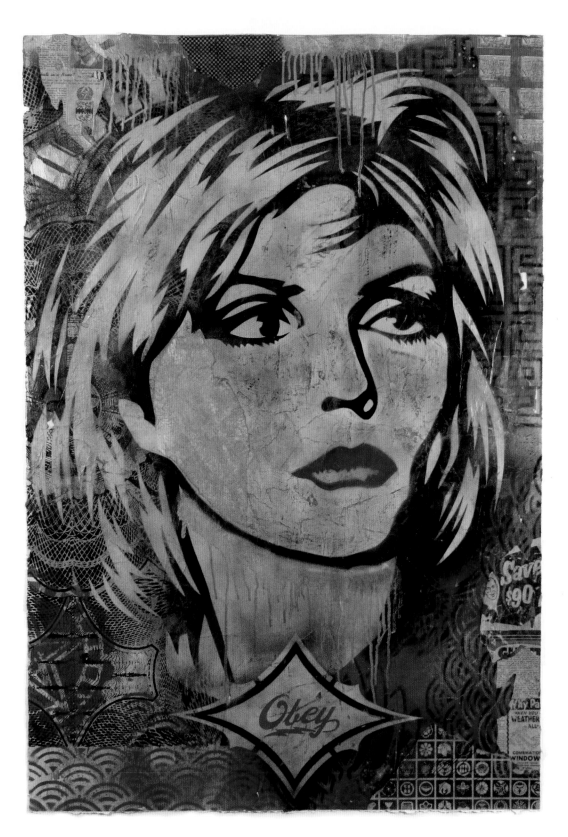

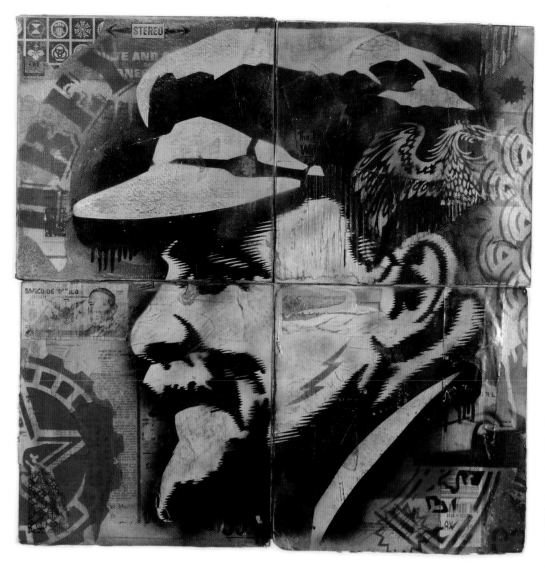

STUDIO / DESIGN FIRM / ARTIST Shepard Fairey - OBEY GIANT (Los Angeles, USA)
WORK / YEAR "Lenin Record", Original Collage Stencil 4 Panel
Album Cover, 24" x 24", 2004
ARTIST Shepard Fairey

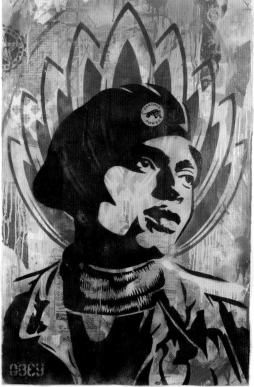

STUDIO / DESIGN FIRM / ARTIST Shepard Fairey - OBEY GIANT (Los Angeles, USA)
WORK / YEAR "Unknown Panther", Original Collage Stencil, 3' x 4', 2004
ARTIST Shepard Fairey

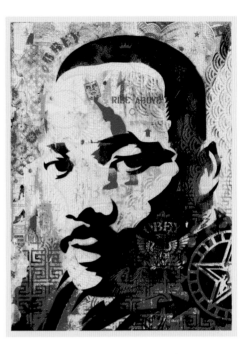

STUDIO / DESIGN FIRM / ARTIST Shepard Fairey - OBEY GIANT (Los Angeles, USA)
WORK / YEAR "Andy Warhol", Original Collage Stencil, 3' x 4', 2004
ARTIST Shepard Fairey

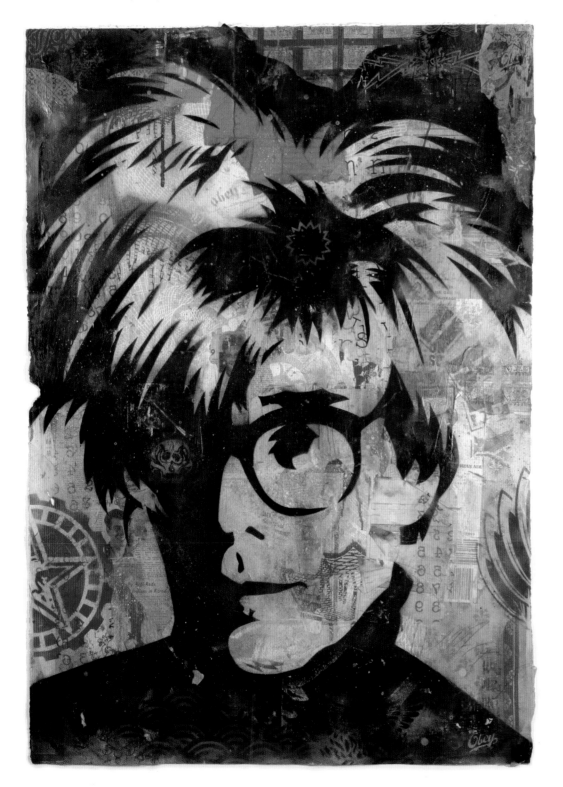

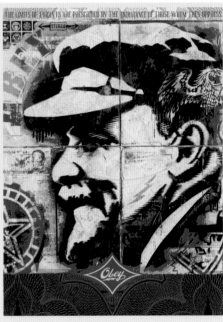

STUDIO / DESIGN FIRM / ARTIST Shepard Fairey - OBEY GIANT (Los Angeles, USA)
WORK / YEAR "MLK", Screen Print, 18" x 24", 2005. Limited Edition of 300.
ARTIST Shepard Fairey

STUDIO / DESIGN FIRM / ARTIST Shepard Fairey - OBEY GIANT (Los Angeles, USA)
WORK / YEAR "Lenin Record", Screen Print, 18" x 24", 2005
Limited Edition of 300.
ARTIST Shepard Fairey

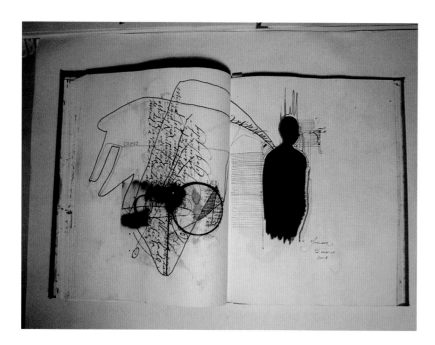

STUDIO / DESIGN FIRM vo6 (Rio de Janeiro, Brazil / Rotterdam, The Netherlands / Barcelona, Spain)
WORK / YEAR Green Mile / started in 2003, finished?
ARTIST Yomar Augusto
DESIGN Yomar Augusto
ILLUSTRATION Yomar Augusto
PHOTOGRAPHY Yomar Augusto
DESCRIPTION Personal sketchbook

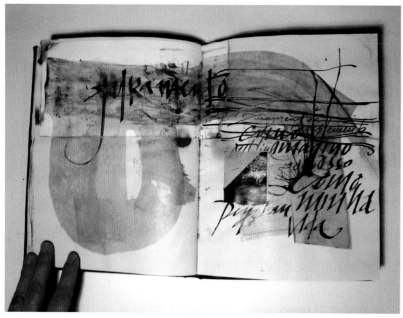

STUDIO / DESIGN FIRM vo6 (Rio de Janeiro, Brazil / Rotterdam, The Netherlands / Barcelona, Spain)
WORK / YEAR Black one / started in 2003, finished in 2004
ARTIST Yomar Augusto
DESIGN Yomar Augusto
ILLUSTRATION Yomar Augusto
PHOTOGRAPHY Yomar Augusto
DESCRIPTION Personal sketchbook

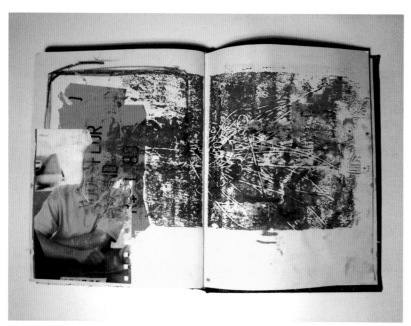

STUDIO / DESIGN FIRM Tomer Hanuka (London, UK)
WORK / YEAR Kill Bill vol. 1 / 2004
ILLUSTRATOR Tomer Hanuka
ART DIRECTOR John Dixon
DESCRIPTION Editorial Illustration for New York Magazine about the sugar coated blood scenes in Kill Bill vol. 1

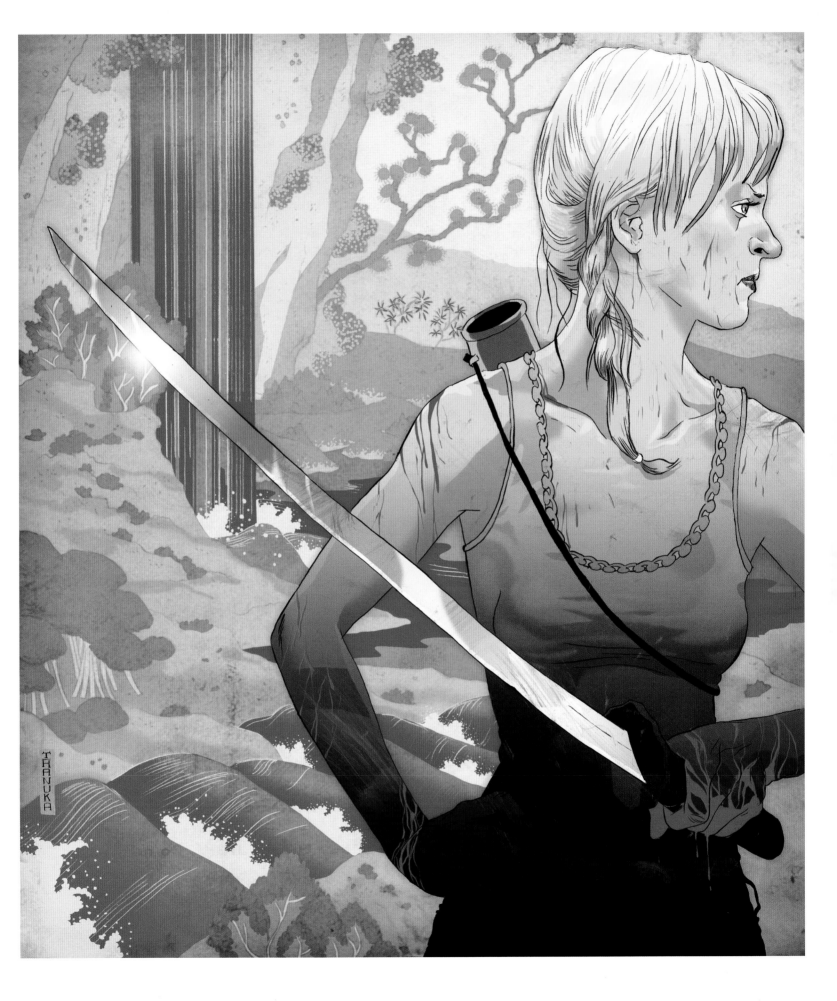

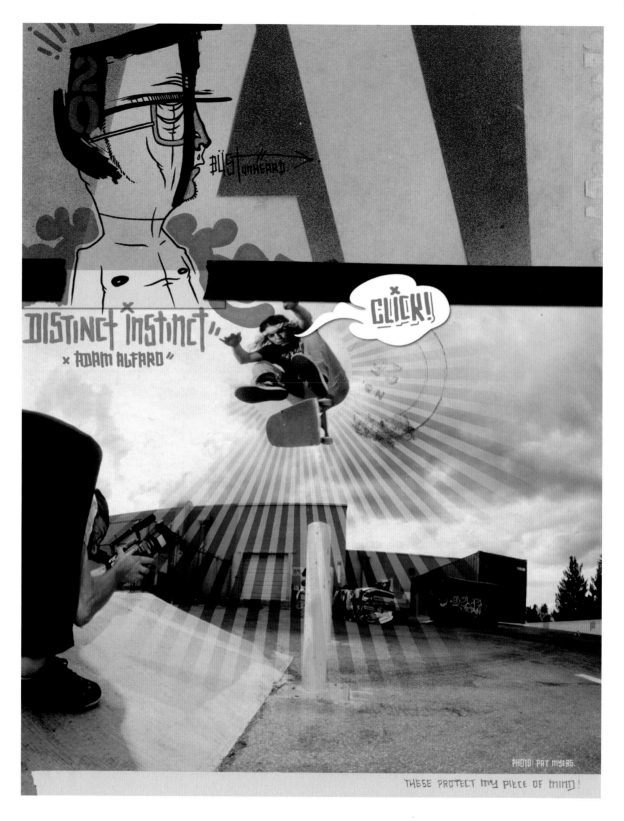

STUDIO / DESIGN FIRM BLK/MRKT (Los Angeles, CA USA)
WORK / YEAR 411VM DVD packaging & booklet design / 2005
ARTIST Kinsey
CREATIVE DIRECTION Kinsey
SHOWN Adam Alfaro Single page
PHOTOGRAPHY Pat Myers

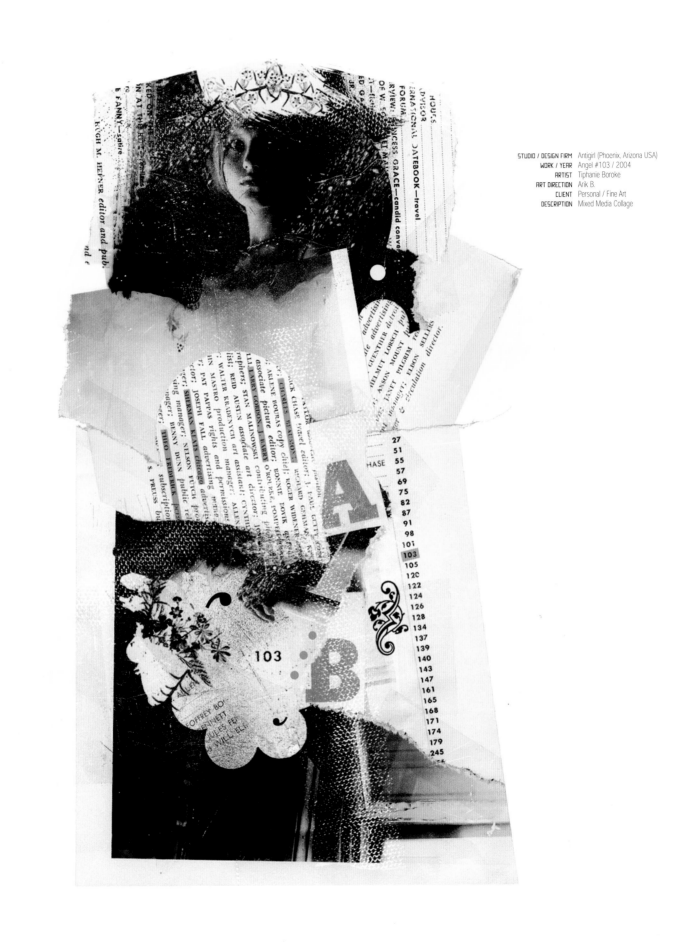

STUDIO / DESIGN FIRM Antigirl (Phoenix, Arizona USA)
WORK / YEAR Angel #103 / 2004
ARTIST Tiphanie Boroke
ART DIRECTION Arik B.
CLIENT Personal / Fine Art
DESCRIPTION Mixed Media Collage

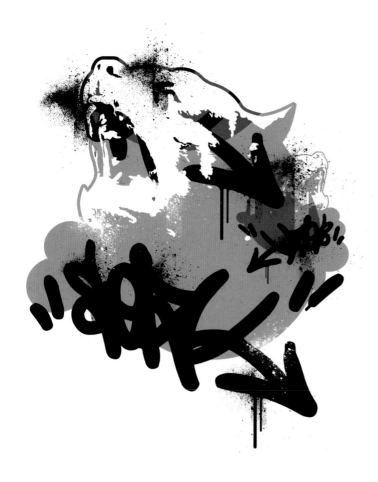

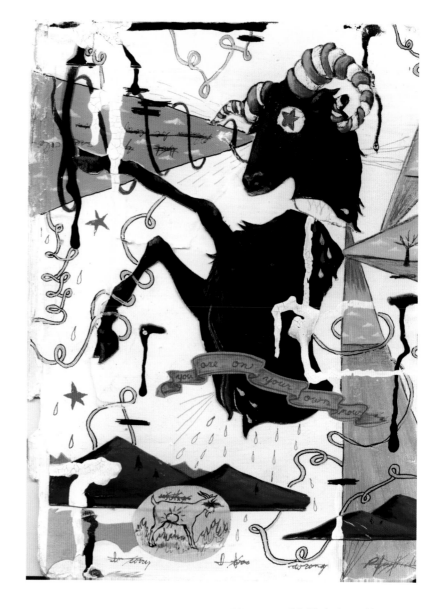

STUDIO / DESIGN FIRM P-Jay Fidler (Los Angeles, USA)
WORK / YEAR "You Are On Your Own Now" / 2004
ARTIST P-Jay Fidler
ILLUSTRATION P-Jay Fidler
DESCRIPTION Cover Illustration "Skratch Magazine".

STUDIO / DESIGN FIRM Digitalultras (Rome, Italy)
WORK / YEAR "Serk-2" / 2005
ARTIST Manuel Musilli
ART DIRECTION, DESIGN Manuel Musilli
ILLUSTRATION Manuel Musilli
CLIENT Personal
DESCRIPTION Illustration.

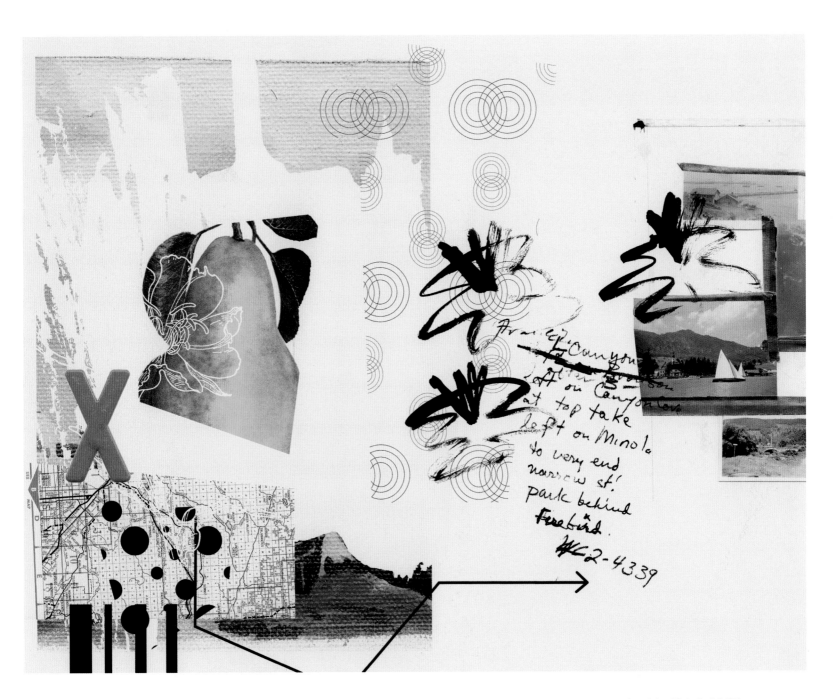

STUDIO / DESIGN FIRM Automatic Art and Design (New York, USA)
WORK / YEAR Illustration / 2003
ARTIST Charles Wilkin
DESIGN / ILLUSTRATION Charles Wilkin
CLIENT Émigré
DESCRIPTION Editorial Illustration.

STUDIO / DESIGN FIRM Boris Tellegen / Delta (Amsterdam, The Netherlands)
WORK / YEAR Sketch / 2001
ARTIST Boris Tellegen / Delta
ART DIRECTION, DESIGN, ILLUSTRATION Boris Tellegen / Delta

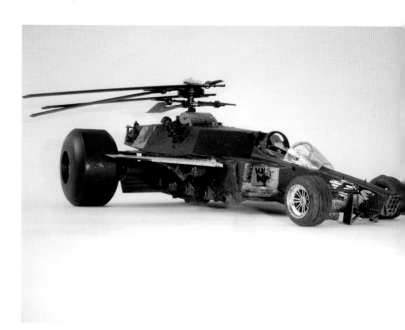

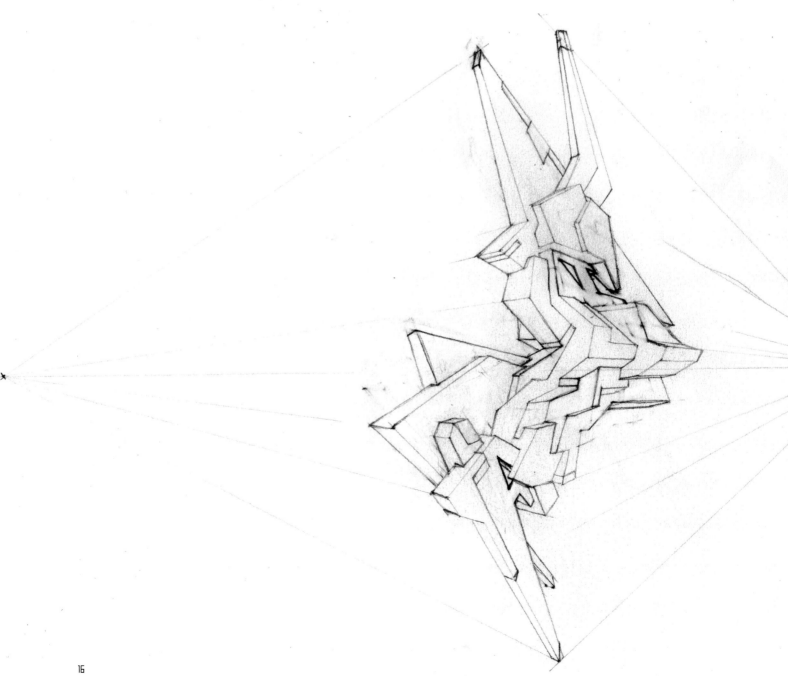

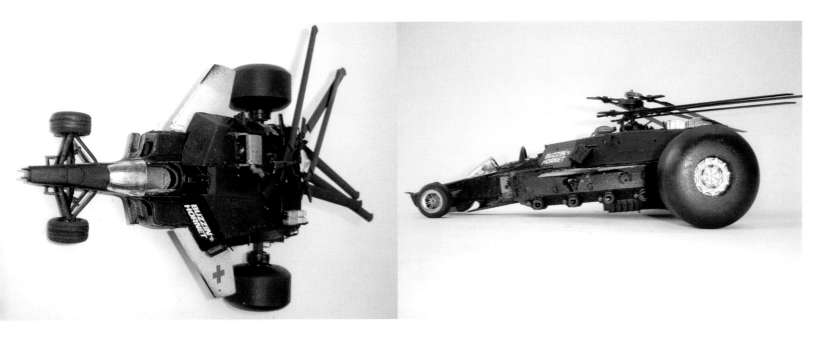

STUDIO / DESIGN FIRM / ARTIST Marok (Berlin, Germany)
WORK / YEAR "Buzzin' Hornet" / 2003
ARTIST Marok
DESCRIPTION One of 12 models of the "vehicles autistique" show in 2003.
A kitmerge project, contains helicopter-formula one-, tankparts
and skateboardwheels.

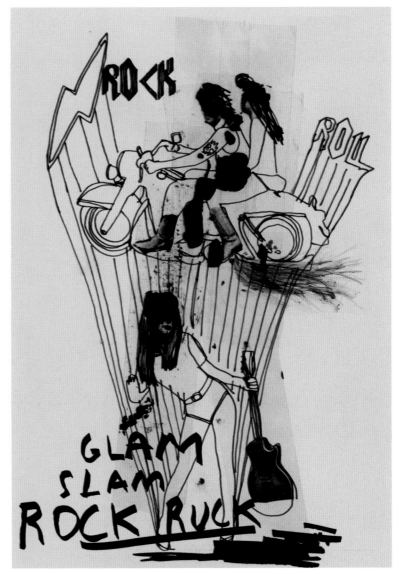

STUDIO / DESIGN FIRM / ARTIST Kev Speck (London, UK)
WORK / YEAR Glam Slam Rock / 2005
ART DIRECTION, DESIGN Kev Speck
ILLUSTRATION Kev Speck
CLIENT WGSN
DESCRIPTION Illustration for clothing.

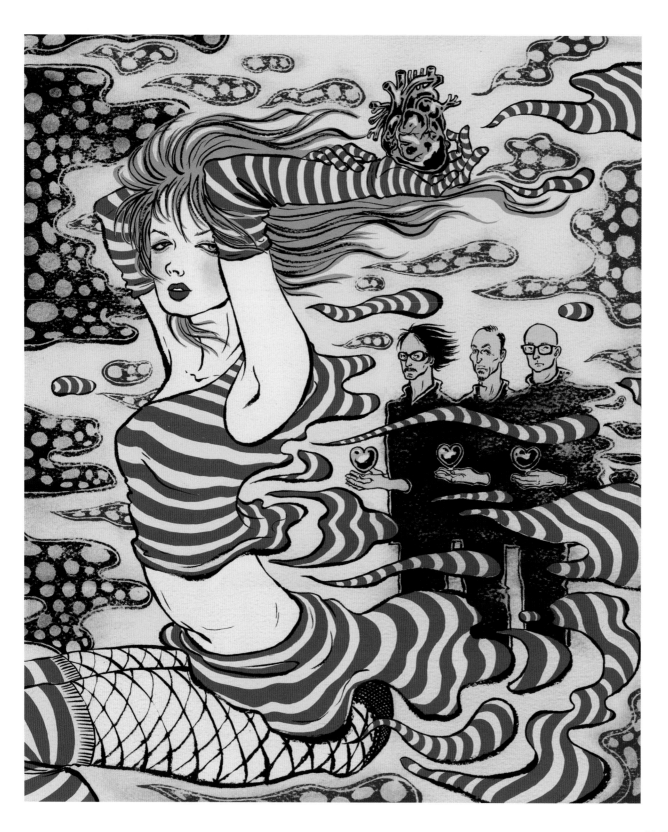

STUDIO / DESIGN FIRM Yuko Shimizu (New York, USA)
WORK / YEAR Portrait of band Garbage / 2005
ARTIST Yuko Shimizu
ILLUSTRATION Yuko Shimizu
ART DIRECTION Christine Bower
CLIENT Rolling Stone Magazine (USA)

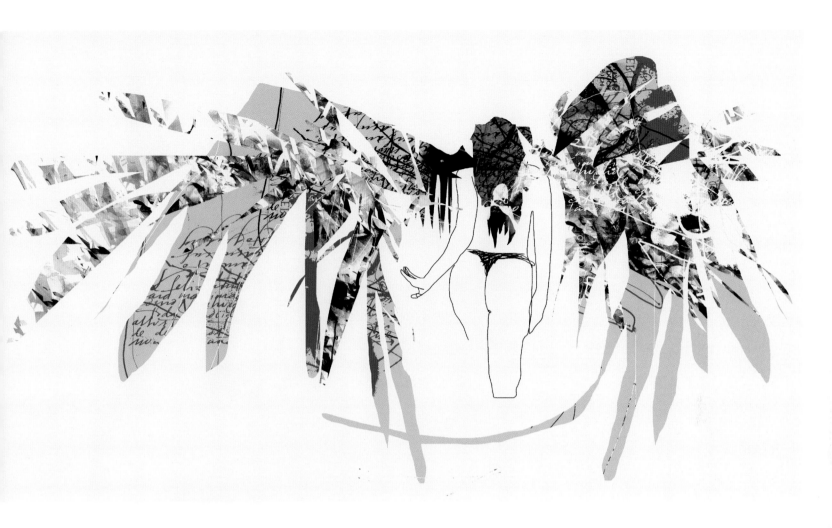

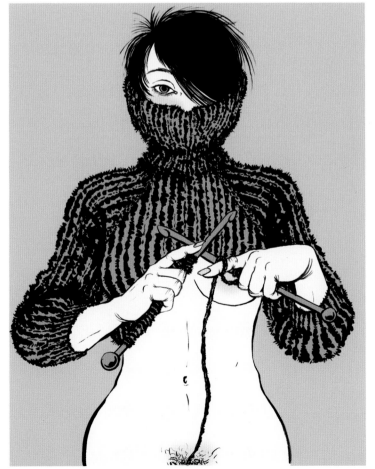

STUDIO / DESIGN FIRM vo6 (Rio de Janeiro, Brazil
 / Rotterdam, The Netherlands / Barcelona, Spain)
WORK / YEAR Strange Angel / 2004
ARTIST Yomar Augusto
DESIGN Yomar Augusto
ILLUSTRATION Yomar Augusto
PHOTOGRAPHY Yomar Augusto
CLIENT Design Radar / Diesel
DESCRIPTION Illustration for fashion project.

STUDIO / DESIGN FIRM Yuko Shimizu (New York, USA)
WORK / YEAR X-small X-short / 2002
ARTIST Yuko Shimizu
ILLUSTRATION Yuko Shimizu
DESCRIPTION One from a personal alphabet book series "Letters
 of Desire". Later published in different publications
 in different countries.

Below

STUDIO / DESIGN FIRM Fifth Floor Inc. (New York, USA)
WORK / YEAR Dedicated to Winsor McCay & Little Nemo / 2005
ARTIST Danijel Zezelj
CREATIVE DIRECTION Danijel Zezelj
ART DIRECTION. DESIGN . ILLUSTRATION. PHOTO. COPY Danijel Zezelj
CLIENT Edizioni Art Core, Italy.
DESCRIPTION Limited Edition Portfolio.

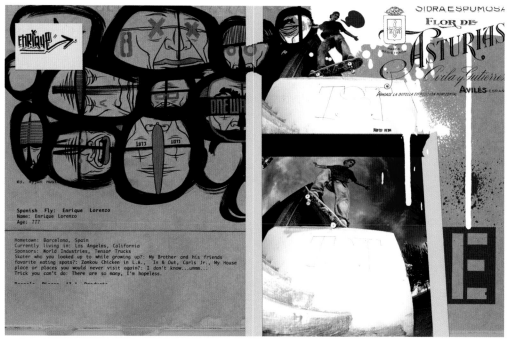

STUDIO / DESIGN FIRM BLK/MRKT (Los Angeles, CA USA)
WORK / YEAR 411VM DVD packaging & booklet design / 2005
ARTIST Kinsey
CREATIVE DIRECTION Kinsey
SHOWN Enrique Lorenzo Spread (Above)
SHOWN Stefan Janoski Spread (P. 21 Top)
SHOWN Danny Montoya Spread (P. 21 Bottom)
PHOTOGRAPHY Reda (Above)
PHOTOGRAPHY Landi (P. 21 Top)
PHOTOGRAPHY Pete Thompson (P. 21 Bottom)

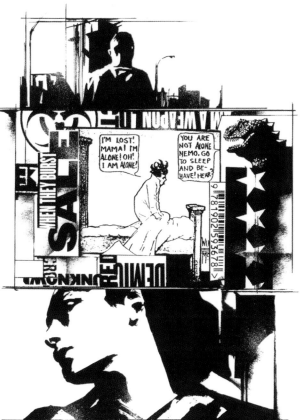

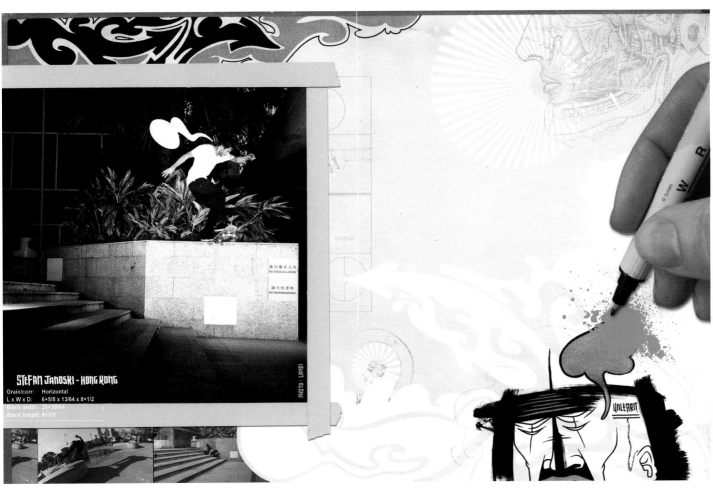

STEFAN JANOSKI - HONG KONG

Grain/corr: Horizontal
L x W x D: 6+5/8 x 13/64 x 8+1/2
Blank width: 26+39/64
Blank height: 8+1/2

PHOTO : LAIBI

UNLEARN

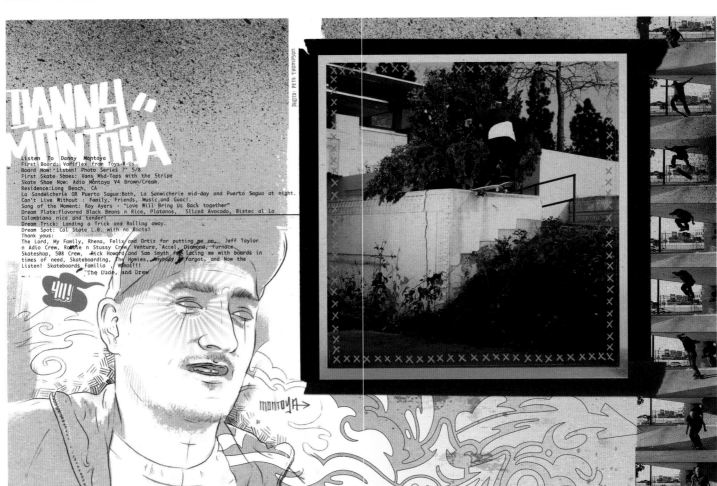

PHOTO : PETE THOMPSON

DANNY "MONTOYA"

Listen To Danny Montoya
First Board: Variflex from Toys-R-Us
Board Now:"Listen! Photo Series 7" 5/8
First Skate Shoes: Vans Mid-Tops with the Stripe
Skate Shoe Now: Adio Montoya V4 Brown/Cream.
Residence:Long Beach, CA
La Sandwicherie OR Puerto Sagua:Both, La Sanwicherie mid-day and Puerto Sagua at night.
Can't Live Without : Family, Friends, Music,and Guac!
Song of the Moment: Ray Ayers - "Love Will Bring Us Back together"
Dream Plate:Flavored Black Beans n Rice, Platanos, Sliced Avocado, Bistec al La
Colombiana nice and tender!
Dream Trick: Landing a Trick and Rolling away.
Dream Spot: Cal State L.B. with no Boots!
Thank yous:
The Lord, My Family, Rhena, Felix and Ortiz for putting me on, Jeff Taylor
n Adio Crew, Ramble n Stussy Crew, Ventura, Accel, Diamond, Furnace
Skateshop, 508 Crew, Rick Howard and Sam Smyth for Lacing me with boards in
times of need, Skateboarding, The Homies, Anybody I forgot, and Now the
Listen! Skateboards Familia , Vamos!!!
"The Dude, and Drew"

411!

montoya

21

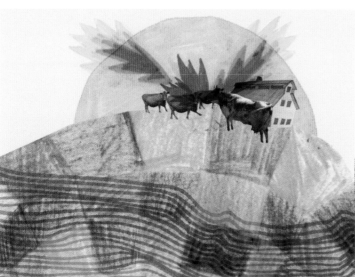

STUDIO / DESIGN FIRM / ARTIST Eatjapanesefood / Holly Wales (London, UK)
WORK / YEAR "When Sellotape Attacks" / 2005
ART DIRECTION Holly Wales
CLIENT Personal
DESCRIPTION Mixed Media 3D.

STUDIO / DESIGN FIRM / ARTIST Eatjapanesefood / Holly Wales (London, UK)
WORK / YEAR "Memories" / 2005
ART DIRECTION Holly Wales
ANIMATION Holly Wales
CLIENT Personal
DESCRIPTION A 1 minute animation which looked at the nature of a stream of consciousness when concerned with memory.

STUDIO / DESIGN FIRM Andrew Rae (London, UK)
WORK / YEAR "Characters" / 1999-2005
ARTIST Andrew Rae
DESCRIPTION Illustration put together with characters designed for personal use and for various clients.

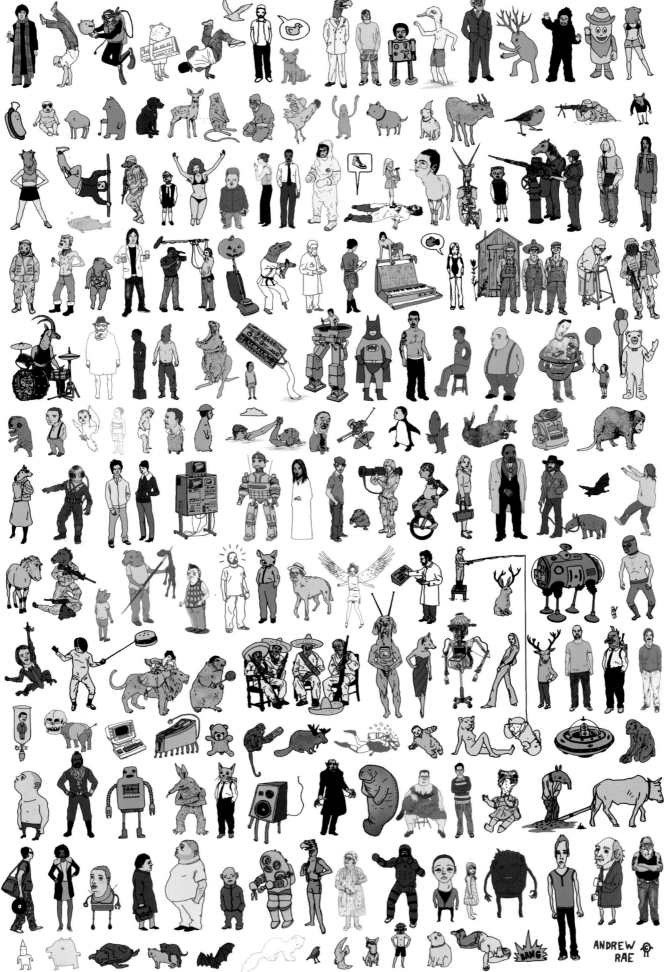

ANDREW RAE

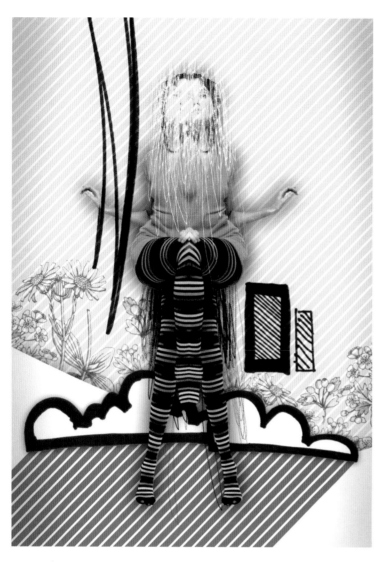

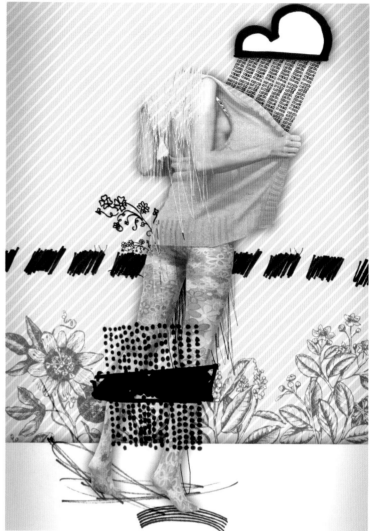

STUDIO / DESIGN FIRM Bruno Savona / Adabsurdum (Cagliari, ITALY)
WORK / YEAR Pink01 - Pink02 / 2005
ILLUSTRATOR / ART DIRECTOR Bruno Savona

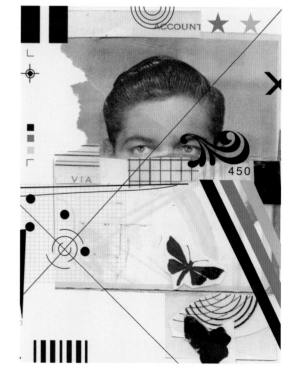

STUDIO / DESIGN FIRM Automatic Art and Design (New York, USA)
WORK / YEAR Illustration / 2003
ARTIST Charles Wilkin
DESIGN / ILLUSTRATION Charles Wilkin
CLIENT Automatic / Index-A
DESCRIPTION Book Illustration.

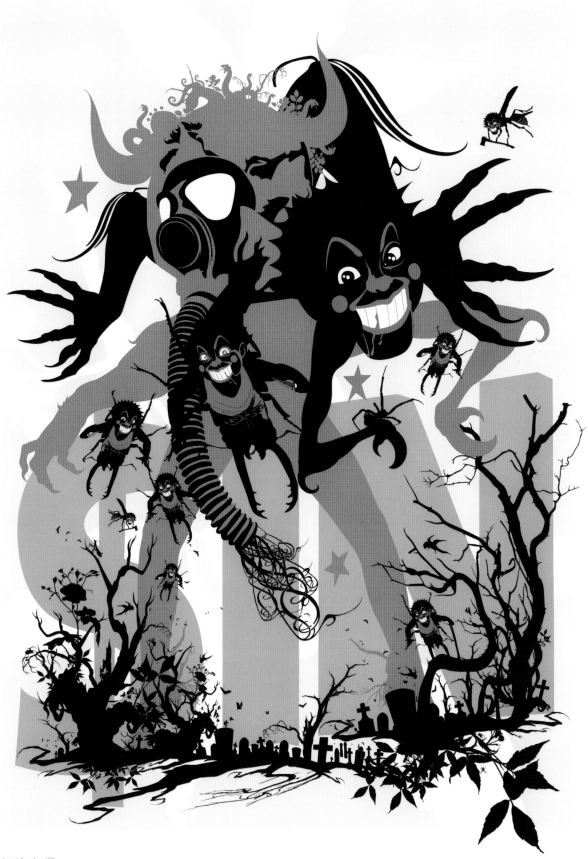

STUDIO / DESIGN FIRM Insect (London, UK)
WORK / YEAR Webcrawler / 2003
ARTIST Paul Insect
CREATIVE DIRECTION Paul Insect
ART DIRECTION, DESIGN, ILLUSTRATION Paul Insect
CLIENT Insect
DESCRIPTION Personal / ltd Screenprint.

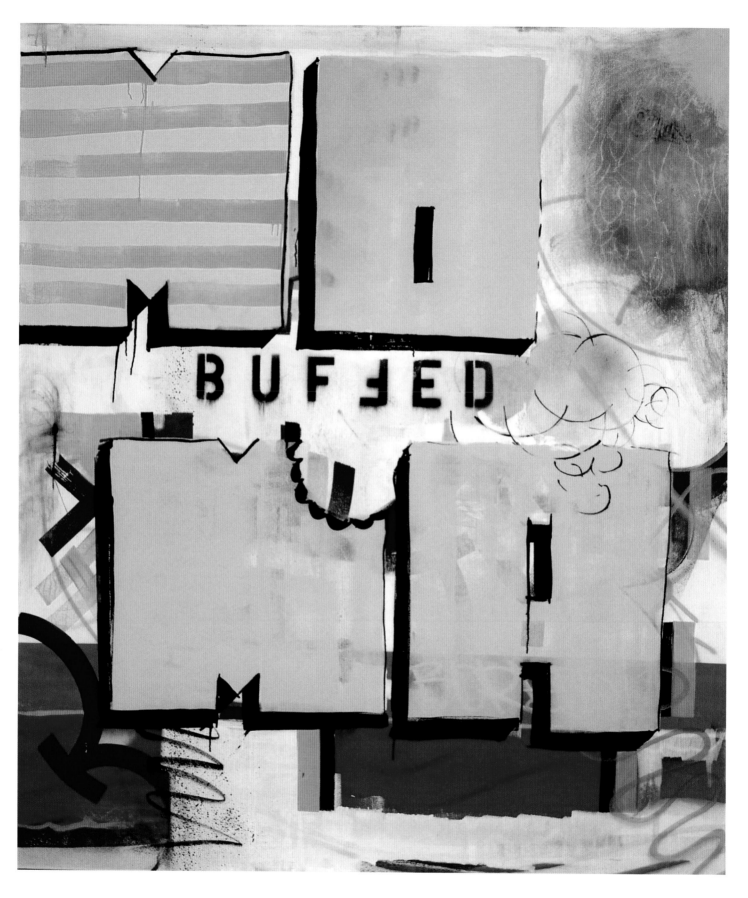

STUDIO / DESIGN FIRM / ARTIST Marok (Berlin, Germany)
WORK / YEAR 'MoMa buffed' / 2003
ARTIST Marok
DESCRIPTION Painting 180x180 cm canvas.

STUDIO / DESIGN FIRM No-Domain (Barcelona, Spain)
WORK / YEAR Adidas origami series 001-002-003 - Adidas marker series 001 / 2005
ARTIST No-Domain
CREATIVE DIRECTION No-Domain
ART DIRECTION No-Domain
CLIENT Advanced Music / Adidas
DESCRIPTION Series of slides for Sonar 2005 opening party.

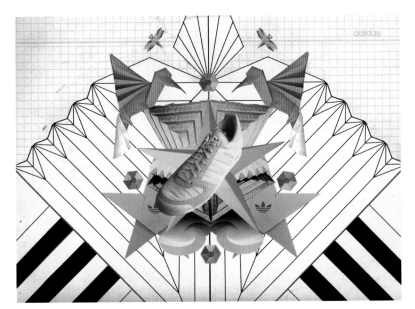

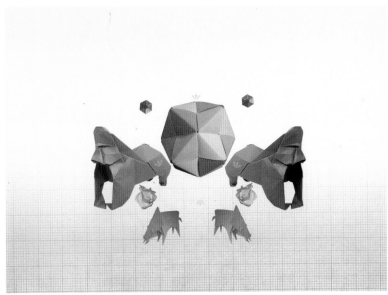

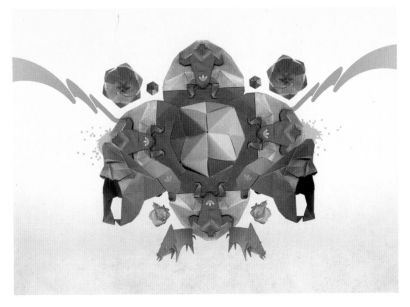

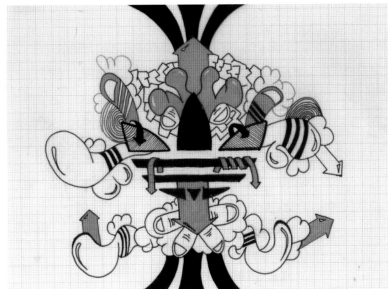

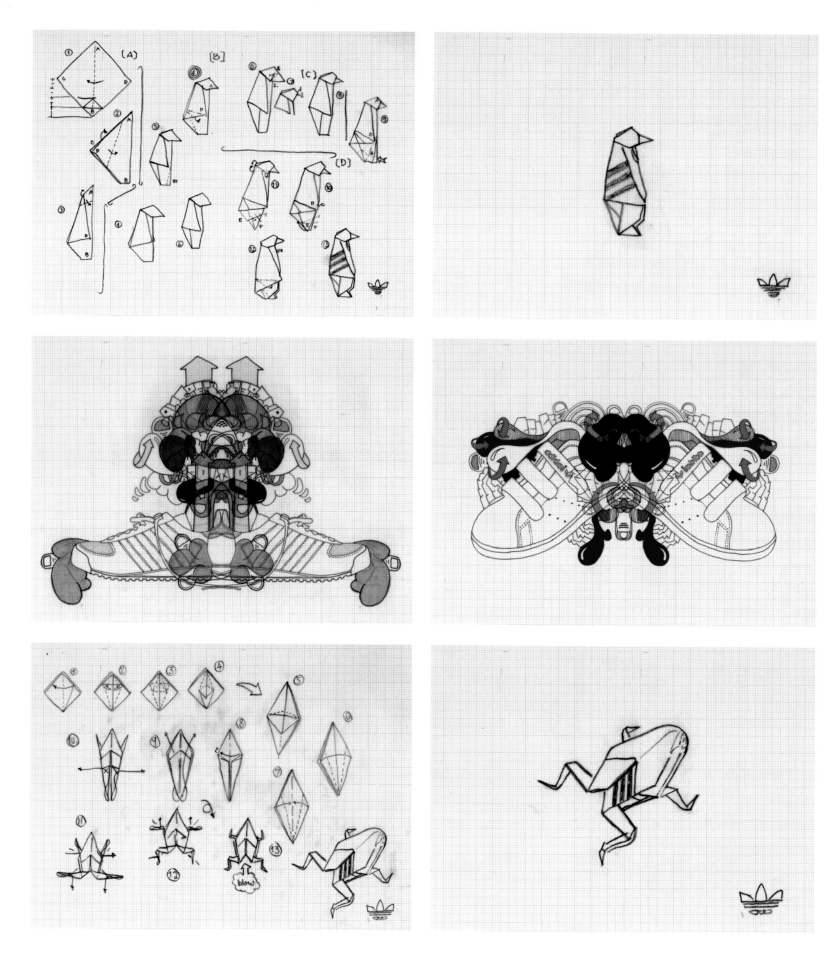

STUDIO / DESIGN FIRM No-Domain (Barcelona, Spain)
WORK / YEAR Adidas origami series 005-004-006-007 - Adidas marker 002-003 / 2005
ARTIST No-Domain
CREATIVE DIRECTION No-Domain
ART DIRECTION No-Domain
CLIENT Advanced Music / Adidas
DESCRIPTION Series of slides for Sonar 2005 opening party.

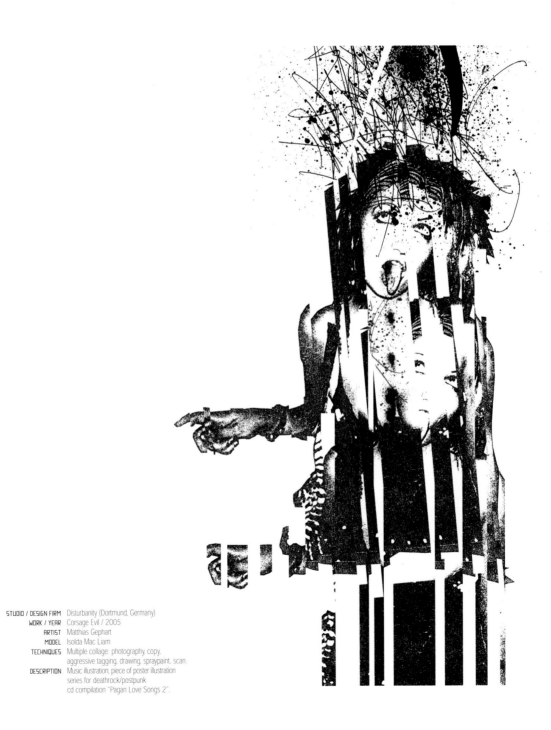

STUDIO / DESIGN FIRM Disturbanity (Dortmund, Germany)
WORK / YEAR Corsage Evil / 2005
ARTIST Matthias Gephart
MODEL Isolda Mac Liam
TECHNIQUES Multiple collage: photography, copy,
aggressive tagging, drawing, spraypaint, scan.
DESCRIPTION Music illustration, piece of poster illustration
series for deathrock/postpunk
cd compilation "Pagan Love Songs 2".

this is for you

a small place to take it all
your inside and out
both mine and yours
it doesn't matter, just get it out in
steal, slip, appropriate, borrow (a bit)

wrong doesn't exist here
play god, big brother, big cheese
dare to bare yourself
to yourself if no one else

impress, distress, express yourself
lay it on the line
you show me yours, I'll show you mine

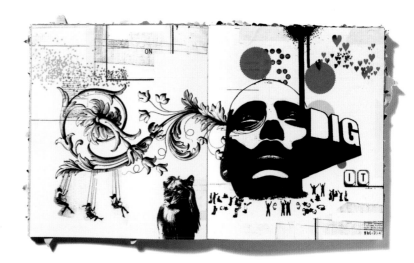

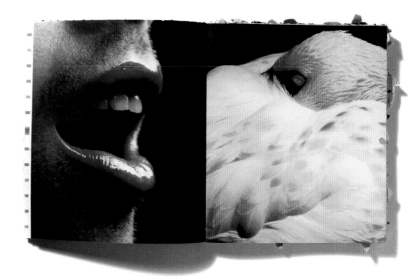

CREATIVE DIRECTOR Chris Ashworth
ART DIRECTOR / DESIGNER Mark Fraser
CONCEPT Mark Fraser, Chris Myers
ILLUSTRATIONS Jimmy Turrell (www.safe-place.net)
WRITING Mike Benson, Jason Graham, Larry White
PRODUCTION MANAGER Sunita Nanda
REPRO Steven Ono
PRINTING Westerham Press
IMAGES Getty Images

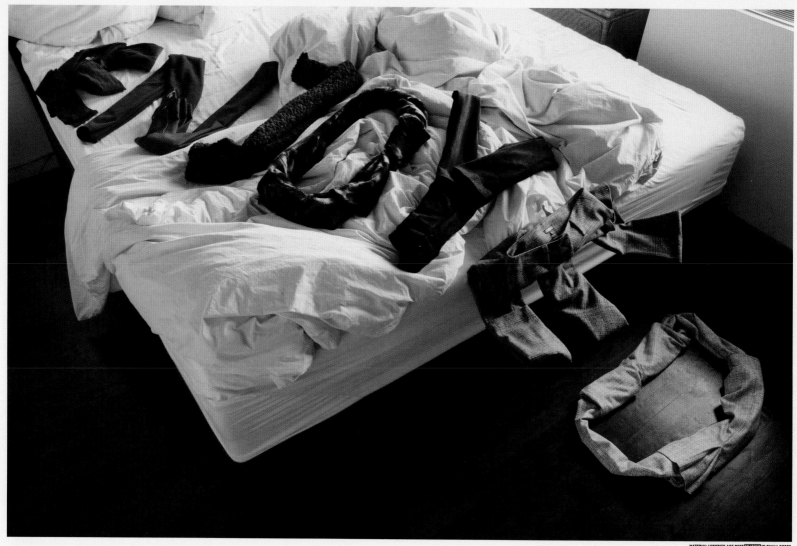

MATERIAL LUXURIES ARE BEST ENJOYED IN SMALL DOSES

STUDIO / DESIGN FIRM Sagmeister Inc. (New York, USA)
WORK / YEAR Anni Kuan Brochure, Gold / 2005
ART DIRECTION Stefan Sagmeister
ILLUSTRATION / PHOTOGRAPHY / DESIGN Ariane Spanari
CLIENT Anni Kuan
DESCRIPTION Newsprint catalogue for New York fashion designer including a piece of actual gold. The entire catalogue spells out: "Material Luxuries are best enjoyed in small doses" which is one of the points of a list titled "things I have learned in my life so far" I found in my diary.

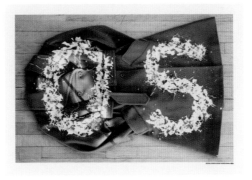

ANNI KUAN
HAPPILY INVITES YOU TO PREVIEW THE
FALL AND WINTER 2005 COLLECTION AT
THE FASHION COTERIE FROM SUNDAY,
FEB 27TH TO TUESDAY, MAR 1ST 2005,
PIER 90, BOOTH 622, NEW YORK CITY

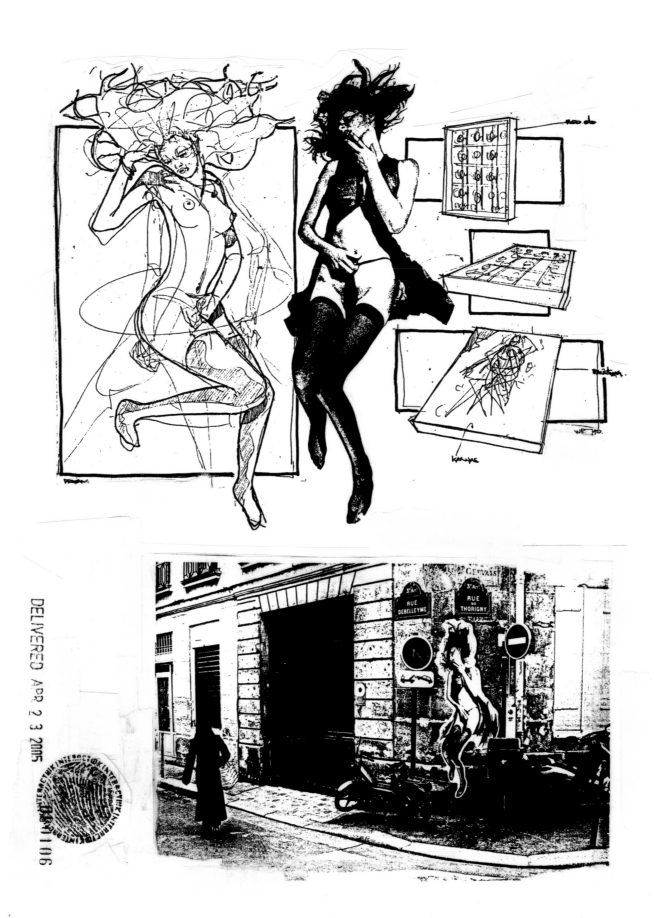

WK INTERVENTION URBAN STREET PARIS 2005

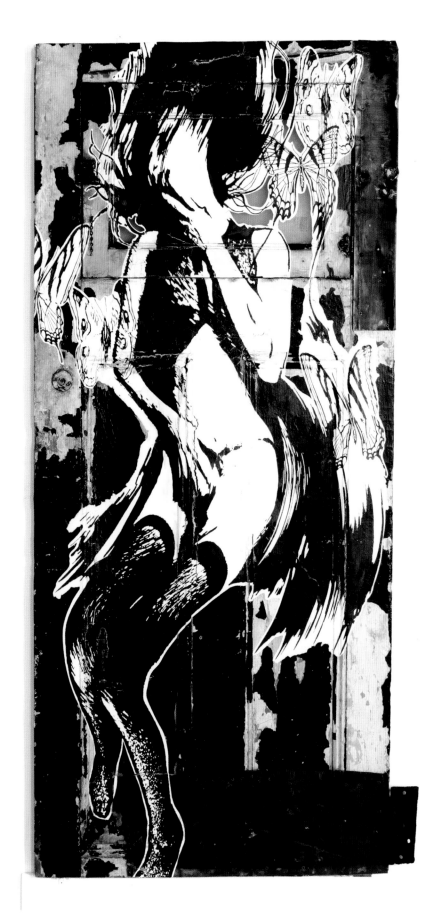

STUDIO / DESIGN FIRM / ARTIST WK Interact (New York, USA)
WORK / YEAR Butterfly Dream / 1998
MODEL Yael Reich

STUDIO / DESIGN FIRM / ARTIST Ed Fella (Los Angeles, USA)
WORK / YEAR Ed Fella Website, 2005
ART DIRECTION, DESIGN, ILLUSTRATION Ed Fella
DESCRIPTION The pages were made by using collage, hand lettering and drawing and scanned into the computer.
The website structure and navigation was programmed in underneath by a professional website designer.

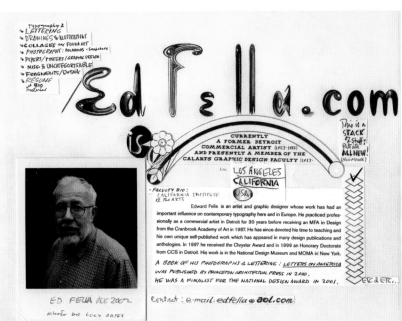

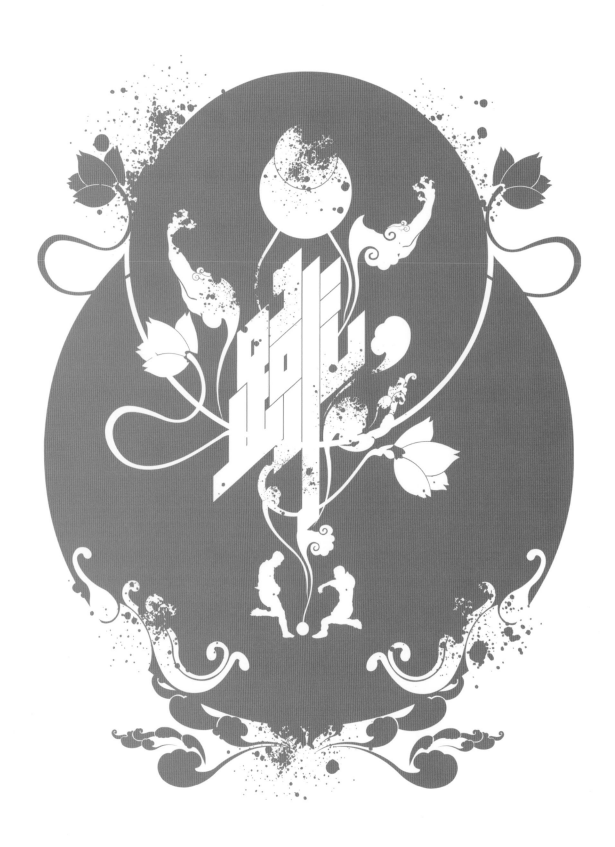

STUDIO / DESIGN FIRM Sixstation / Benny Luk (Hong Kong, China)
WORK / YEAR 蹴(kick) / 2005
ARTIST Benny Luk
ART DIRECTION, DESIGN Benny Luk
CLIENT Nike-Asia

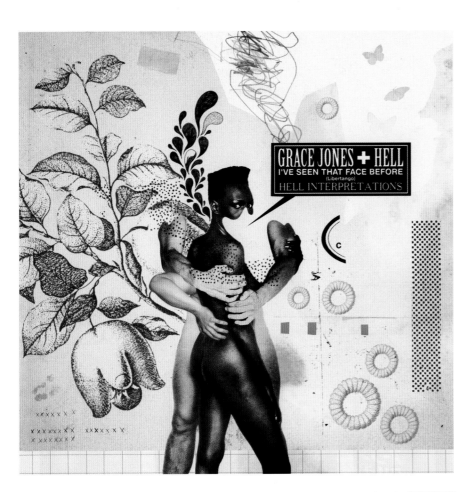

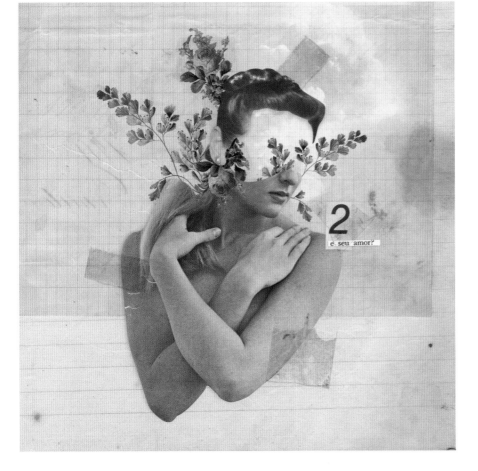

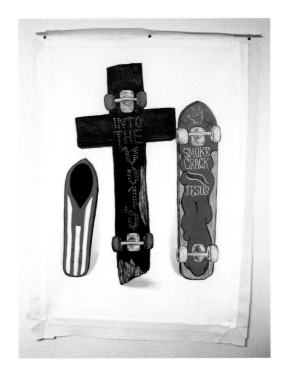

STUDIO / DESIGN FIRM / ARTIST Eduardo Recife / Misprinted Type (Belo Horizonte, Brazil)
WORK / YEAR Grace Jones + Hell / 2005
CREATIVE DIRECTION Eduardo Recife
ART DIRECTION, DESIGN Eduardo Recife
ILLUSTRATION Eduardo Recife
CLIENT Gigolo Records
DESCRIPTION LP packaging.

STUDIO / DESIGN FIRM / ARTIST Scarful (Rome, Italy)
WORK / YEAR Into the void / 2005
ARTIST Scarful
ILLUSTRATION Scarful
DESCRIPTION Painting, acrylics on canvas, 80x120cm.

STUDIO / DESIGN FIRM / ARTIST Eduardo Recife / Misprinted Type (Belo Horizonte, Brazil)
WORK / YEAR E o amor? (What about love?) / 2004
CREATIVE DIRECTION Eduardo Recife
ART DIRECTION, DESIGN Eduardo Recife
ILLUSTRATION Eduardo Recife
DESCRIPTION Personal Project.

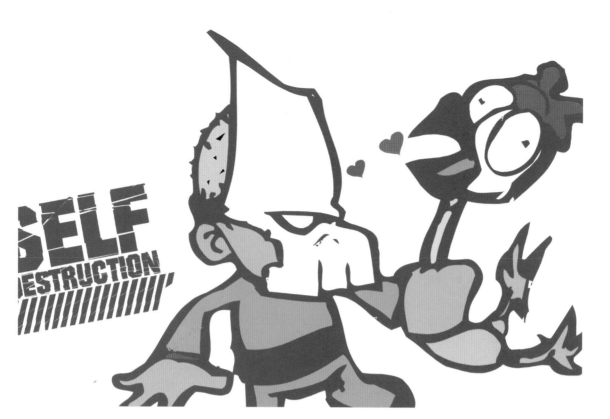

Left - Right
STUDIO / DESIGN FIRM Niko Stumpo / The Hanazuki Company
 (Amsterdam, The Netherlands)
WORK / YEAR Print Work for AiKO / 2004
CREATIVE DIRECTION Niko Stumpo
ART DIRECTION, DESIGN Niko Stumpo
DESCRIPTION Print work for t-shirts, magazines and books.

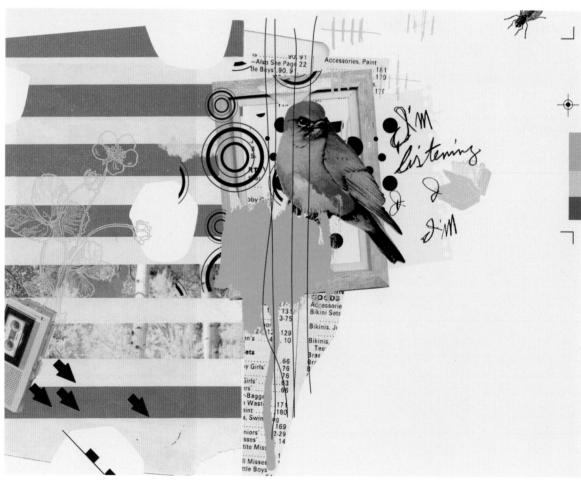

STUDIO / DESIGN FIRM Automatic Art and Design (New York, USA)
WORK / YEAR Illustration / 2003
ARTIST Charles Wilkin
DESIGN / ILLUSTRATION Charles Wilkin
CLIENT Émigré
DESCRIPTION Editorial Illustration.

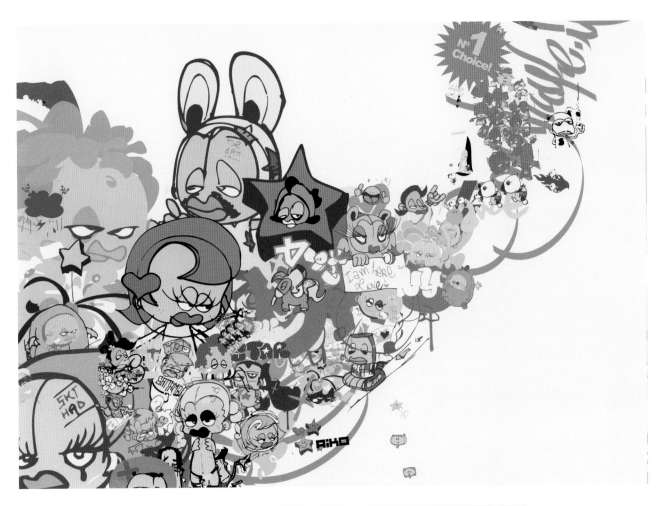

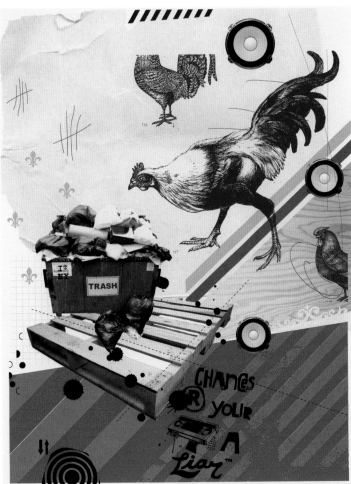

STUDIO / DESIGN FIRM Automatic Art and Design (New York, USA)
WORK / YEAR Illustration / 2005
ARTIST Charles Wilkin
DESIGN / ILLUSTRATION Charles Wilkin
CLIENT Semi-Permanent
DESCRIPTION Book Illustration.

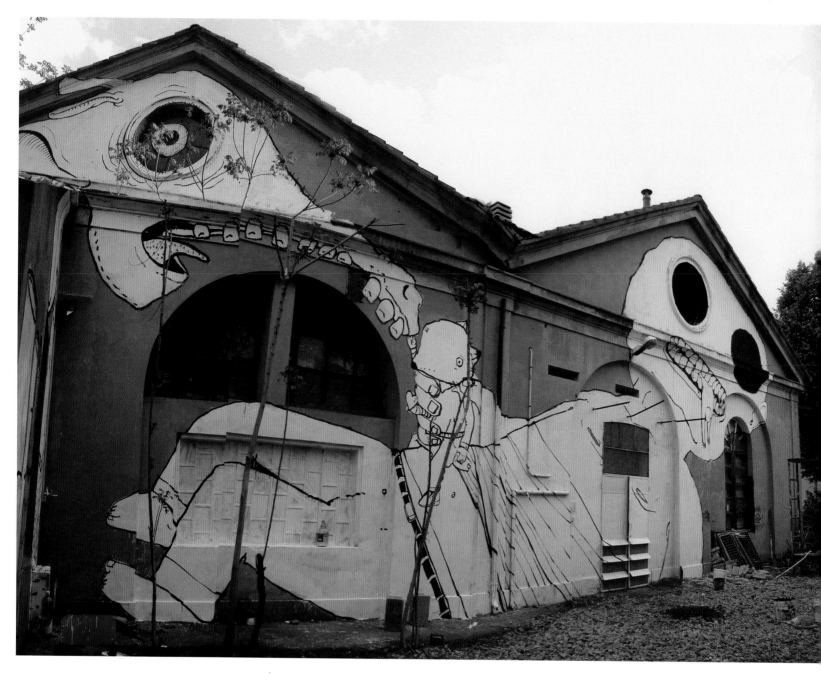

STUDIO / DESIGN FIRM / ARTIST blu (Bologna, Italy)
WORK / YEAR no title / 2005
DESCRIPTION Wall painting (mural).

STUDIO / DESIGN FIRM Disturbanity (Dortmund, Germany)
WORK / YEAR Bile Disketch / 2005
ARTIST Matthias Gephart
TECHNIQUES Lost Love and intense lack of understanding, photography, copy, drawing, tagging, scan and vectorrism.
DESCRIPTION Free illustration, overworked sketchbook piece, broken graphic impression of broken relationship.

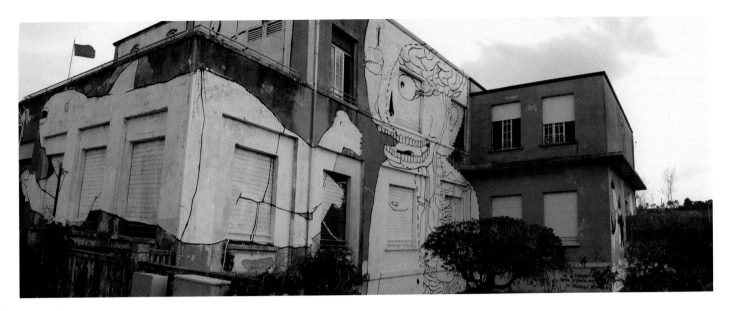

STUDIO / DESIGN FIRM / ARTIST blu (Bologna, Italy)
WORK / YEAR no title / 2005
DESCRIPTION Wall painting (mural).

STUDIO / DESIGN FIRM Disturbanity (Dortmund, Germany)
WORK / YEAR Go see Kontakt46 / 2002
ARTIST Matthias Gephart
TECHNIQUES Multiple collage, including pochoir, photography, copy, scan, type sampling + letter cutting, offset.
DESCRIPTION Illustration poster for german punk/hc band Kontakt46.

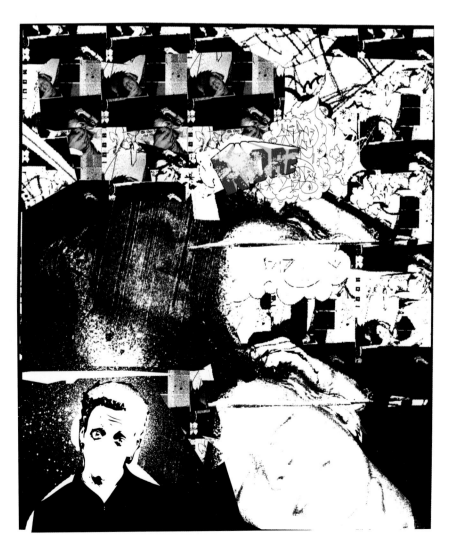

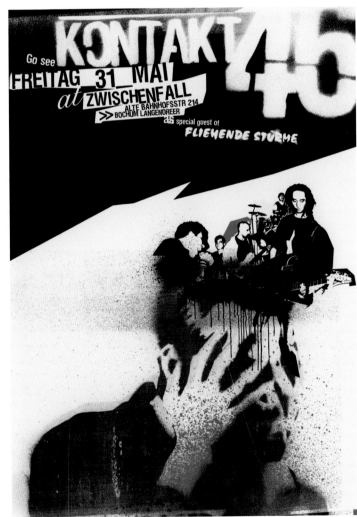

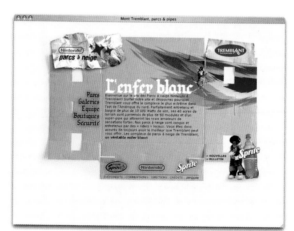

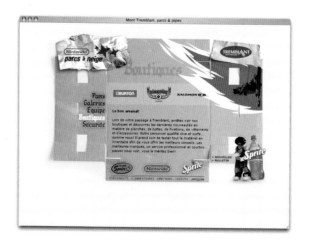

STUDIO / DESIGN FIRM PUR l'agence interactive
 (Québec, Canada)
WORK / YEAR White Evil, Mont Tremblant
 Parks & Pipes / 2005
ART DIRECTION, DESIGN Stéphane Groleau
ANIMATION Stéphane Groleau
PROGRAMMING Stéphane Groleau
PHOTO Stéphane Groleau
PARK CARTON MODEL Jean-François Hallé
INTRODUCTION VIDEO Christian Noël
COPY Jean-Philippe Larochelle
CLIENT Mont Tremblant - Intrawest
DESCRIPTION Website.

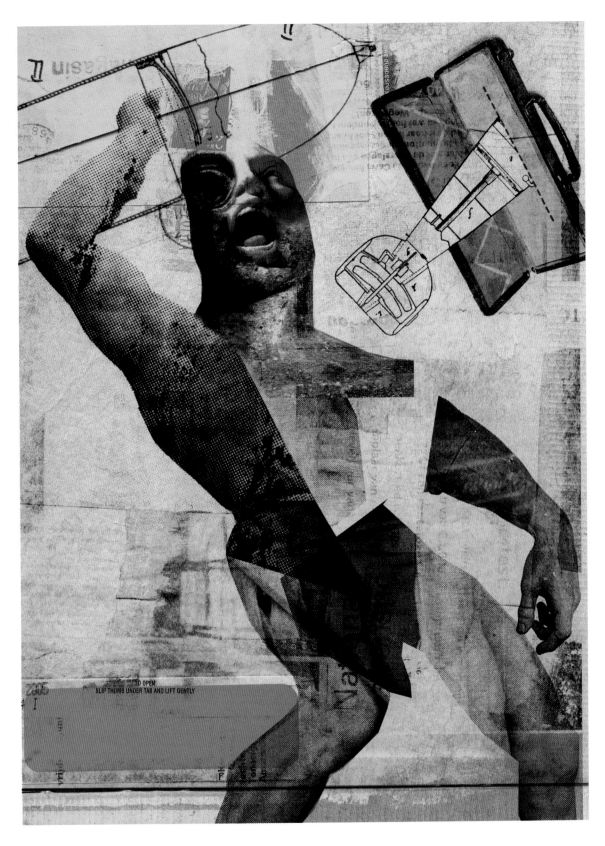

STUDIO / DESIGN FIRM Peter Hermann (Odense, Denmark)
WORK / YEAR The flying suitcase / 2005
ARTIST Peter Hermann
ART DIRECTION, DESIGN Peter Hermann
ILLUSTRATION Peter Hermann
CLIENT DSB
DESCRIPTION Illustration for short story.

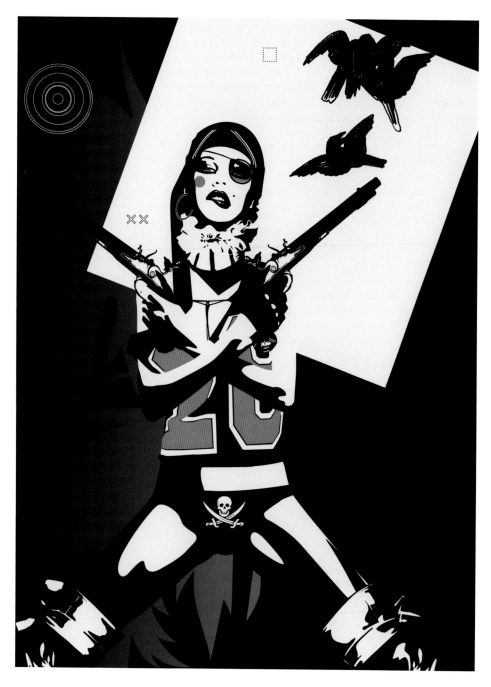

STUDIO / DESIGN FIRM Jasper Goodall (Brighton, UK)
WORK / YEAR Jolly Roger / 2004
ARTIST Jasper Goodall
ART DIRECTION, DESIGN, ILLUSTRATION Jasper Goodall
CLIENT The Face magazine
DESCRIPTION Editorial Illustration.

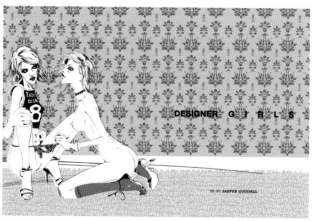

DESIGNER G I R L S

STUDIO / DESIGN FIRM Jasper Goodall (Brighton, UK)
WORK / YEAR DV Chanel / 2003
WORK / YEAR DV Dior / 2003
ARTIST Jasper Goodall
ART DIRECTION, DESIGN, ILLUSTRATION Jasper Goodall
CLIENT Deliciae Vitae magazine
DESCRIPTION Editorial Illustrations.

STUDIO / DESIGN FIRM Jasper Goodall (Brighton, UK)
WORK / YEAR Bubblegum / 2004
WORK / YEAR Vanilla / 2004
ARTIST Jasper Goodall
ART DIRECTION, DESIGN, ILLUSTRATION Jasper Goodall
CLIENT Big Active / Future Lap Fundation
DESCRIPTION Illustrations.

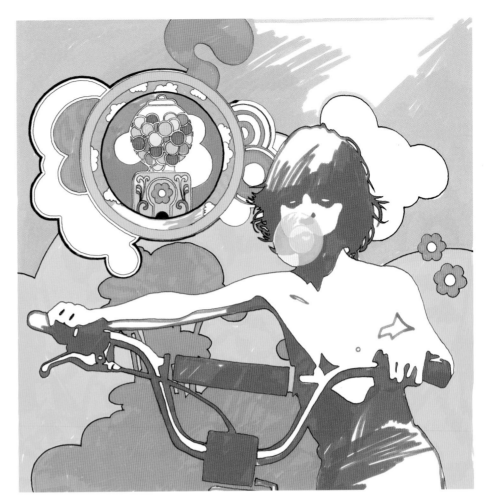

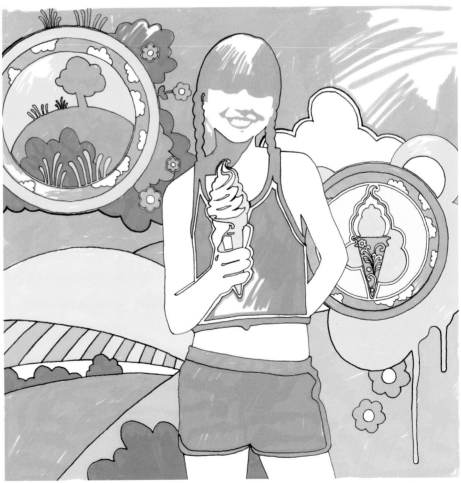

STUDIO / DESIGN FIRM Jasper Goodall (Brighton, UK)
WORK / YEAR Pink Silk / 2005
ARTIST Jasper Goodall
ART DIRECTION, DESIGN, ILLUSTRATION Jasper Goodall
CLIENT Self
DESCRIPTION Unpublished Illustration.

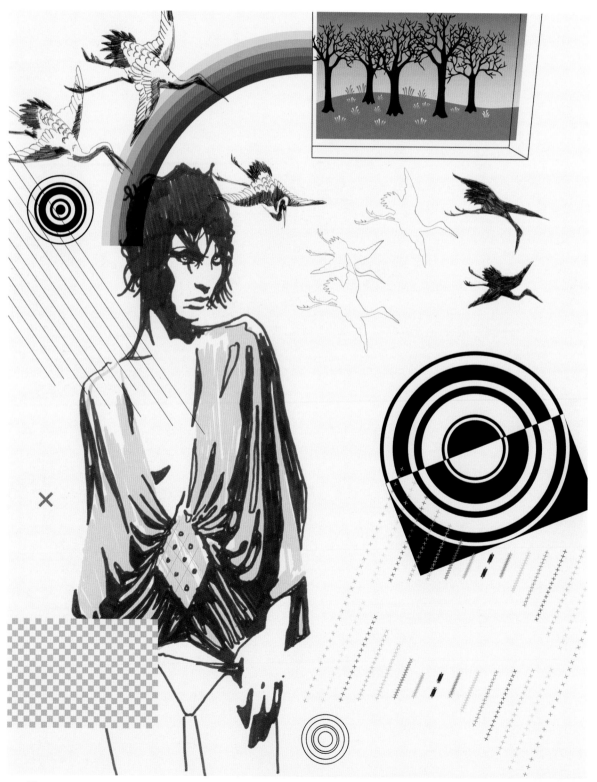

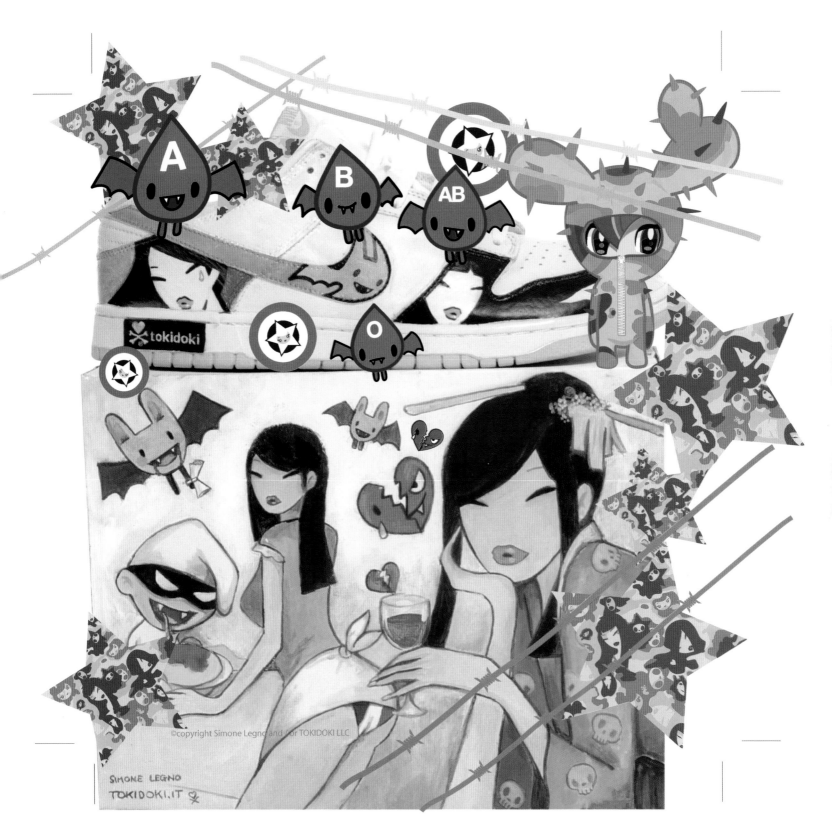

©copyright Simone Legno and / or TOKIDOKI LLC

SIMONE LEGNO
TOKIDOKI.IT

STUDIO / DESIGN FIRM TOKIDOKI LLC (Los Angeles, USA)
WORK / YEAR Blood sucker / 2005
ARTIST Simone Legno
ILLUSTRATION Simone Legno

STUDIO / DESIGN FIRM TOKIDOKI LLC (Los Angeles, USA)
WORK / YEAR Bad news from a bastard boyfriend / 2004
ARTIST Simone Legno
ILLUSTRATION Simone Legno

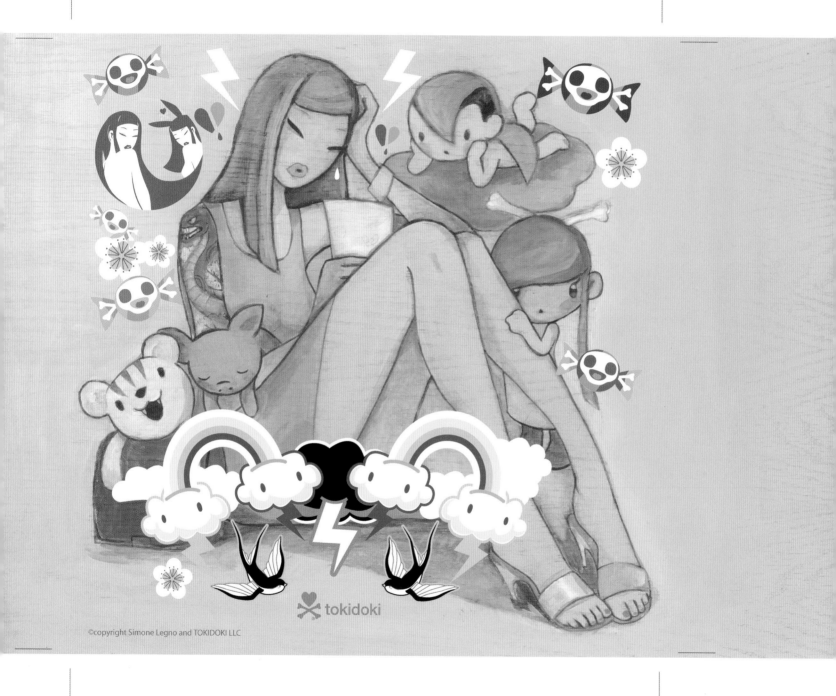

STUDIO / DESIGN FIRM TOKIDOKI LLC (Los Angeles, USA)
WORK / YEAR Shunga sul culetto / 2004
ARTIST Simone Legno
ILLUSTRATION Simone Legno

STUDIO / DESIGN FIRM TOKIDOKI LLC (Los Angeles, USA)
WORK / YEAR A walk with the new babysitter / 2003
ARTIST Simone Legno
ILLUSTRATION Simone Legno

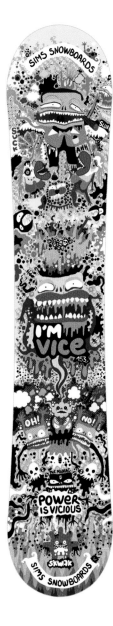
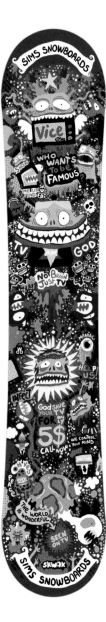
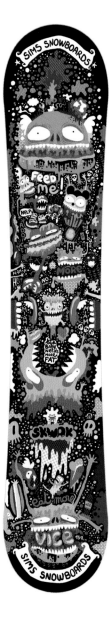

STUDIO / DESIGN FIRM SKWAK (Lille, France)
WORK / YEAR Vice Sims Snowboard 153cm / 2005
WORK / YEAR Vice Sims Snowboard 156cm / 2005
WORK / YEAR Vice Sims Snowboard 159cm / 2005
ARTIST SKWAK
ILLUSTRATION SKWAK
DESCRIPTION Illustrations (Design) for Sims Snowboards
new collection (Vice) - by SKWAK (2005).

STUDIO / DESIGN FIRM Niko Stumpo / The Hanazuki Company
(Amsterdam, The Netherlands)
WORK / YEAR Print Work for AiKO / 2004
CREATIVE DIRECTION Niko Stumpo
ART DIRECTION, DESIGN Niko Stumpo
DESCRIPTION Print work for t-shirts, magazines and books.

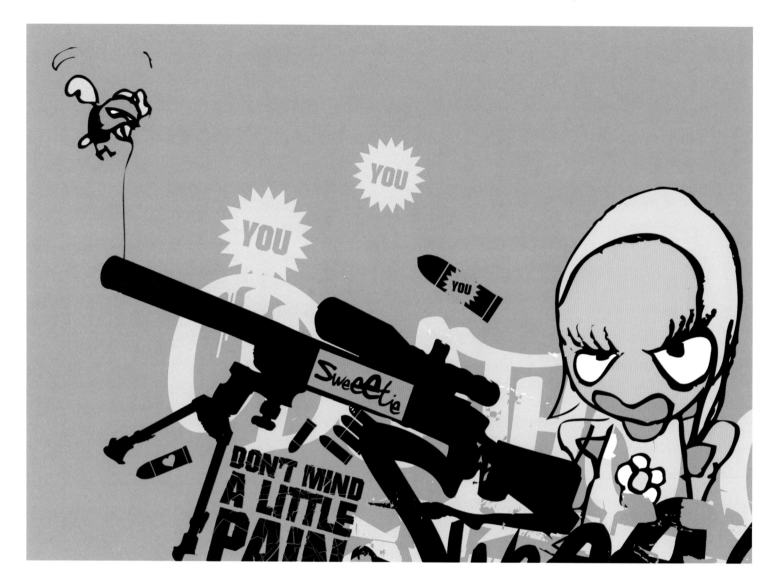

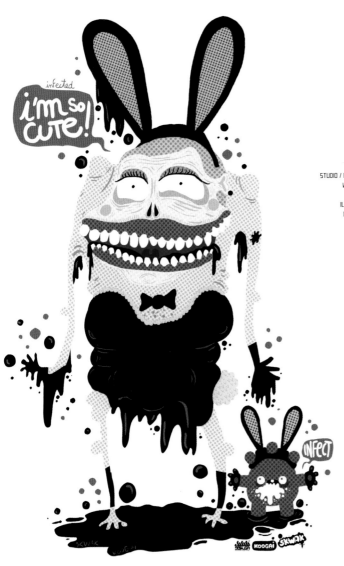

STUDIO / DESIGN FIRM SKWAK (Lille, France)
WORK / YEAR Infected Bunny / 2005
ARTIST SKWAK
ILLUSTRATION SKWAK
DESCRIPTION Illustration for Pictoplasma - ESSENCE OF
RABBIT - the bunny mandala project - by
SKWAK (2005).

STUDIO / DESIGN FIRM Vault49 (New York, USA)
WORK / YEAR Beastie Boys / 2004
ART DIRECTION, DESIGN Vault49
CLIENT NME
DESCRIPTION Editorial.

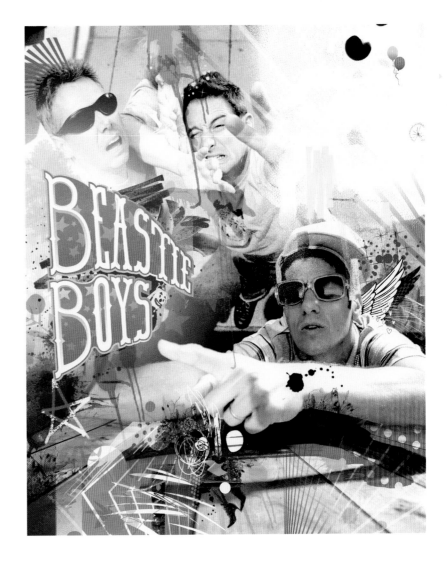

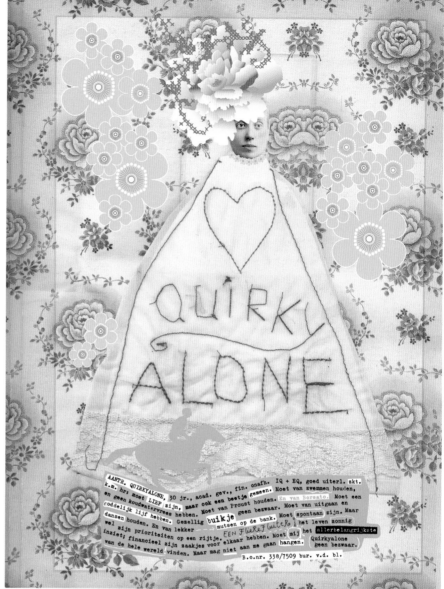

STUDIO / DESIGN FIRM Studio 't Brandt Weer (Den Haag, The Netherlands)
WORK / YEAR Quirky Alone / 2004
ARTIST Marenthe Otten
ART DIRECTION, DESIGN Marenthe Otten
ILLUSTRATION Marenthe Otten
CLIENT CARP
DESCRIPTION Illustration for magazine.

STUDIO / DESIGN FIRM Miles Donovan / Peepshow (London, UK)
WORK / YEAR Art Department Promo Spring 2004 / 2004
ARTIST Miles Donovan
CREATIVE DIRECTION Miles Donovan
CLIENT Art Department
DESCRIPTION Promotional.

STUDIO / DESIGN FIRM Fawn Gehweiler / No Candy (Los Angeles, USA)
WORK / YEAR "I'm with the band" / 2003
ARTIST Fawn Gehweiler
DESCRIPTION Personal work from "Sundae Girls" series
enamels on glass, photo collage, digital.

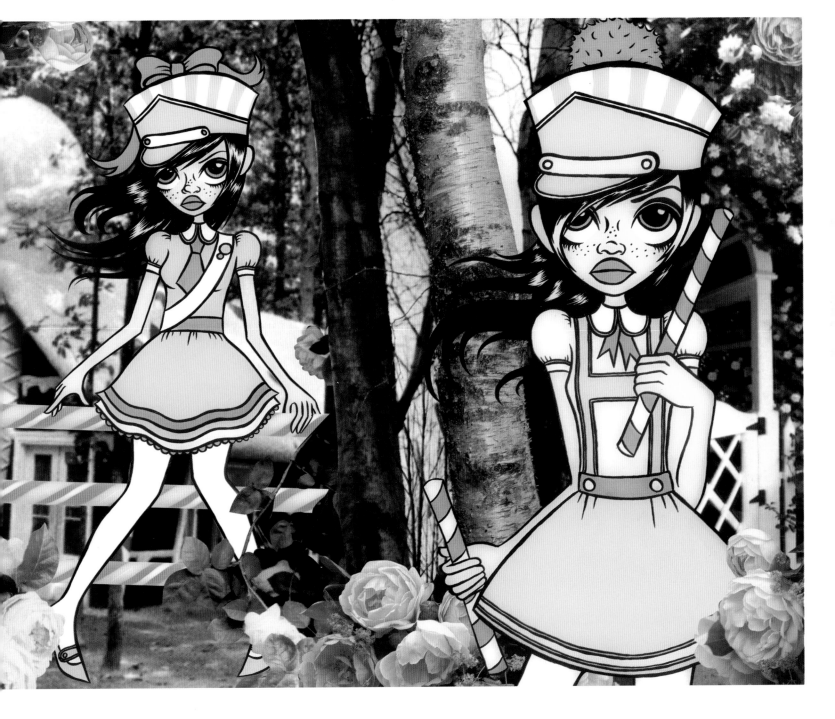

STUDIO / DESIGN FIRM Guillermo Tragant (Chicago, USA)
WORK / YEAR Furia / 2005
ARTIST Guillermo Tragant
ART DIRECTION, DESIGN Guillermo Tragant
CLIENT Furia
DESCRIPTION Illustration for bag.

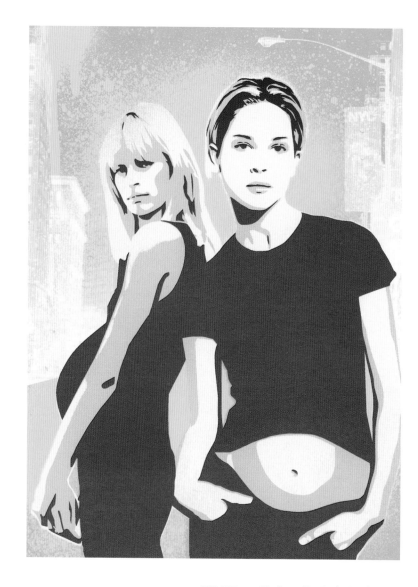

STUDIO / DESIGN FIRM Miles Donovan / Peepshow (London, UK)
WORK / YEAR Pregnant New York / 2004
ARTIST Miles Donovan
CREATIVE DIRECTION Miles Donovan / Danielle Campbell
CLIENT Telegraph Newspapers PLC
DESCRIPTION Editorial.

STUDIO / DESIGN FIRM Fawn Gehweiler / No Candy (Los Angeles, USA)
WORK / YEAR "Carousel" / 2004
ARTIST Fawn Gehweiler
DESCRIPTION Illustration for Wad magazine, France,
 pencil, collage, digital.

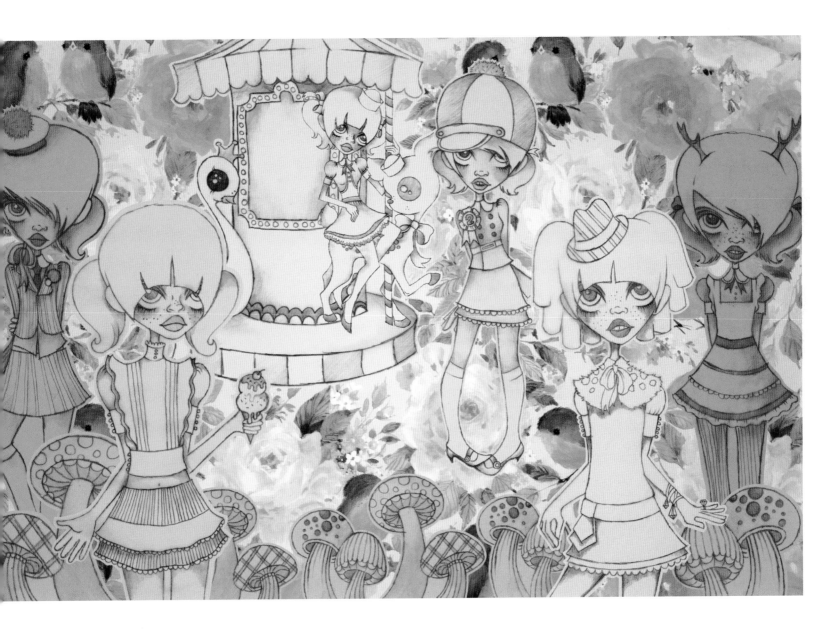

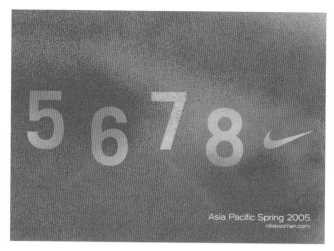

5 6 7 8

Asia Pacific Spring 2005
nikewomen.com

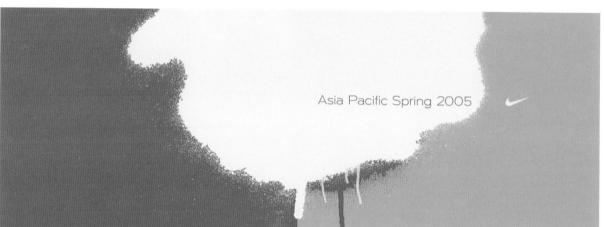

Asia Pacific Spring 2005

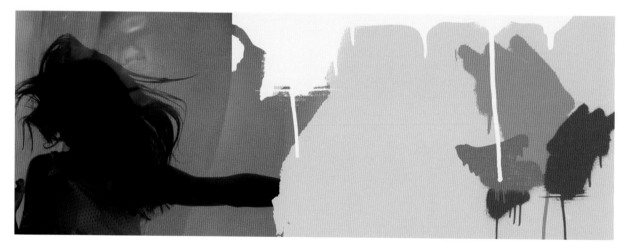

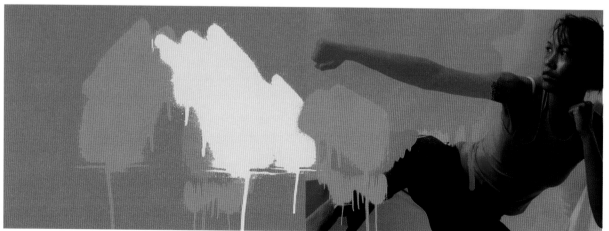

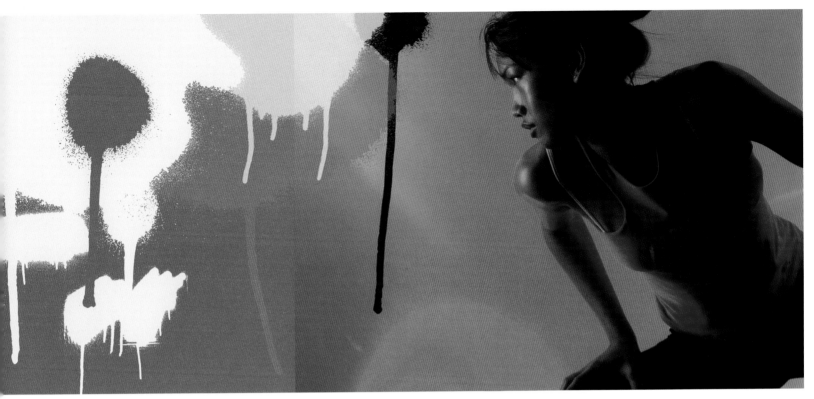

Nike Shox Rhythmic

This shoe is for the "gym-diva" who participates in a variety of trendy, new workouts. The durable upper offers protection for dance movements. It is also double lasted for lateral support. A breathable mesh tongue and large open mesh create maximum breathability. It has triangular columns for ultimate stability. The circular columns provide great cushioning and a smooth transition when jumping and stomping. It has a non-stick and non-marking outsole with a pivot point and flex grooves for dance movement. The Duralon pod was included for enhanced cushioning.

Hip-Hop Messenger

The Hip-Hop Messenger bag features a magnetic closure to easily access contents, with an exterior zippered pocket to access personal items. Personal items can also be secured within the interior zippered pocket. Shoulder strap is adjustable and can be custom fit. The bag is fully lined to provide a smooth look and feel inside the bag.

STUDIO / DESIGN FIRM Plazm (Portland, USA)
WORK / YEAR Nike 5678 book / 2005
ART DIRECTION Joshua Berger
DESIGN Eric Mast, Todd Houlette
CLIENT Nike Asia
DESCRIPTION Creation of a 60-page media promotion book to coincide with the launch of Nike's hip-hop inspired "5678" women's campaign. All art is hand-painted and/or spray-painted.

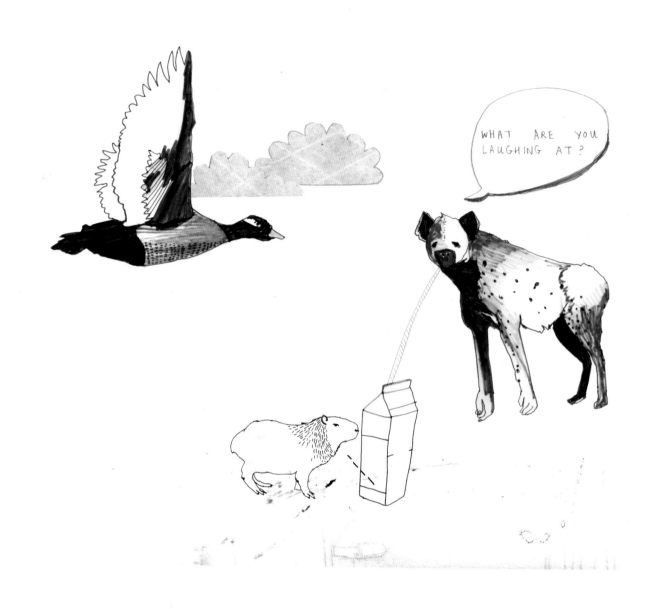

STUDIO / DESIGN FIRM / ARTIST Eatjapanesefood / Holly Wales (London, UK)
WORK / YEAR "What Are You Laughing At?" & "Milk It For All It's Worth" / 2005
ART DIRECTION Holly Wales
CLIENT We Live Round Here Too
DESCRIPTION A double page spread for the 'We Live Round Here Too'
illustration fanzine.

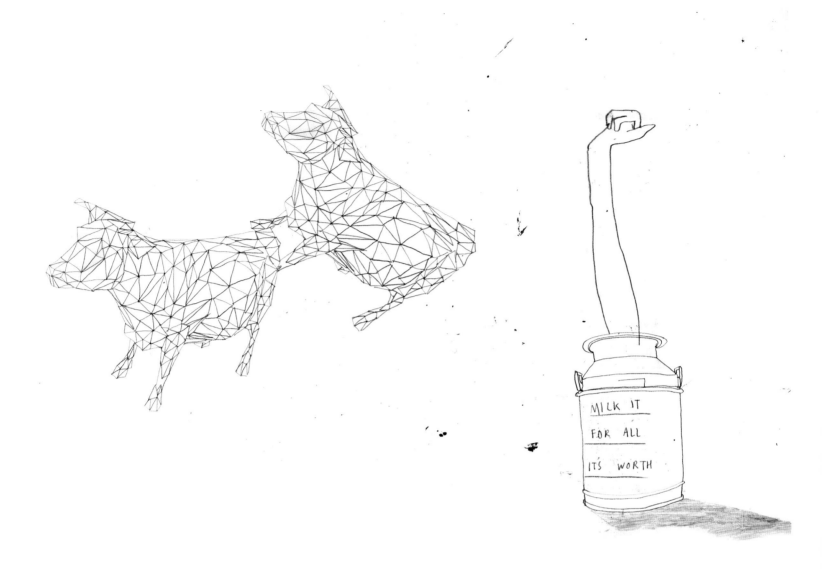

MILK IT

FOR ALL

IT'S WORTH

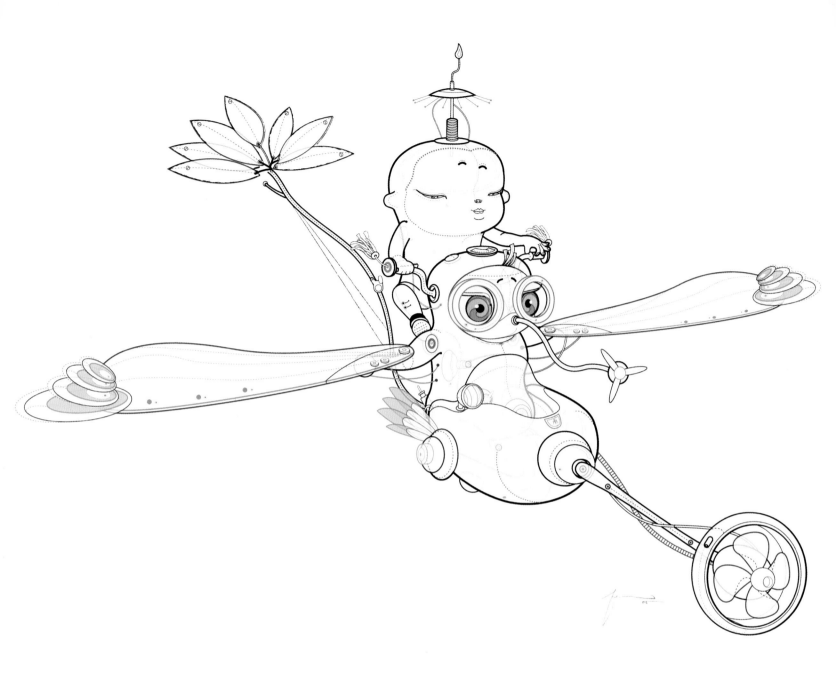

STUDIO / DESIGN FIRM Feric / Eric Feng (New York, USA)
WORK / YEAR (Top) Fevolution II - Two dream to one / 2005
WORK / YEAR (Right) Fevolution II - Logo / 2005
ARTIST Eric Feng
ART DIRECTION, DESIGN Eric Feng
ILLUSTRATION Eric Feng
CLIENT Self

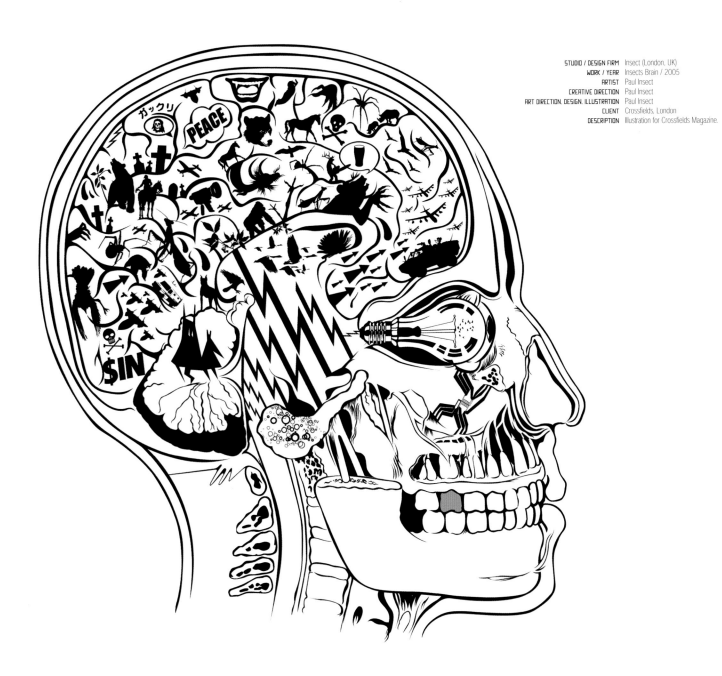

STUDIO / DESIGN FIRM Insect (London, UK)
WORK / YEAR Insects Brain / 2005
ARTIST Paul Insect
CREATIVE DIRECTION Paul Insect
ART DIRECTION, DESIGN, ILLUSTRATION Paul Insect
CLIENT Crossfields, London
DESCRIPTION Illustration for Crossfields Magazine.

Ⓐ The *Insect brain*

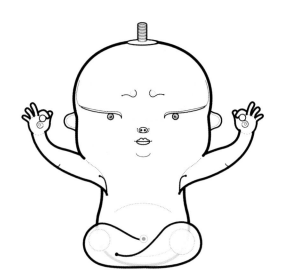

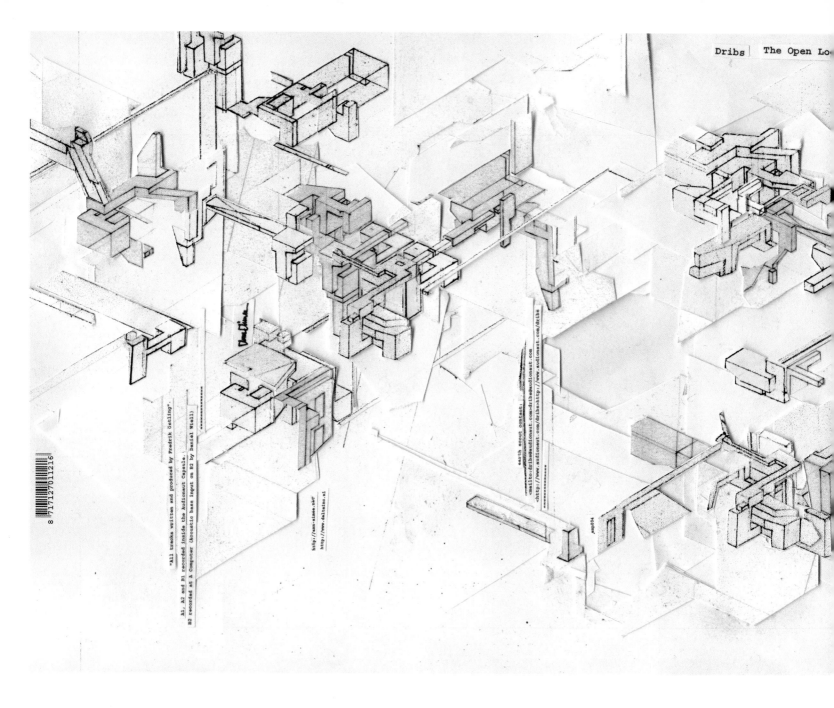

"All tracks written and produced by Fredrik Gething."

A1, A2 and B1 recorded inside the Audiomaut Capsule.
B2 recorded at A Computer (Acoustic bass input on B2 by Daniel Wiell)

http://ann-aimee.net
http://www.deltainc.nl

earth scout contact:
email:dribs@audiomaut.com
<http://www.audiomaut.com/dribs>http://www.audiomaut.com/dribs

STUDIO / DESIGN FIRM Boris Tellegen / Delta (Amsterdam, The Netherlands)
WORK / YEAR Dribbs, the open log book EP / 2003
ARTIST Boris Tellegen / Delta
ART DIRECTION, DESIGN, ILLUSTRATION Boris Tellegen / Delta
CLIENT / LABEL Ann Aimee
DESCRIPTION Design for record cover.

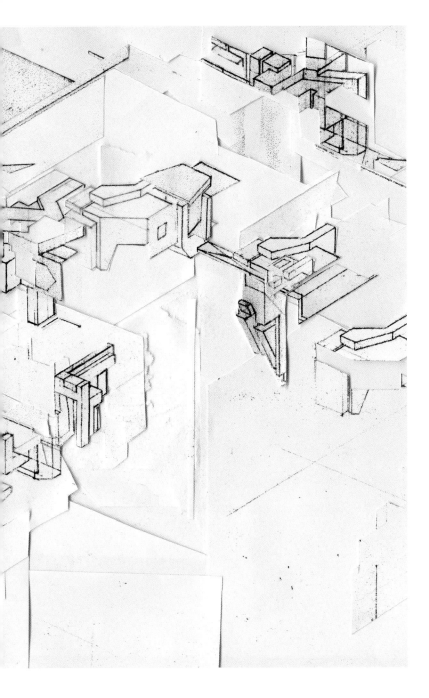

STUDIO / DESIGN FIRM Inkunstruction Studio Art&Design
 (Niort / Metz / Paris, France)
WORK / YEAR "Fat Camp Feva/Disconnected" / 2004
ART DIRECTION Collaboration Inkunstruction/Mc Pherson/Funkstörung
DESIGN Inkunstruction
PHOTO Mark Mc Pherson
CLIENT / LABEL Funkstörung / !k7 Record
DESCRIPTION Maxi-Vynil.
CHARACTERS ON PAPER Yok

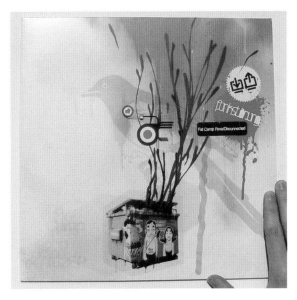

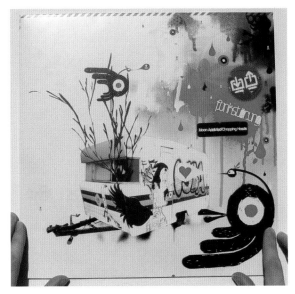

STUDIO / DESIGN FIRM Inkunstruction Studio Art&Design
 (Niort / Metz / Paris, France)
WORK / YEAR "Moon Addicted/Chopping Heads" / 2004
ART DIRECTION Collaboration Inkunstruction/Mc Pherson/Funkstörung
DESIGN Inkunstruction
PHOTO Mark Mc Pherson
CLIENT / LABEL Funkstörung / !k7 Record
DESCRIPTION Maxi-Vynil.

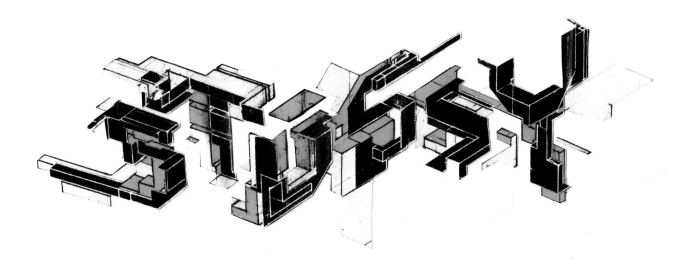

STUDIO / DESIGN FIRM Boris Tellegen / Delta (Amsterdam, The Netherlands)
WORK / YEAR Stüssy / 2004
ARTIST Boris Tellegen / Delta
ART DIRECTION, DESIGN, ILLUSTRATION Boris Tellegen / Delta
CLIENT Stüssy
DESCRIPTION Design for t-shirt.

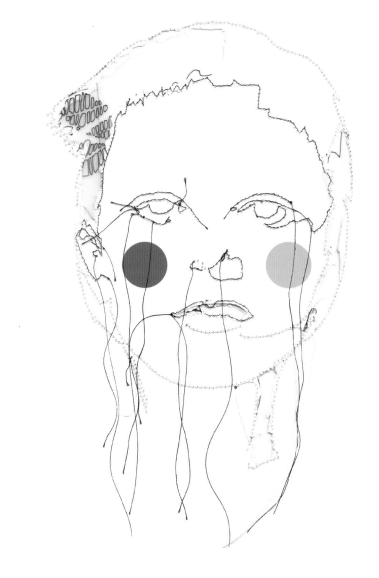

STUDIO / DESIGN FIRM Marie O'Connor / Peepshow (London, UK)
WORK / YEAR Untitled / 2002
ARTIST Marie O'Connor
ART DIRECTION Marie O'Connor
ILLUSTRATION Marie O'Connor
CLIENT Hanatsubaki Magazine, Japan
DESCRIPTION Stitched illustration.

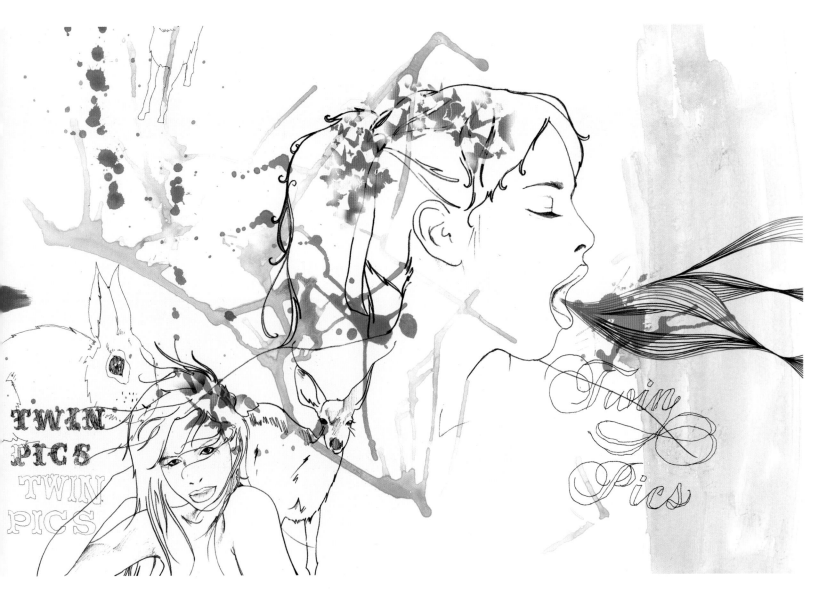

TWIN
PICS
TWIN
PICS

STUDIO / DESIGN FIRM Raffaele Primitivo, Fornari Adv.Dept. (Civitanova Marche, Italy)
WORK / YEAR Illustration for Catalogue / 2004
ARTIST Raffaele Primitivo
ART DIRECTION Caterina Aimone
DESIGN, ILLUSTRATION, COPY Raffaele Primitivo
CLIENT Fornarina

STUDIO / DESIGN FIRM Boris Tellegen / Delta (Amsterdam, The Netherlands)
WORK / YEAR Sketches / 2000
ARTIST Boris Tellegen / Delta
ART DIRECTION, DESIGN, ILLUSTRATION Boris Tellegen / Delta
DESCRIPTION Sketches for club More, Modena. Defumo project.

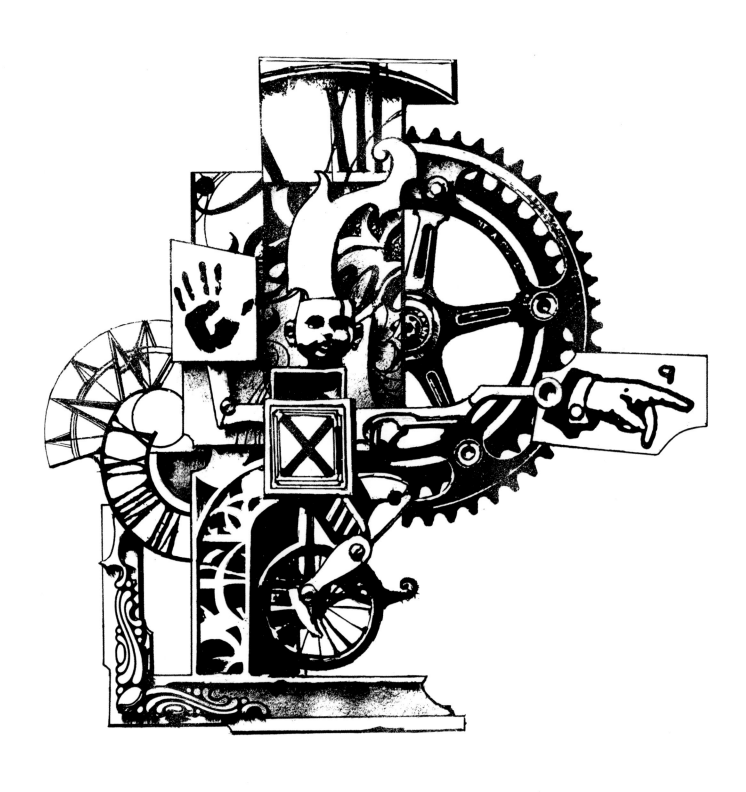

STUDIO / DESIGN FIRM Fifth Floor Inc. (New York, USA)
WORK / YEAR Happy 05 / 2004
ARTIST Danijel Zezelj
CREATIVE DIRECTION Danijel Zezelj
ART DIRECTION, DESIGN , ILLUSTRATION, PHOTO, COPY Danijel Zezelj
CLIENT Self
DESCRIPTION New Years Card.

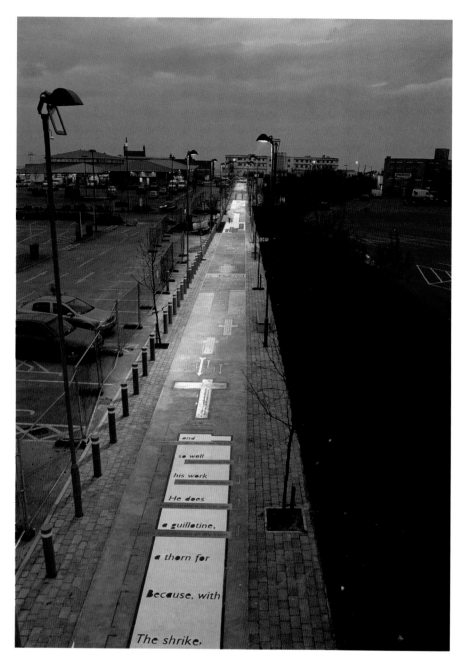

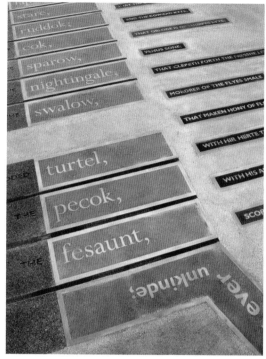

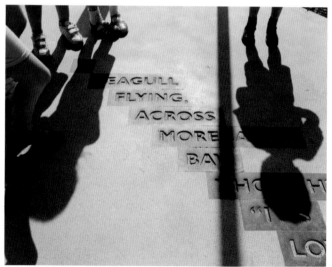

STUDIO / DESIGN FIRM Why Not Associates (London, UK)
WORK / YEAR A Flock of Words / 2003
ART DIRECTION Why Not Associates and Gordon Young
INSTALLATION WITH Russell Coleman
PHOTOGRAPHY Rocco Redondo

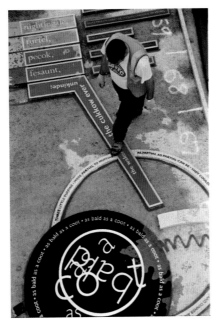

DESCRIPTION Graphic designers Why Not Associates have, in collaboration with artist Gordon Young, created 'A Flock of Words' to celebrate the bird watching haven of Morecambe Bay on the north west coast of England. The 320m long typographic pavement is constructed from granite, concrete, steel, brass, bronze and glass. 'A Flock of Words' is a path of poems, traditional sayings and song lyrics that all relate to birds. It begins with the book of Genesis and stretches from Shakespeare to Spike Milligan. The path physically connects the railway station and the seafront, its purpose is to provide a visual and thematic link between them, in a way that informs, entertains, educates and stimulates.

Towards the seaward end, the path is punctuated by a 9 metre typographic column, which leads the text from the pavement into the sky. The path then stretches out towards the magnificent art deco Midland Hotel (currently undergoing restoration) designed by Oliver Hill in 1933 with interiors by Eric Gill. As homage to Gill, the greatest letterform designer of his generation, all the fonts used in the pavement are his.

The project was an aspect of 'Tern', an arts led regeneration project on Morecambe Bay, launched by the Lancaster City Council in 1992. Its mission was to physically and spiritually refresh and re-image Morecambe and set it apart from its recent past and its competitors.

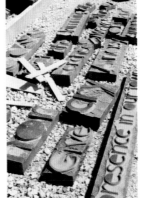

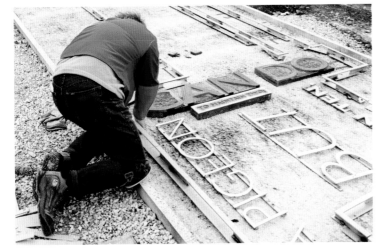

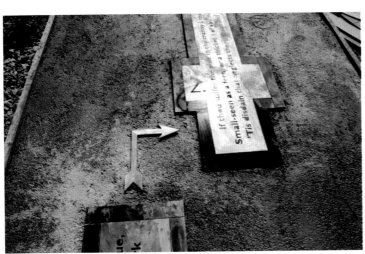

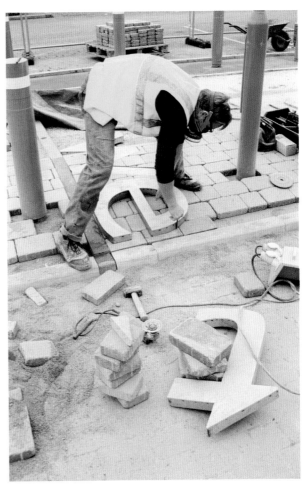

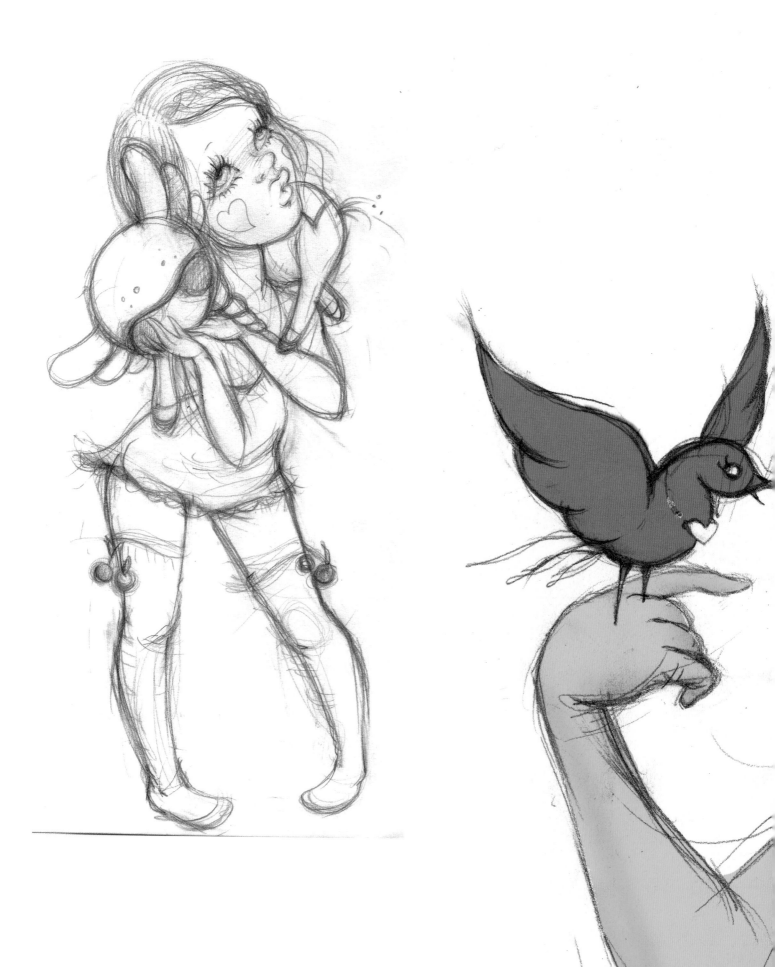

Pages 72-73
STUDIO / DESIGN FIRM / ARTIST Fafi (Paris, France)
WORK / YEAR Salomé & Birtak drawing, 2005
WORK / YEAR Lucille & Birdili drawing colored with computer, 2005
ARTIST Fafi

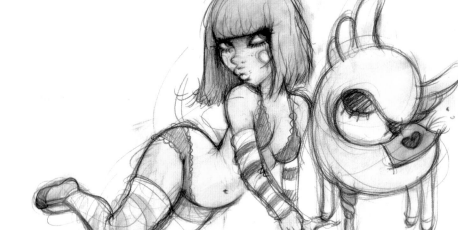

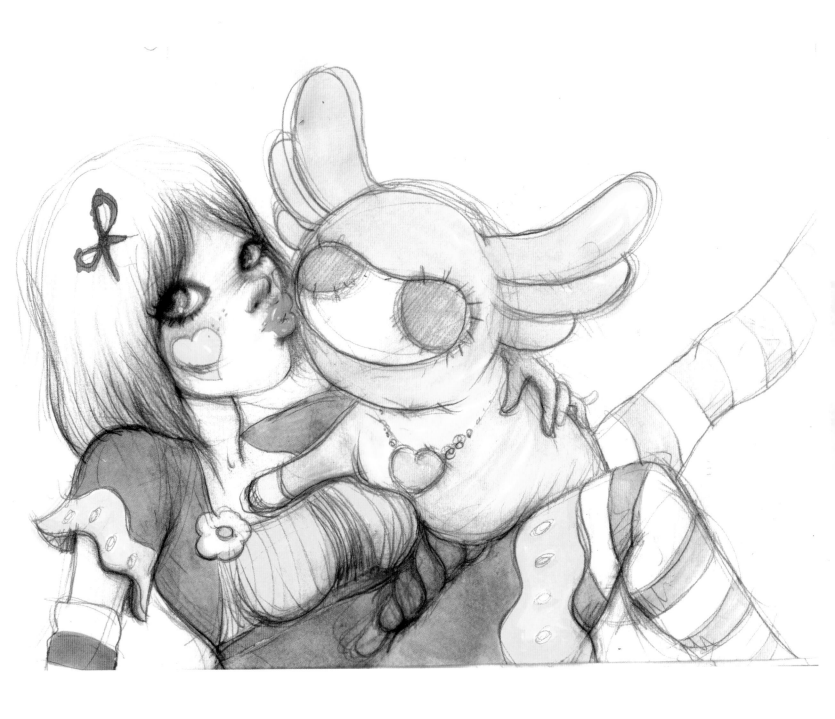

STUDIO / DESIGN FIRM / ARTIST Fafi (Paris, France)
WORK / YEAR (P. 74, Top) Mimi & Hmilo & Birtak drawing, 2005
WORK / YEAR (P. 74) Carla & Birtak drawing, 2005
WORK / YEAR (P. 75) Fafinette & Birtak drawing, 2005

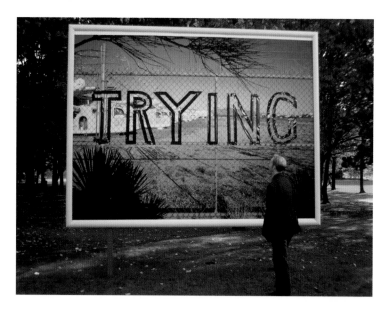

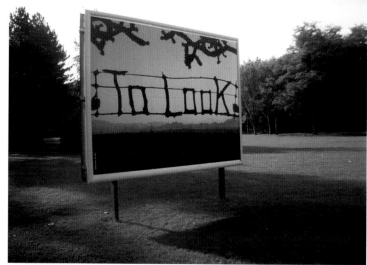

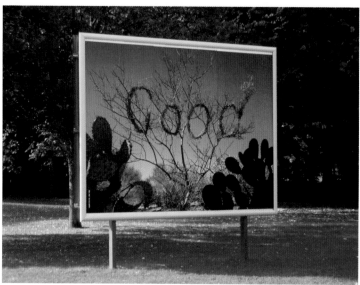

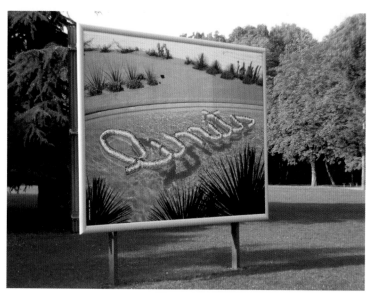

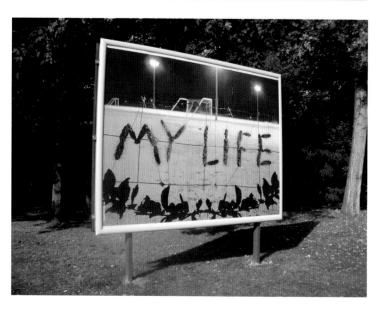

STUDIO / DESIGN FIRM Sagmeister Inc. (New York, USA)
WORK / YEAR Trying to look good limits my life / 2004
ART DIRECTION Stefan Sagmeister
DESIGN Stefan Sagmeister, Matthias Ernstberger
PHOTO Matthias Ernstberger
CLIENT Art Grandeur Nature
DESCRIPTION The title of this work (and its content) is among the few things I have learned in my life so far (some of the others are: Having guts always works out for me and Everything I do always comes back to me).
Broken up into 5 parts Trying / to look / good / limits / my life and displayed in sequence as typographic billboards in Paris, they work like a sentimental greeting card left in the park.

STUDIO / DESIGN FIRM Seacreative (Varese, Italy)
WORK / YEAR Sketch / 2005
ARTIST Seacreative
ILLUSTRATION Seacreative

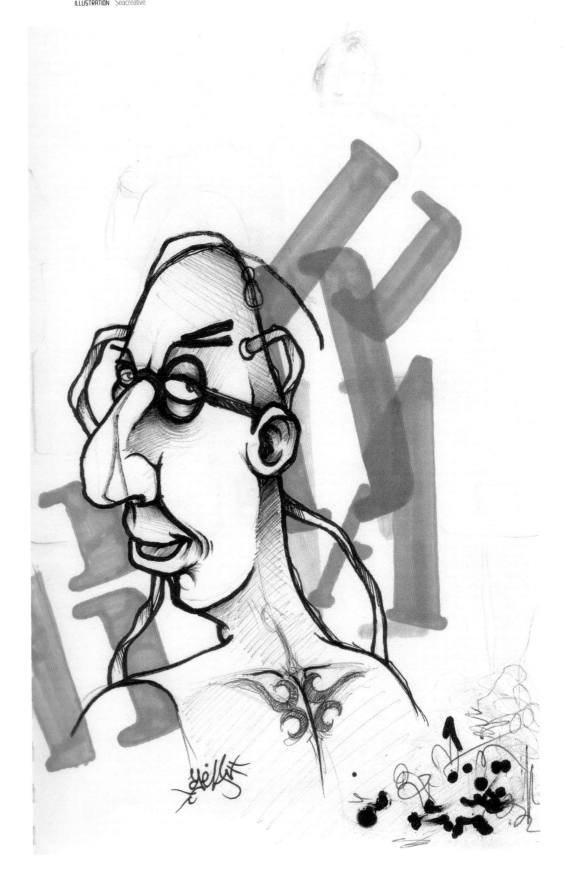

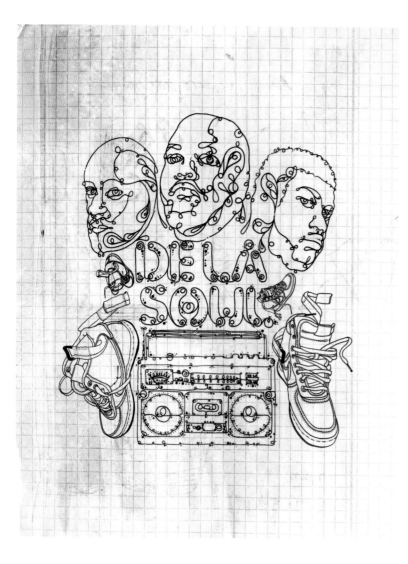

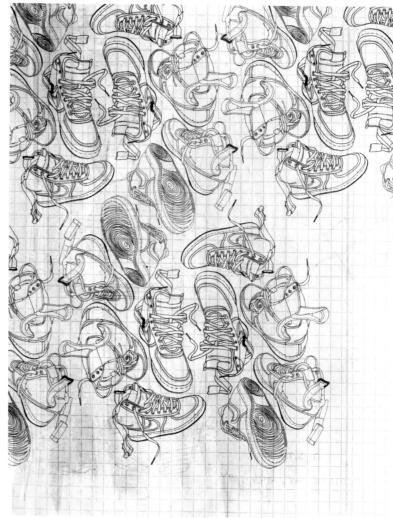

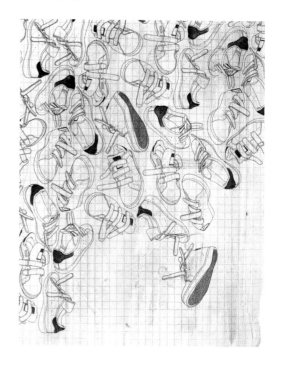

STUDIO / DESIGN FIRM / ARTIST MASA (Caracas, Venezuela)
WORK / YEAR DelaSOUL / 2005
CREATIVE DIRECTION. MASA / No-Domain
ART DIRECTION. DESIGN. ILLUSTRATION MASA
CLIENT No-Domain - Sonar Music Festival, BCN-Spain
DESCRIPTION Illustrations developed for De La Soul Concert Visuals.

Top Right
STUDIO / DESIGN FIRM / ARTIST MASA (Caracas, Venezuela)
WORK / YEAR WALK this WAY series NIKE VANDALS pattern / 2005
CREATIVE DIRECTION. ART DIRECTION. DESIGN. ILLUSTRATION MASA
CLIENT / DESCRIPTION MASA, Promotional postcard.

STUDIO / DESIGN FIRM / ARTIST MASA (Caracas, Venezuela)
WORK / YEAR WALK this WAY series ADIDAS Stan Smith pattern / 2005
CREATIVE DIRECTION. ART DIRECTION. DESIGN. ILLUSTRATION MASA
CLIENT / DESCRIPTION MASA, Promotional postcard.

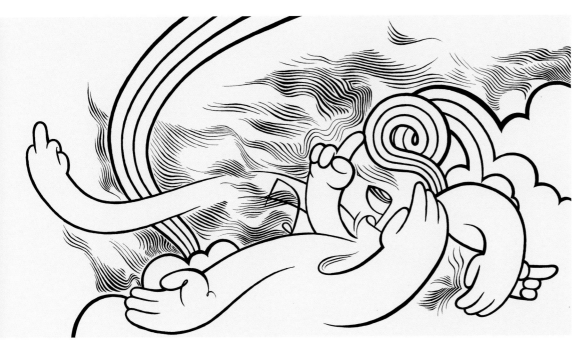

STUDIO / DESIGN FIRM / ARTIST Rinzen (Sydney / Brisbane / Berlin)
WORK / YEAR Neomu / 2004
ILLUSTRATION Rinzen
CLIENT Neomu
DESCRIPTION Ink on paper.

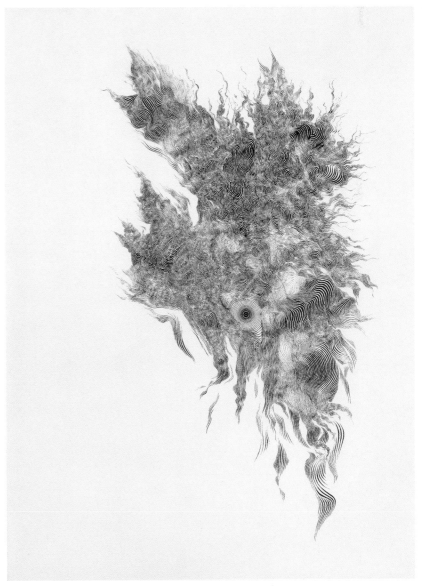

STUDIO / DESIGN FIRM / ARTIST Rinzen (Sydney / Brisbane / Berlin)
WORK / YEAR Basefield / 2004
ILLUSTRATION Rinzen
EXHIBITION Lost and Found exhibition, Melbourne.
DESCRIPTION Ink on paper.

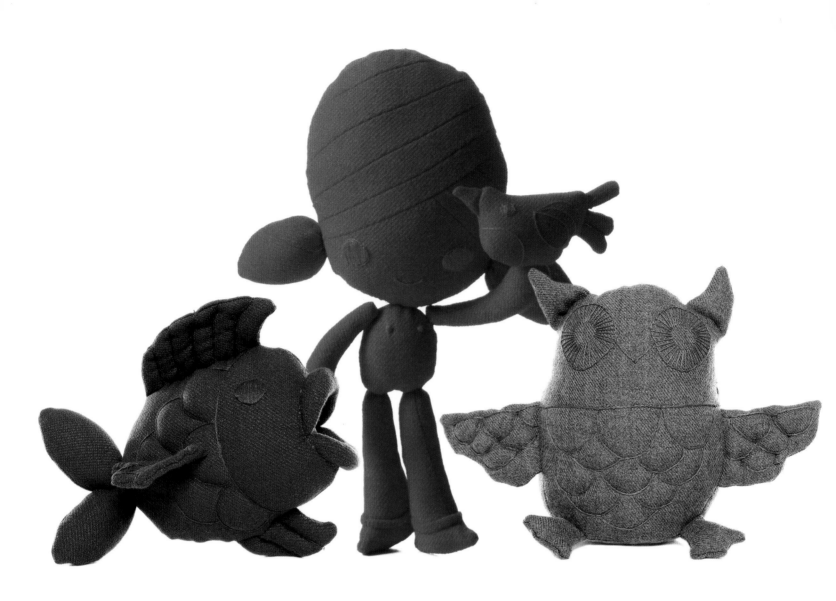

01. Lizard Lion Eagle
02. Photo Soul Decay
03. Old Earth
04. As Below So Above
05. Chicken Pox
06. Godhead Omlet
07. Freelance Zenarchist
08. Scream
09. Quicksilver
10. Camera Shy
11. Nova Toast
12. Marshes
13. Dead Owl Skunk
14. Turtle Bear
15. Zapata Physicians
16. Petit Mort

2nd rec
(c) & (p) 2004 2nd rec (www.2ndrec.com)
Distributed by Hausmusik (www.hausmusik.com)

Noah23 Jupiter Sajitarius

Jupiter
Sajitarius

2ND021

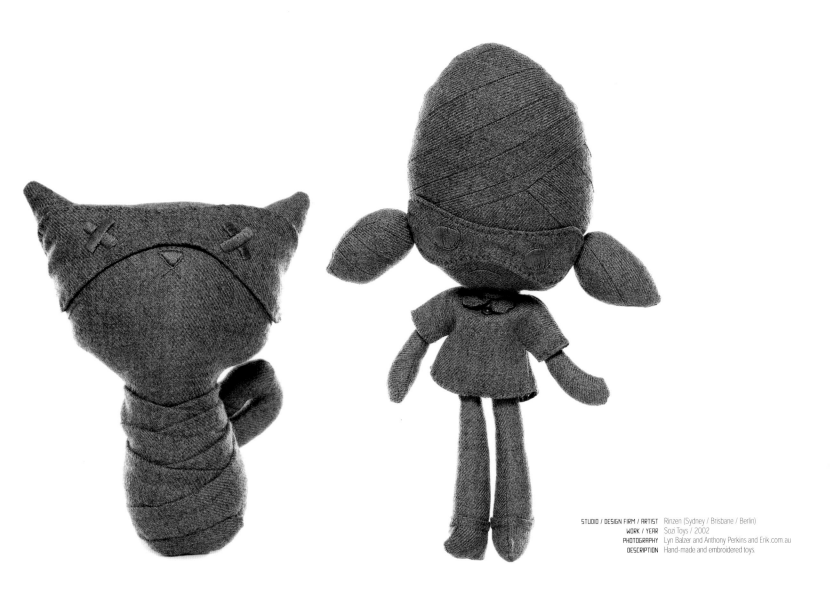

STUDIO / DESIGN FIRM / ARTIST Rinzen (Sydney / Brisbane / Berlin)
WORK / YEAR Sozi Toys / 2002
PHOTOGRAPHY Lyn Balzer and Anthony Perkins and Erik.com.au
DESCRIPTION Hand-made and embroidered toys.

STUDIO / DESIGN FIRM / ARTIST SFaustina (Oakland, USA)
WORK / YEAR Noah 23 Cd/Lp / 2004
ART DIRECTION SFaustina
ARTWORK SFaustina
CLIENT www.2ndrec.com

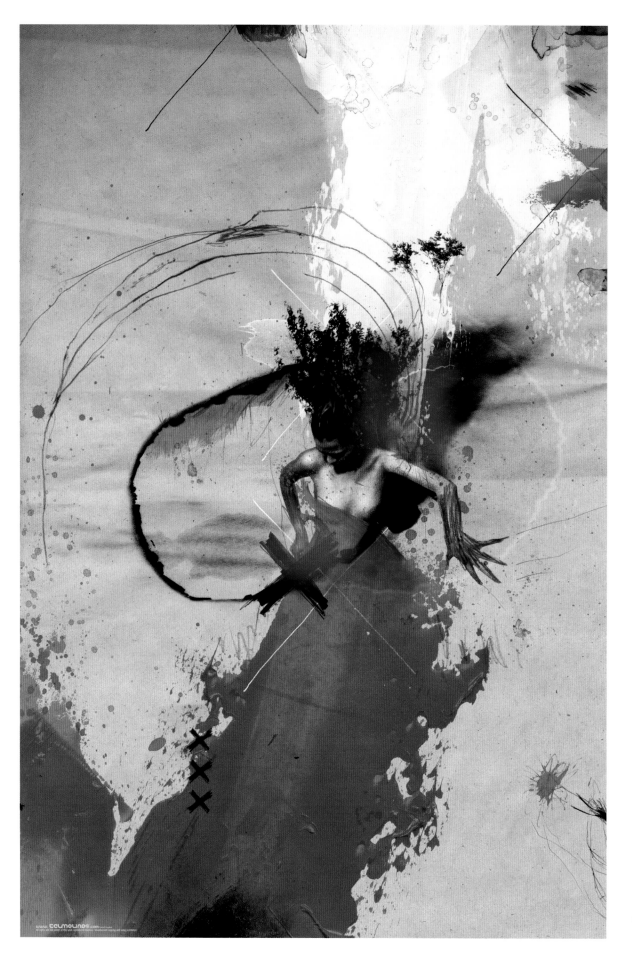

STUDIO / DESIGN FIRM Matthieu Appriou / Telmolindo (Paris, France)
WORK / YEAR Illustration / 2004
ARTIST Matthieu Appriou
ILLUSTRATION Matthieu Appriou
CLIENT Personal work

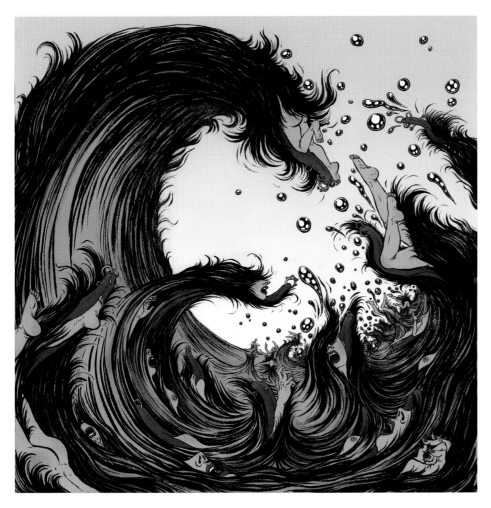

STUDIO / DESIGN FIRM Yuko Shimizu (New York, USA)
WORK / YEAR Illustration for article on natural disaster / 2005
ARTIST Yuko Shimizu
ILLUSTRATION Yuko Shimizu
ART DIRECTION Rob Wilson
CLIENT Playboy (USA)

STUDIO / DESIGN FIRM Matthieu Appriou / Telmolindo (Paris, France)
WORK / YEAR Illustration / 2003
ARTIST Matthieu Appriou
ILLUSTRATION Matthieu Appriou
CLIENT Rojo magazine

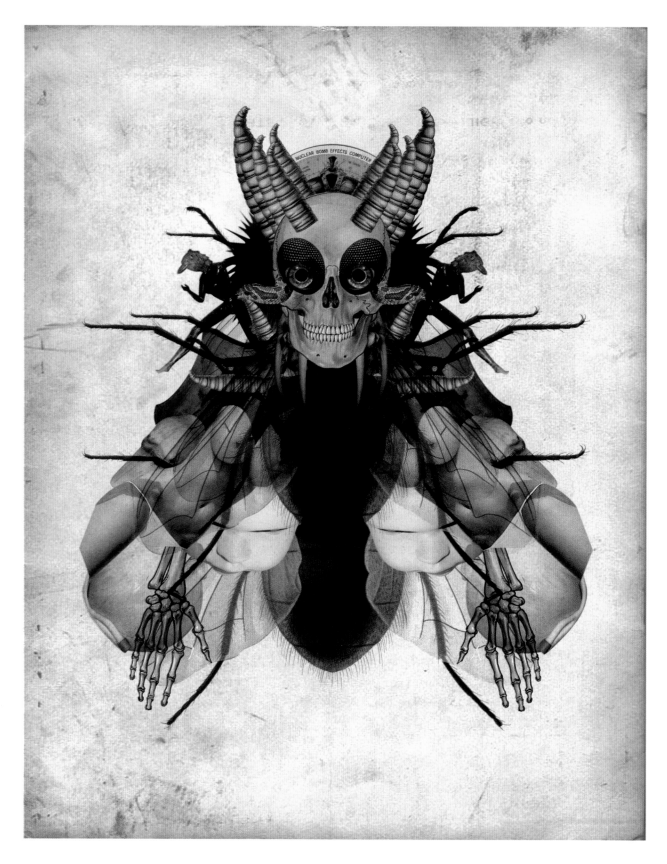

STUDIO / DESIGN FIRM Insect (London, UK)
WORK / YEAR Theme - Evil Sect / 2005
ARTIST Paul Insect
CREATIVE DIRECTION Paul Insect
ART DIRECTION, DESIGN, ILLUSTRATION Paul Insect
CLIENT Sport & Street Magazine / Collezioni - Italy
DESCRIPTION Commissioned 10 page illustration spreads.

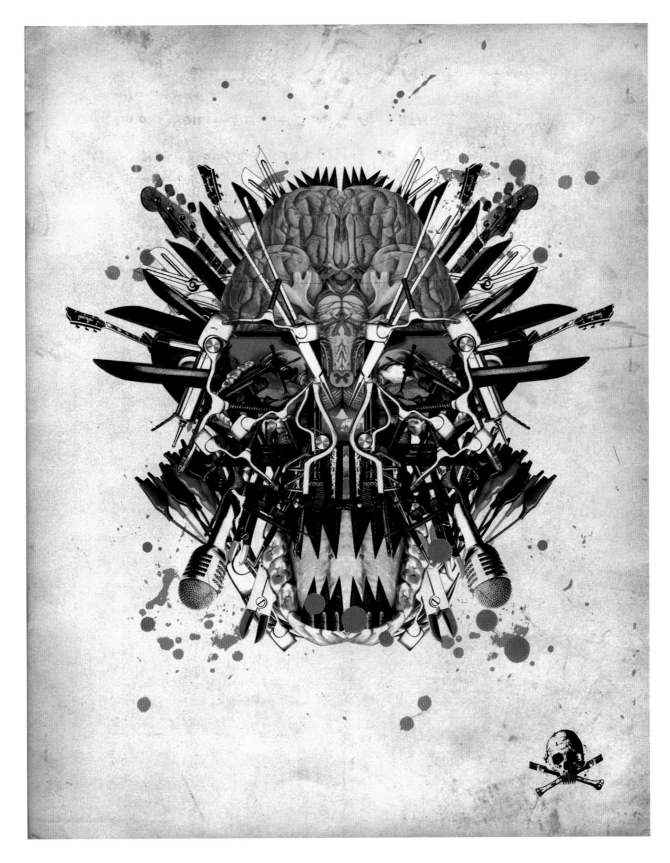

STUDIO / DESIGN FIRM Insect (London, UK)
WORK / YEAR Theme - Evil Sect / 2005
ARTIST Paul Insect / Luke Insect
CREATIVE DIRECTION Paul Insect / Luke Insect
ART DIRECTION, DESIGN, ILLUSTRATION Paul Insect / Luke Insect
CLIENT Sport & Street Magazine / Collezioni - Italy
DESCRIPTION Commisioned 10 page illustration spreads.

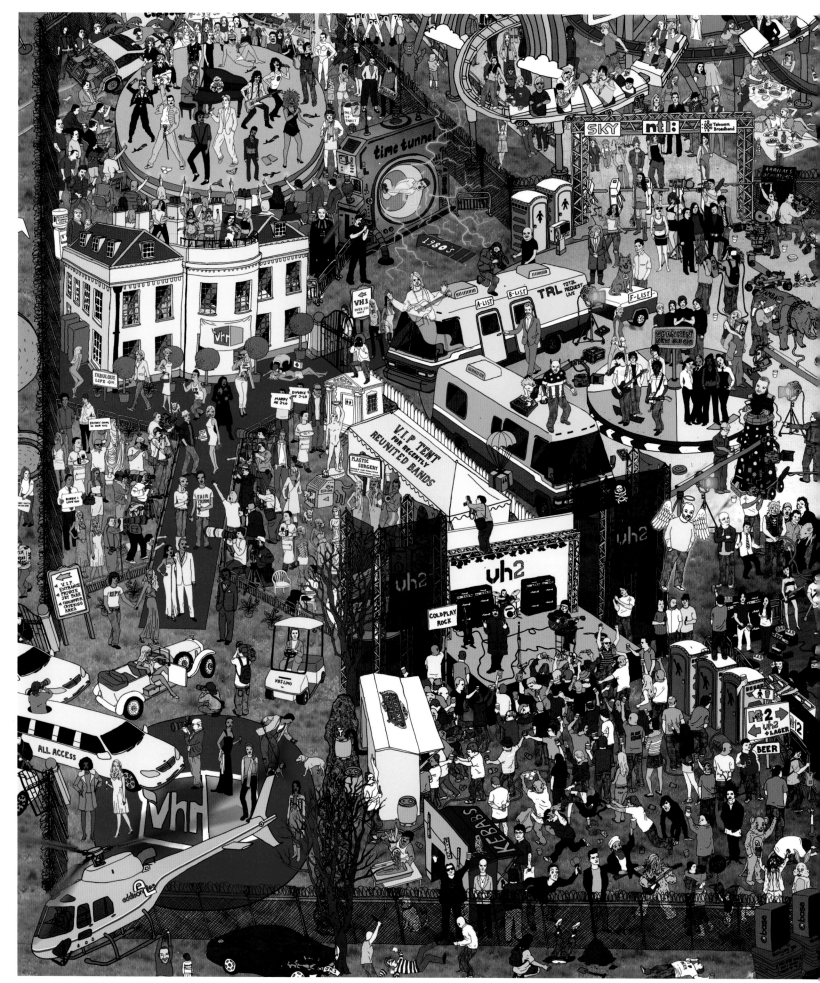

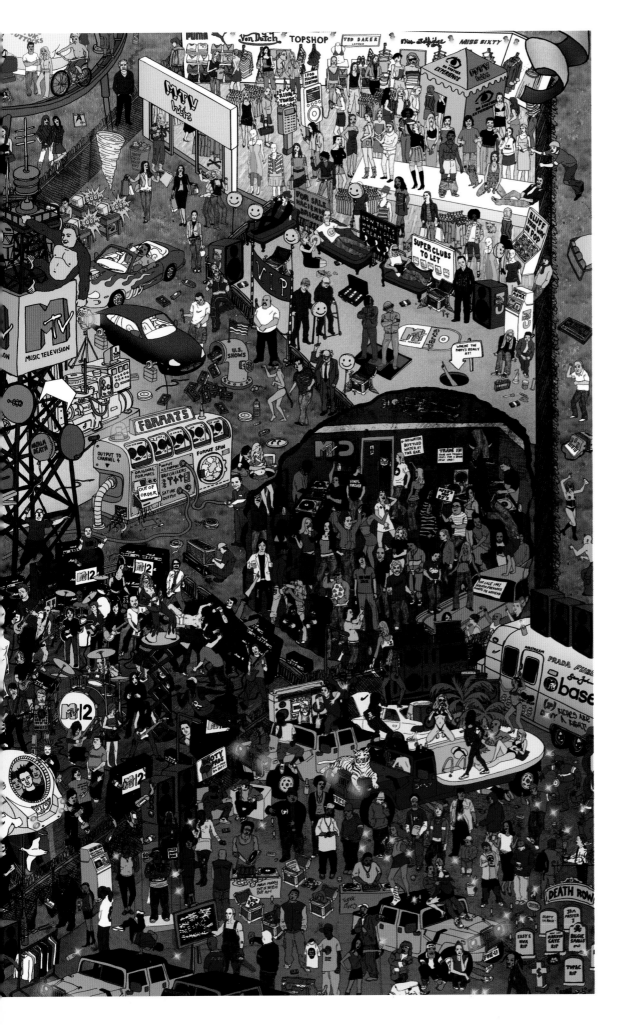

STUDIO / DESIGN FIRM Andrew Rae (London, UK)
WORK / YEAR MTV Festival / 2005
ARTIST Andrew Rae
CLIENT MTV UK, Karmarama
DESCRIPTION Poster representing the various channels owned by MTV.

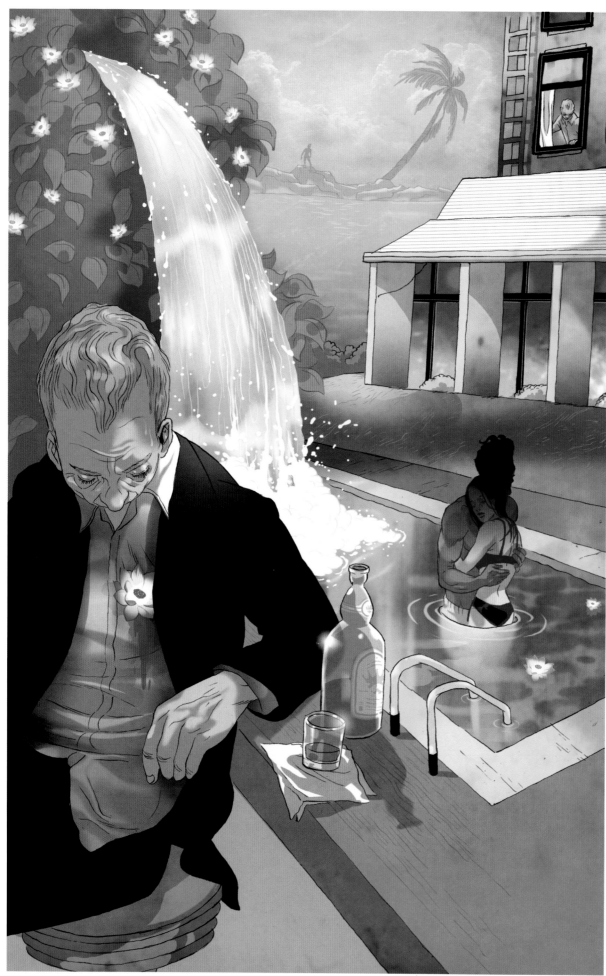

STUDIO / DESIGN FIRM Tomer Hanuka (London, UK)
WORK / YEAR Bipolar 5 back cover / 2005
ILLUSTRATOR Tomer Hanuka
ART DIRECTOR Tomer Hanuka
DESCRIPTION Book cover for comics anthology
shared with twin brother Asaf
caller 'Bipolar' published by
Alternative Comics.

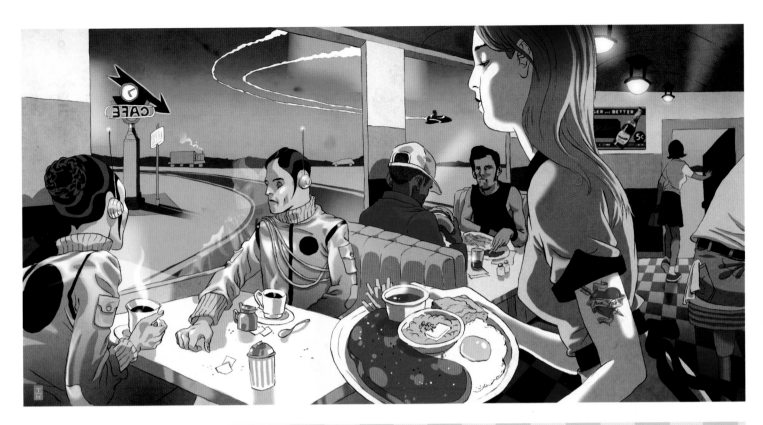

STUDIO / DESIGN FIRM Tomer Hanuka (London, UK)
WORK / YEAR Future Diner / 2004
ILLUSTRATOR Tomer Hanuka
ART DIRECTOR Kevin Demaria
DESCRIPTION Editorial Illustration for Gourmet
Magazine about road side diners
surviving for many year in their
current format.

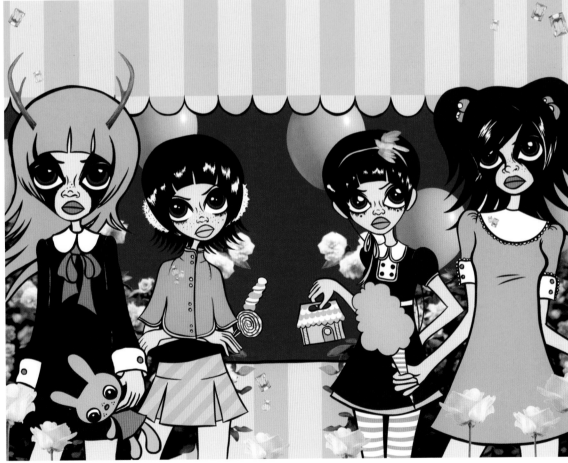

STUDIO / DESIGN FIRM Fawn Gehweiler / No Candy (Los Angeles, USA)
WORK / YEAR "Just can't get enough" / 2002
ARTIST Fawn Gehweiler
DESCRIPTION Illustration for CSNA magazine, New York.
collage, digital.

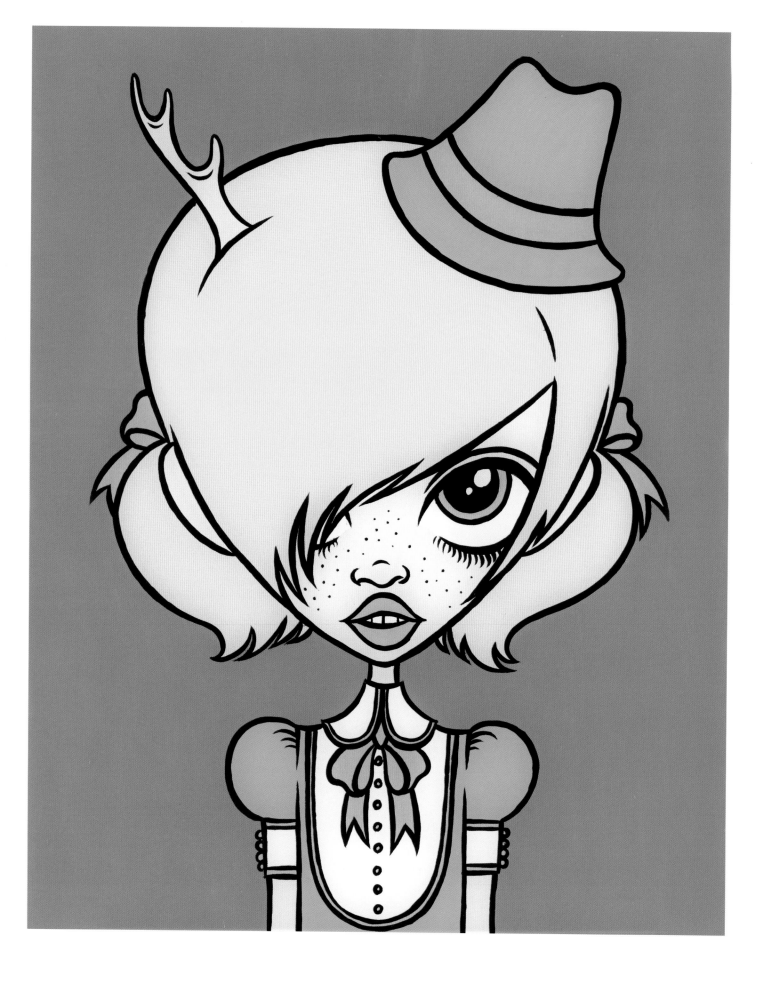

Le lièvre n'eut pas le courage de s'opposer plus longtemps à ses amis. Il partit en traînant les pattes faire un brin de toilette et s'habiller. Au bout d'un long moment, il sortit de chez lui.

– Enfin ! rouspéta le hérisson. Tu en as mis du temps.

– Tu vas voir, on va bien s'amuser, dit la taupe.

12

Pour la première fois depuis longtemps, le lièvre semblait se détendre

STUDIO / DESIGN FIRM Cassandrem / Cassandre Montoriol (Paris, France)
WORK / YEAR "Monsieur De La Fontaine, le lièvre ne vous dit pas merci" / 2005
ARTIST Cassandre Montoriol
ILLUSTRATION Cassandre Montoriol
CLIENT Editions Thierry Magnier
DESCRIPTION Acrylique et crayon de couleur sur papier.

P. 90
STUDIO / DESIGN FIRM Fawn Gehweiler / No Candy (Los Angeles, USA)
WORK / YEAR "Oh Deer" / 2004
ARTIST Fawn Gehweiler
DESCRIPTION Personal work from "Alpine Girls" series, enamels on glass.

Top

STUDIO / DESIGN FIRM Hula+Hula (Mexico City, Mexico)
WORK / YEAR MTV Top 20 "program open bumper" / 2004
ARTIST Cha! & Quique Ollervides
ART DIRECTION Hula+Hula & Daniel Bravo
ILLUSTRATION Cha! Quique Ollervides, Maja Hürst, Jorge Herrera
CLIENT MTV Latinamerica
DESCRIPTION TV Show Opening Sequence (packaging).

STUDIO / DESIGN FIRM Hula+Hula (Mexico City, Mexico)
WORK / YEAR La Bruja / 2004
ARTIST Cha! & Quique Ollervides
ILLUSTRATION Cha! & Quique Ollervides
FLASH ANIMATION Jorge Herrera
CLIENT Canal Once
DESCRIPTION TV bumper (packaging).

STUDIO / DESIGN FIRM Hula+Hula (Mexico City, Mexico)
WORK / YEAR MTV Top 20 "bumpers 13-17-19-6" & "program close bumper" / 2004
ARTIST Cha! & Quique Ollervides
ART DIRECTION Hula+Hula & Daniel Bravo
ILLUSTRATION Cha! Quique Ollervides, Maja Hürst, Jorge Herrera
CLIENT MTV Latinamerica
DESCRIPTION TV Show Opening Sequence (packaging).

STUDIO / DESIGN FIRM / ARTIST Koa (Lille, France)
WORK / YEAR Creamy Ghosts / 2005
CREATIVE DIRECTION Koa
ART DIRECTION Koa
ILLUSTRATION Koa
CLIENT Vaporz Magazine
DESCRIPTION Illustration.

STUDIO / DESIGN FIRM Hausgrafik (Zurich, Switzerland)
WORK / YEAR Poster Illustration / 2005
ARTIST Urs Althaus
ILLUSTRATION Urs Althaus
CLIENT Salzhaus, Winterthur, Switzerland

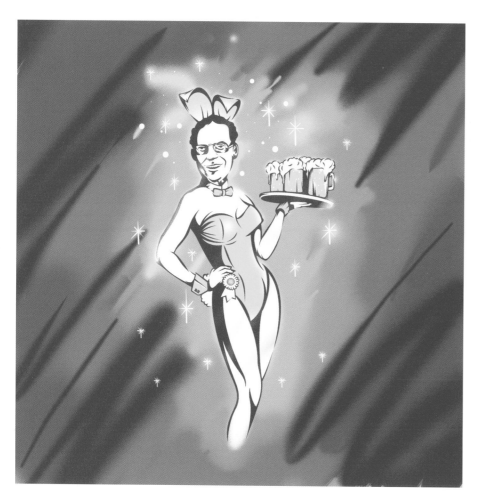

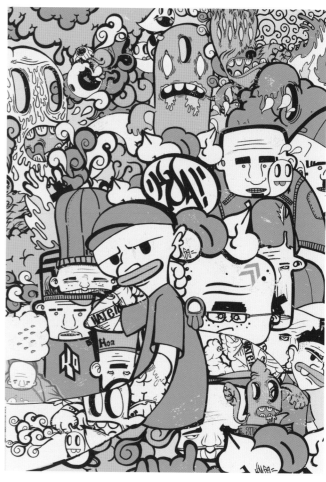

STUDIO / DESIGN FIRM / ARTIST Koa (Lille, France)
WORK / YEAR From My Hood / 2005
CREATIVE DIRECTION Koa
ART DIRECTION Koa
ILLUSTRATION Koa
CLIENT Vierkant Magazine
DESCRIPTION Illustration.

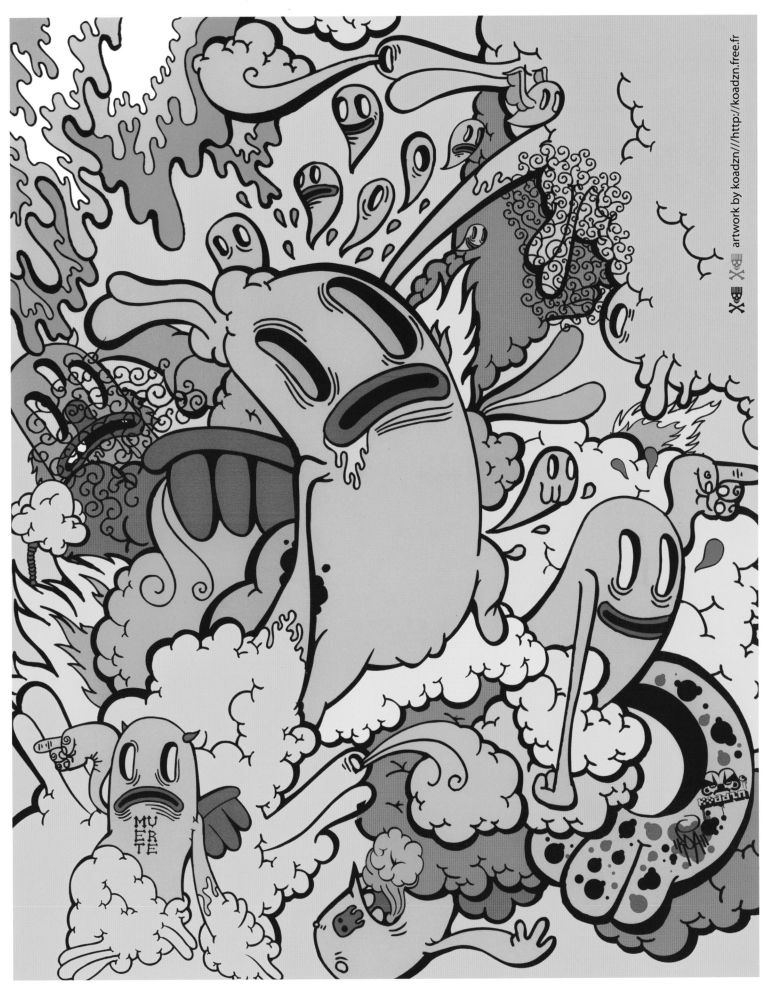

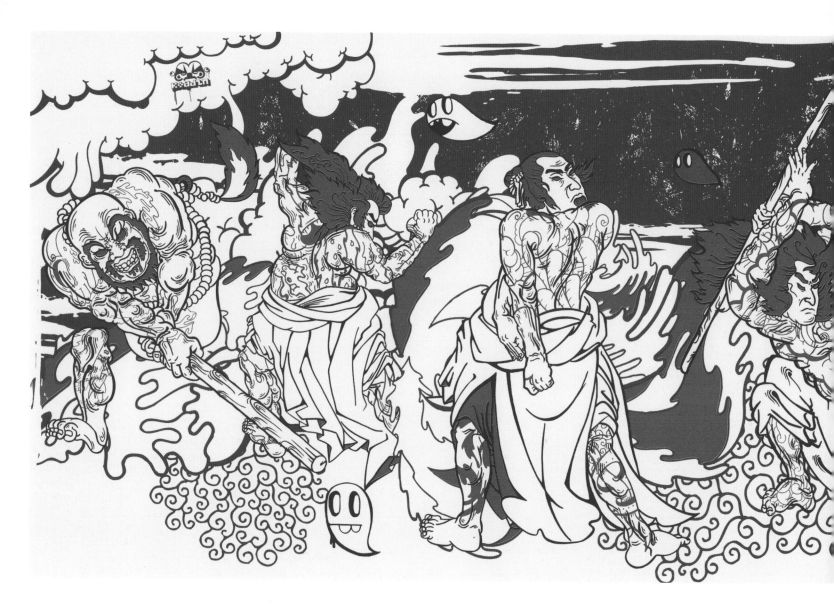

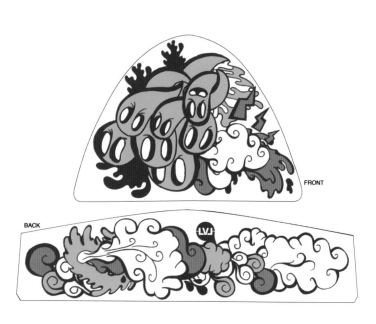

FRONT

BACK

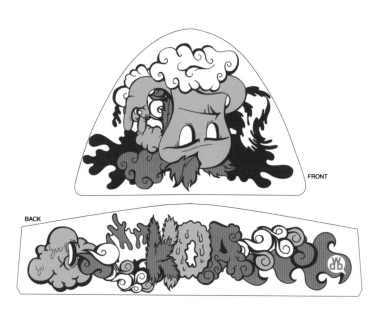

FRONT

BACK

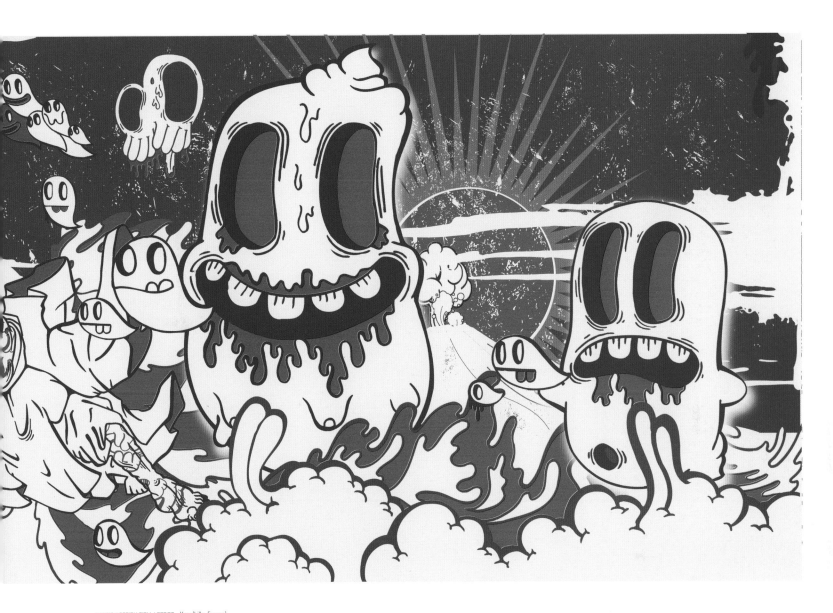

STUDIO / DESIGN FIRM / ARTIST Koa (Lille, France)
WORK / YEAR Samurai vrs Ghosts / 2005
CREATIVE DIRECTION Koa
ART DIRECTION Koa
ILLUSTRATION Koa
CLIENT Retroactif Book Vol 2
DESCRIPTION Illustration.

STUDIO / DESIGN FIRM / ARTIST Koa (Lille, France)
WORK / YEAR Ghosts sand shoes / 2005
CREATIVE DIRECTION Koa
ART DIRECTION Koa
ILLUSTRATION Koa
CLIENT Make Feet Beautiful
DESCRIPTION Illustrate for a sand shoes production.

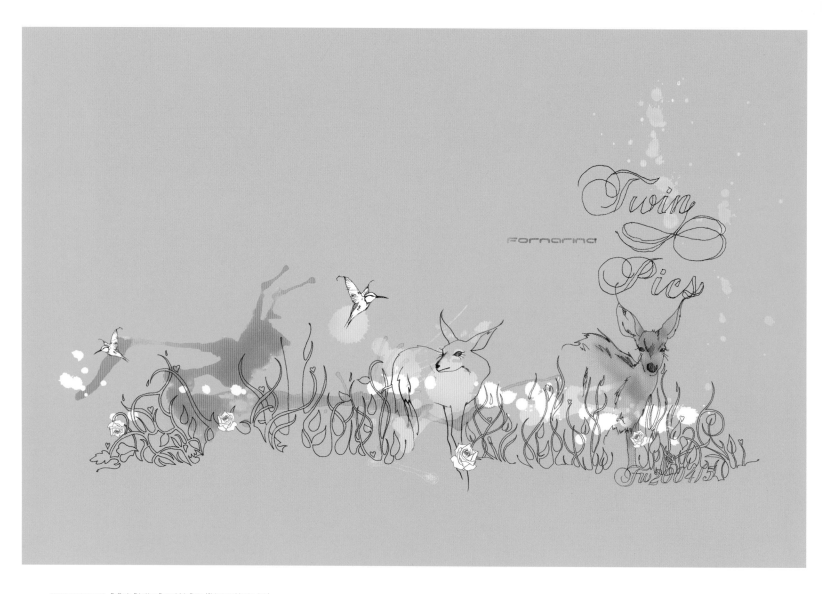

STUDIO / DESIGN FIRM Raffaele Primitivo, Fornari Adv.Dept. (Civitanova Marche, Italy)
WORK / YEAR Illustration for Catalogue, Window Display / 2004
ARTIST Raffaele Primitivo
ART DIRECTION Caterina Aimone
DESIGN, ILLUSTRATION, COPY Raffaele Primitivo
CLIENT Fornarina

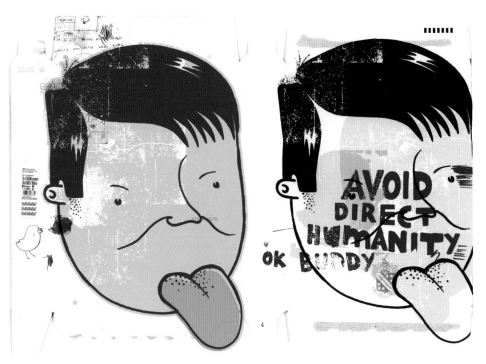

STUDIO / DESIGN FIRM / ARTIST Nicholas Deakin (Cardiff, UK)
WORK / YEAR Avoid / 2005
ART DIRECTION, DESIGN Nicholas Deakin
ILLUSTRATION Nicholas Deakin
CLIENT Cenzo Press
DESCRIPTION Editorial.

STUDIO / DESIGN FIRM Raffaele Primitivo, Fornari Adv.Dept. (Civitanova Marche, Italy)
WORK / YEAR Illustration for Catalogue, Window Display / 2004
ARTIST Raffaele Primitivo
ART DIRECTION Caterina Aimone
DESIGN, ILLUSTRATION, COPY Raffaele Primitivo
PHOTO Francesco Musati + Valentina Aimone
CLIENT Fornarina

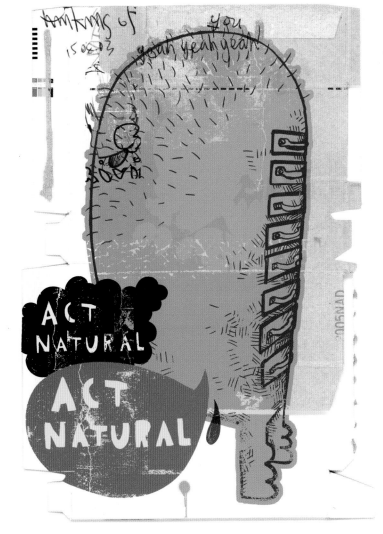

STUDIO / DESIGN FIRM / ARTIST Nicholas Deakin (Cardiff, UK)
WORK / YEAR Drawers / 2005
ART DIRECTION, DESIGN Nicholas Deakin
ILLUSTRATION Nicholas Deakin
CLIENT Personal

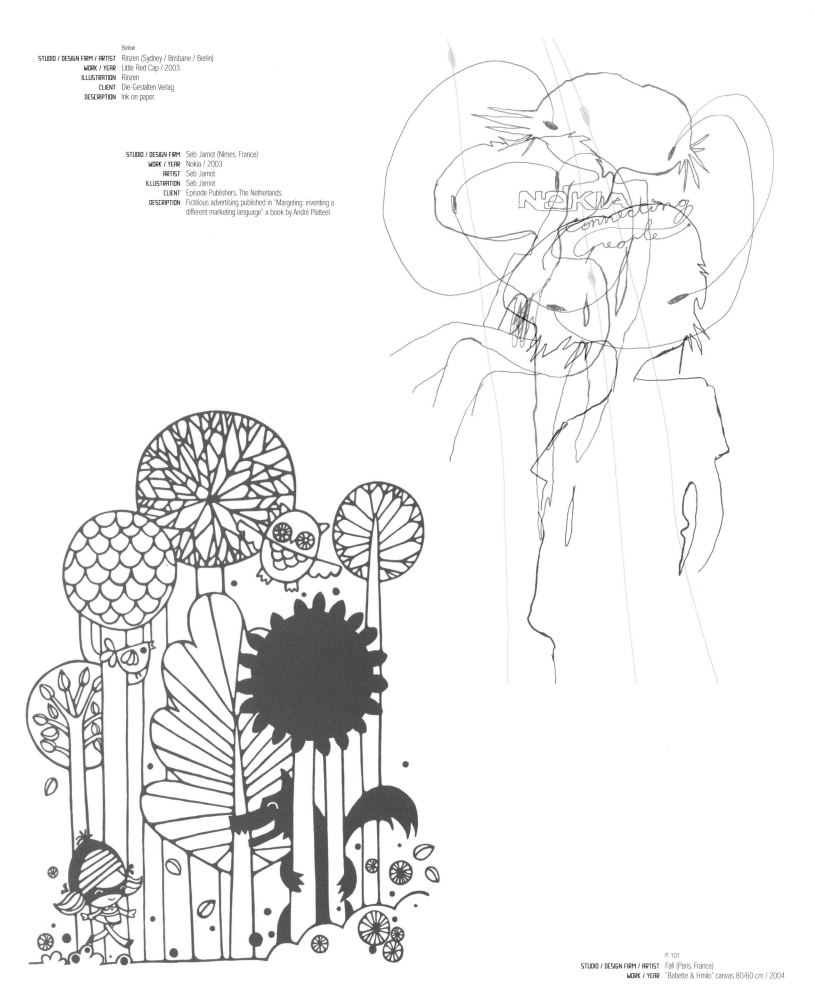

Below
STUDIO / DESIGN FIRM / ARTIST Rinzen (Sydney / Brisbane / Berlin)
WORK / YEAR Little Red Cap / 2003
ILLUSTRATION Rinzen
CLIENT Die-Gestalten Verlag
DESCRIPTION Ink on paper.

STUDIO / DESIGN FIRM Seb Jarnot (Nimes, France)
WORK / YEAR Nokia / 2003
ARTIST Seb Jarnot
ILLUSTRATION Seb Jarnot
CLIENT Episode Publishers, The Netherlands.
DESCRIPTION Fictitious advertising published in "Margeting: inventing a different marketing language" a book by André Platteel.

P. 101
STUDIO / DESIGN FIRM / ARTIST Fafi (Paris, France)
WORK / YEAR "Babette & Hmilo" canvas 80/60 cm / 2004

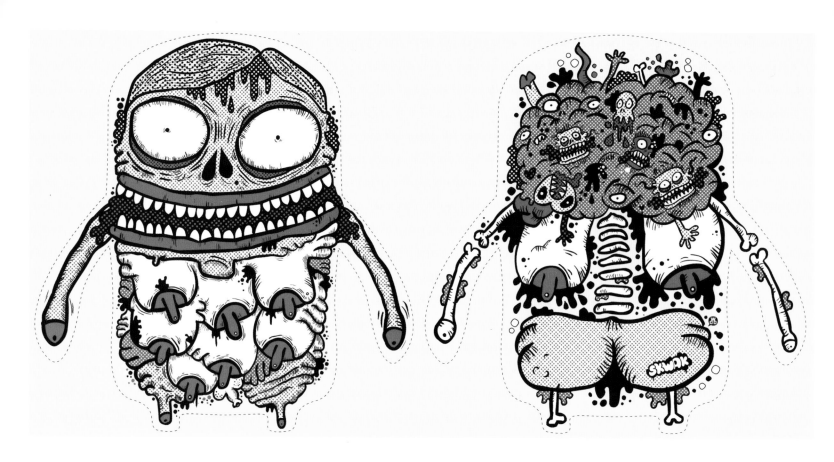

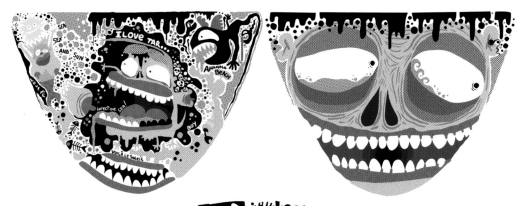

STUDIO / DESIGN FIRM SKWAK (Lille, France)
WORK / YEAR The Maniac / 2005
ARTIST SKWAK
ILLUSTRATION SKWAK
DESCRIPTION Design for a Maniac puppet (exhibition with Levelart crew).

STUDIO / DESIGN FIRM SKWAK (Lille, France)
WORK / YEAR Infected Beach / 2005
ARTIST SKWAK
ILLUSTRATION SKWAK
DESCRIPTION Design Espadrille for Makefeetbeautiful / String Republic Corp (Collection Summer 2006).

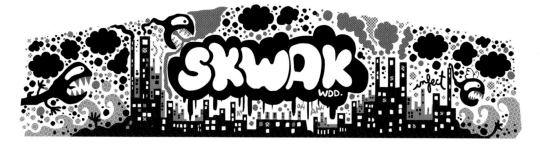

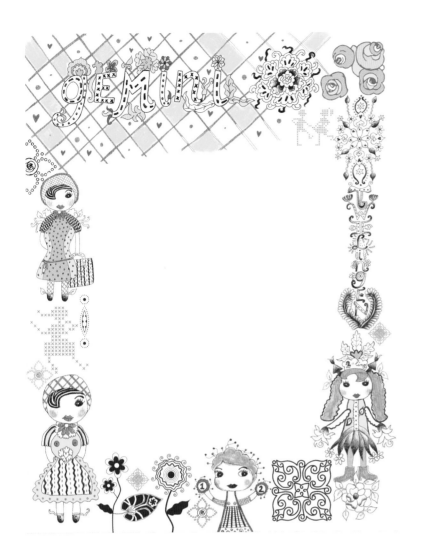

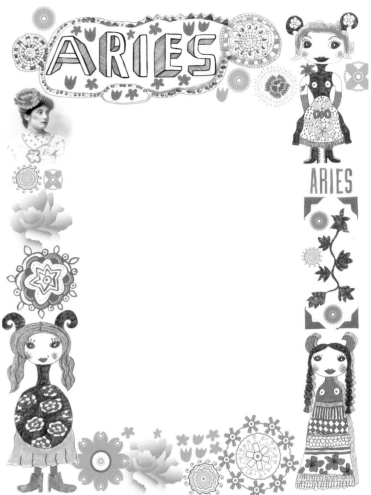

STUDIO / DESIGN FIRM Studio 't Brandt Weer (Den Haag, The Netherlands)
WORK / YEAR Elle Girl Gemini / 2005
WORK / YEAR Elle Girl Aries / 2005
ARTIST Marenthe Otten
ART DIRECTION, DESIGN Marenthe Otten
ILLUSTRATION Marenthe Otten
CLIENT Elle Girl
DESCRIPTION Illustrations for magazine.

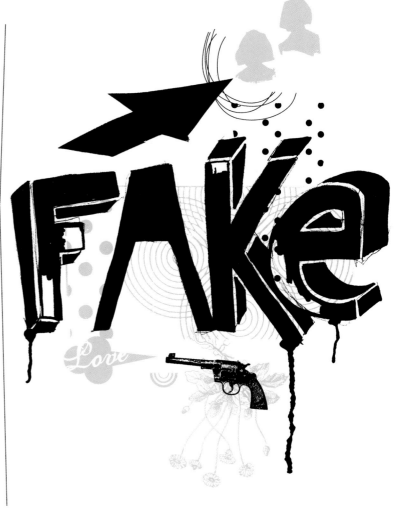

STUDIO / DESIGN FIRM Automatic Art and Design (New York, USA)
WORK / YEAR Illustrations / 2004
ARTIST Charles Wilkin
DESIGN / ILLUSTRATION Charles Wilkin
CLIENT Arkitip #20
DESCRIPTION Magazine Layout.

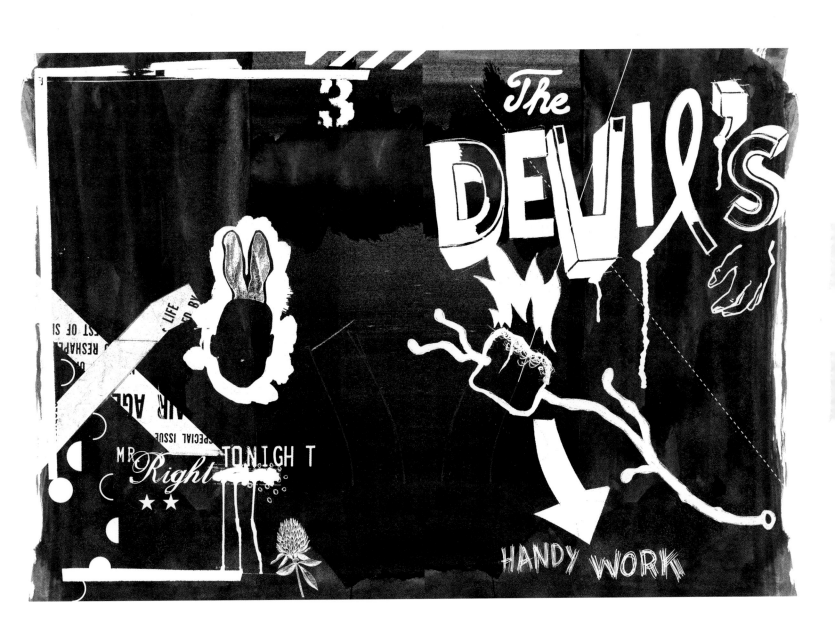

STUDIO / DESIGN FIRM Cassandrem / Cassandre Montoriol (Paris, France)
WORK / YEAR "La fraise c'est pas de la tarte" / 2005
ARTIST Cassandre Montoriol
ILLUSTRATION Cassandre Montoriol
CLIENT Le goût des mots
DESCRIPTION Crayon.

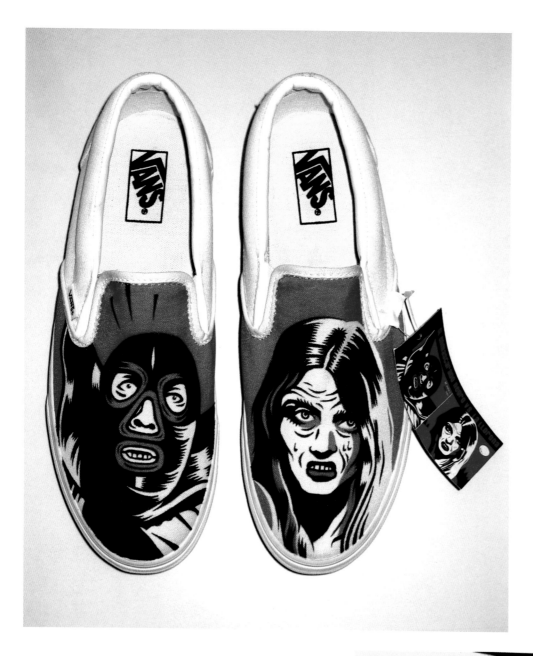

STUDIO / DESIGN FIRM Dr. Alderete (Mexico City, México)
WORK / YEAR El Enmascarado Negro Vs. La Llorona / 2005
ARTIST Dr. Alderete
ART DIRECTION, DESIGN Dr. Alderete
ILLUSTRATION Dr. Alderete
CLIENT Vans Mexico - Kulte
DESCRIPTION Vans customization exhibition "Da Mecsican Estail".

STUDIO / DESIGN FIRM Rodrigo (New York, USA)
WORK / YEAR AW zine issue 9 / 2005
ARTIST Melina Rodrigo
ART DIRECTION, DESIGN Melina Rodrigo
ILLUSTRATION Melina Rodrigo
DESCRIPTION Promotional.

STUDIO / DESIGN FIRM Rodrigo (New York, USA)
WORK / YEAR Illustration for Catfight magazine / 2005
ARTIST Melina Rodrigo
ART DIRECTION, DESIGN Melina Rodrigo
ILLUSTRATION Melina Rodrigo

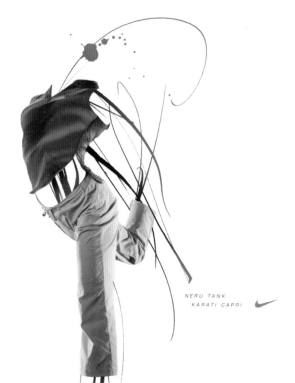

NERU TANK
KARATI CAPRI

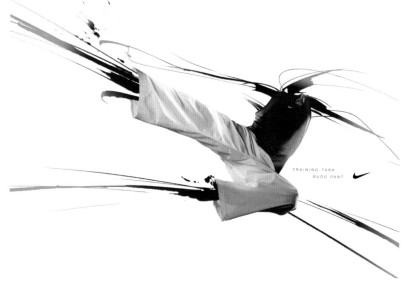

TRAINING TANK
BUDO PANT

STUDIO / DESIGN FIRM Matthieu Appriou / Telmolindo (Paris, France)
WORK / YEAR Illustration / 2005
ARTIST Matthieu Appriou
ILLUSTRATION Matthieu Appriou
CLIENT Personal work

STUDIO / DESIGN FIRM Seb Jarnot (Nimes, France)
WORK / YEAR Nike / 2002
ARTIST Seb Jarnot
ILLUSTRATION Seb Jarnot
CREATIVE DIRECTION Paul Shearer / Glenn Cole
ART DIRECTION Merete Busk
PHOTO Alan Clarke
CLIENT / AGENCY Nike / Wieden + Kennedy (Amsterdam-NL)
DESCRIPTION International print Ad campaign.

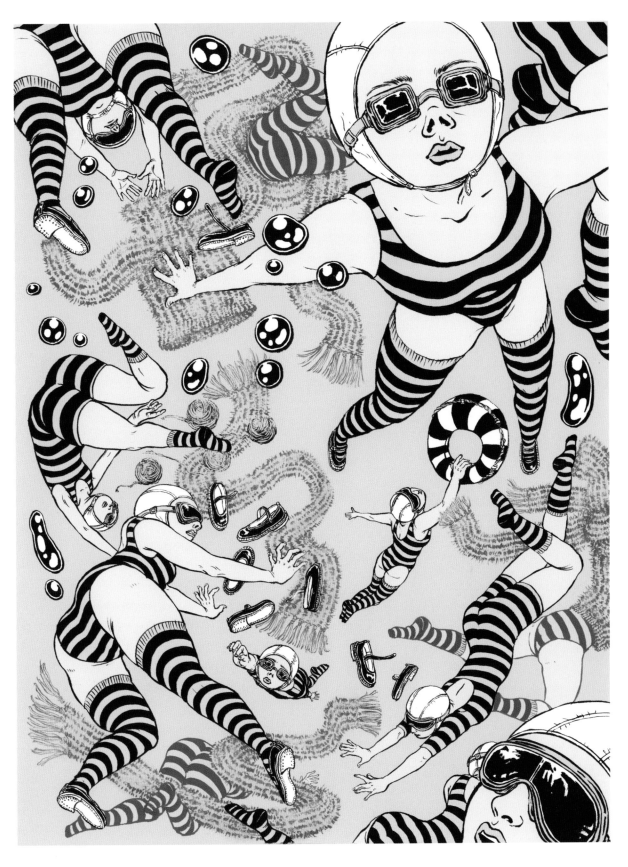

STUDIO / DESIGN FIRM Yuko Shimizu (New York, USA)
WORK / YEAR Illustration / 2004
ARTIST Yuko Shimizu
ILLUSTRATION Yuko Shimizu
ART DIRECTION Antonio De Luca
CLIENT Walrus (Canada)
DESCRIPTION A piece created to be on the cover of literary
magazine, summer reading issue (unpublished)

STUDIO / DESIGN FIRM / ARTIST Rinzen (Sydney / Brisbane / Berlin)
WORKS / YEAR Seeker / 2005
PHOTOGRAPHY jankopetzky.de
EXHIBITION Are you my home? Helium Cowboy Artspace, Hamburg.
DESCRIPTION Acrylic on wood panels 40cm x 40cm.

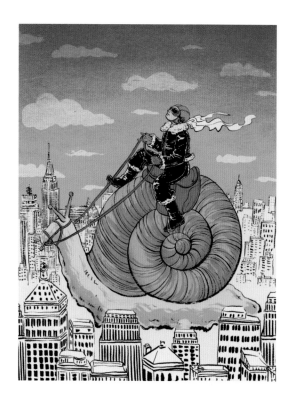

Top & P. 115

STUDIO / DESIGN FIRM Yuko Shimizu (New York, USA)
WORK / YEAR Utne Magazine illustrations / 2004
ARTIST Yuko Shimizu
ILLUSTRATION Yuko Shimizu
ART DIRECTION Kristi Anderson
CLIENT Utne Magazine (USA)
DESCRIPTION Illustrations commissioned by Utne Magazine for cover (P. 115) and inside spread (below) about features on how to take time and relax.

STUDIO / DESIGN FIRM Yuko Shimizu (New York, USA)
WORK / YEAR Changing sides / 2005
ARTIST Yuko Shimizu
ILLUSTRATION Yuko Shimizu
ART DIRECTION SooJin Buzelli
CLIENT Plansponsor Magazine (USA)
DESCRIPTION Illustration created for mutual fund magazine.

STUDIO / DESIGN FIRM GrupoW (Saltillo, Coahuila, México)
WORK / YEAR Nike, Juega 10 / 2005
CREATIVE DIRECTION Miguel Calderon
ART DIRECTION Ulises Valencia
DESIGN Miguel Calderón, Francisco Romahn, César Moreno, Sebastian Mariscal
PROGRAMMING Raúl Uranga, Homero Sousa
VIDEO Ulises Valencia, Jezreel Gutiérrez, Roberto Espero
PHOTOGRAPHY Fernando Valdés
COPY Iván González
STAFF Sara Dávila, Marcela de la Cruz
EXECUTIVE OF ACCOUNTS Stephanie Roldán
CLIENT Nike
DESCRIPTION Web Site, Ad.

STUDIO / DESIGN FIRM Guillermo Tragant (Chicago, USA)
WORK / YEAR Shakira.com / 2005
ARTIST Guillermo Tragant
ART DIRECTION, DESIGN Guillermo Tragant
CLIENT Shakira / Sony
DESCRIPTION Website concept and design for www.shakira.com

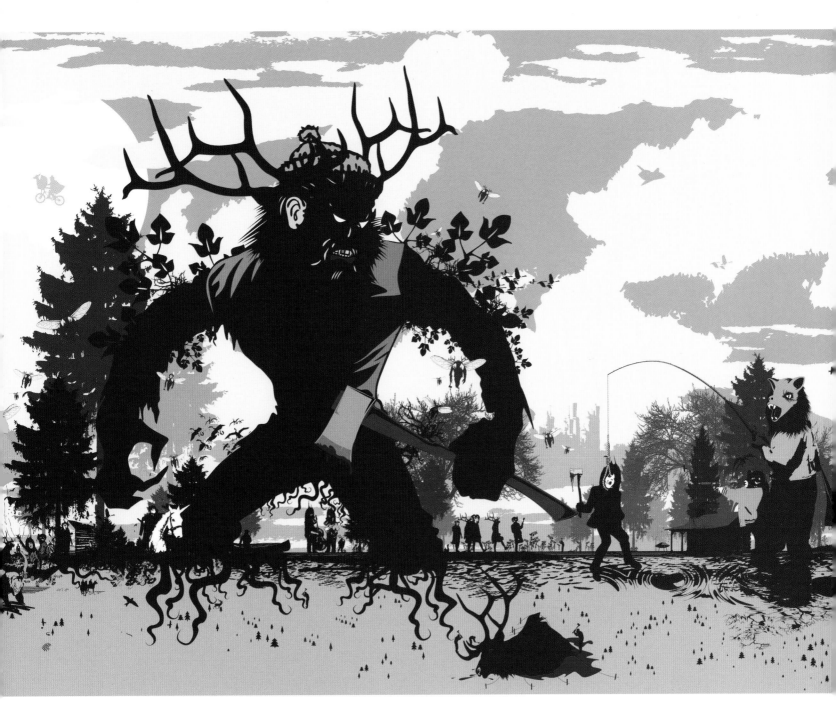

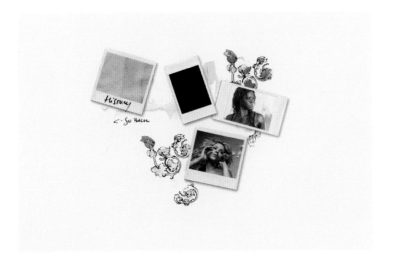

STUDIO / DESIGN FIRM Insect (London, UK)
WORK / YEAR The Hills Have Eyes Insect Exhibition / 2003
ARTIST Paul Insect / Luke Insect
CREATIVE DIRECTION Paul Insect / Luke Insect
ART DIRECTION, DESIGN, ILLUSTRATION Paul Insect / Luke Insect
CLIENT Dreambagsandjaguarshoes / Insect London
DESCRIPTION 10mx4m Large scale Digital Wallpaper.

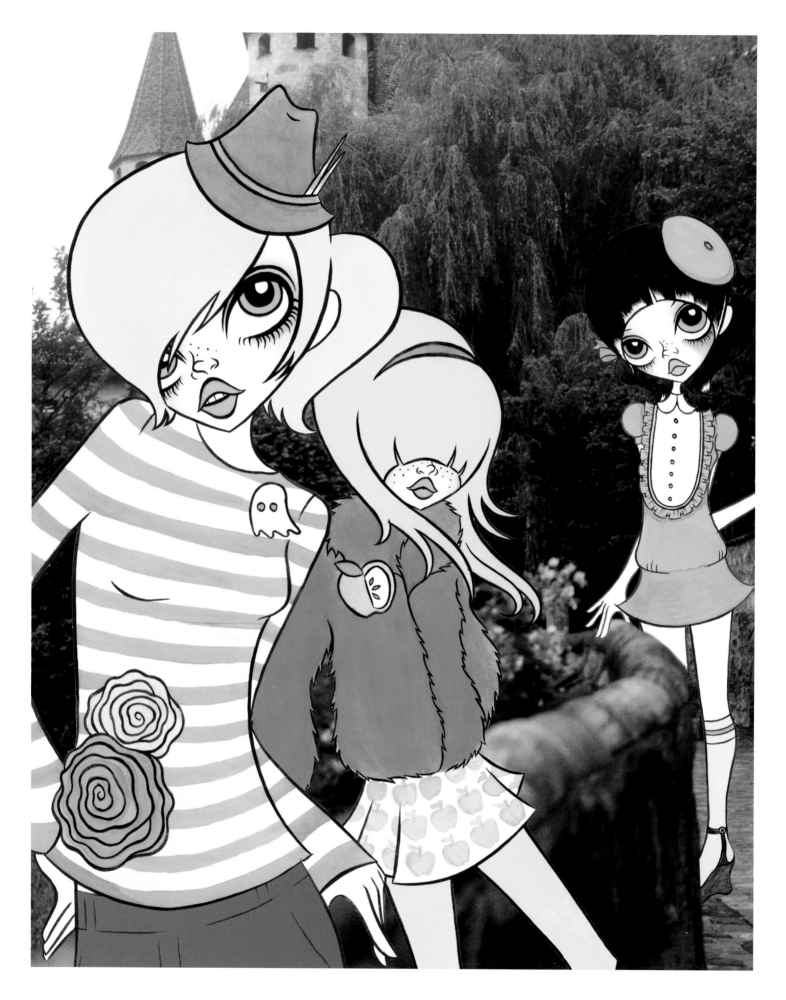

STUDIO / DESIGN FIRM Neuarmy (Philadelphia, USA)
ARTIST Ryan Katrina
WORK / YEAR "Untitled" / 2005
CREATIVE / ART DIRECTION Ryan Katrina
DESIGN / ILLUSTRATION Ryan Katrina
CLIENT Andrea Lugli / Handmade
DESCRIPTION Print/Mixed media.

P. 118
STUDIO / DESIGN FIRM Fawn Gehweiler / No Candy (Los Angeles, USA)
WORK / YEAR "Garden Party" / 2005
ARTIST Fawn Gehweiler
DESCRIPTION Fashion story for Anthem magazine, Los Angeles
EDITORIAL DETAILS Olive wears hat by David Mason, ghost pin by Tatty Devine, shirt by Sonia Rykiel, shorts by built by Wendy.
Jennifer wears vintage jacket by Biba, apple pin by HMS Carousel, skirt by Luella Bartley, tights by Wolford.
Penelope wears vintage angora beret, dress by HMS Carousel, socks and sock garters by Miss Dater, shoes by D-Havz.
All wear eyecolors by Anna Sui and metallic golden green fairy dust by Pixi.

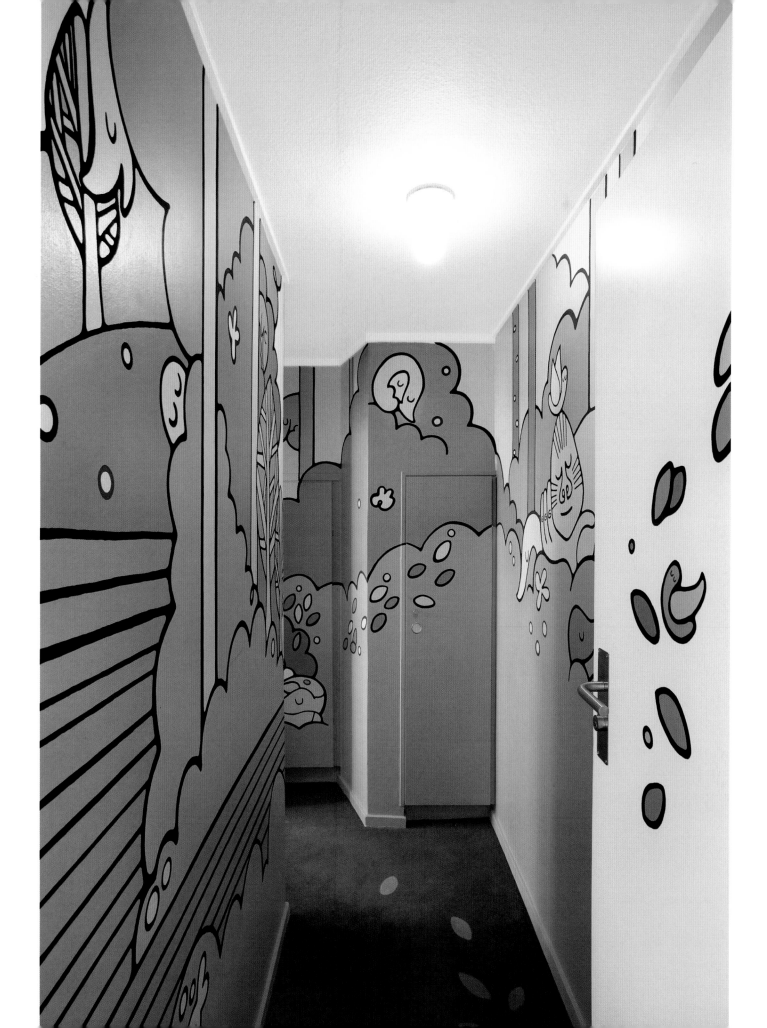

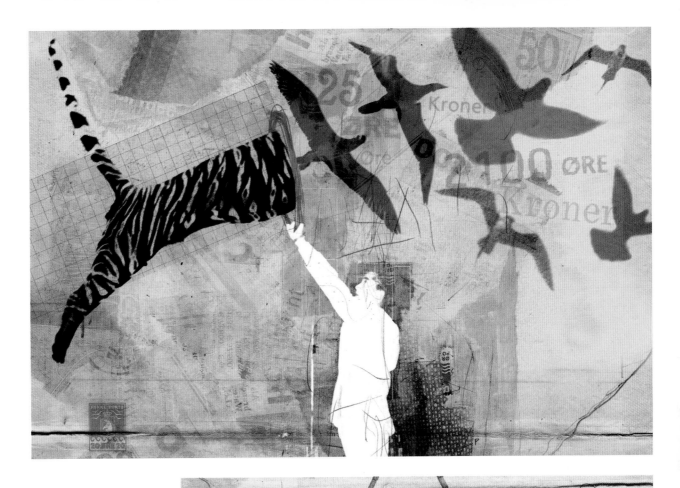

STUDIO / DESIGN FIRM Peter Hermann (Odense, Denmark)
WORK / YEAR (Top) Versatility / 2004
WORK / YEAR Gender prison / 2004
ARTIST Peter Hermann
ART DIRECTION, DESIGN, ILLUSTRATION Peter Hermann
CLIENT BUPL
CLIENT Efterskolen
DESCRIPTION Editorial illustrations.

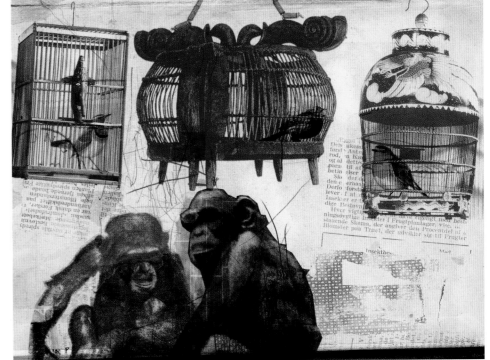

STUDIO / DESIGN FIRM / ARTIST Rinzen (Sydney / Brisbane / Berlin)
WORKS / YEAR Hotel Fox - Sleep Seasons Room / 2005
DESIGN, ILLUSTRATION Rinzen
CLIENT VW
PHOTOGRAPHY diephotodesigner.de
DESCRIPTION Hotel room, hand-painted walls (acrylic paint),
bedspread and quilt hand dyed and appliqued.

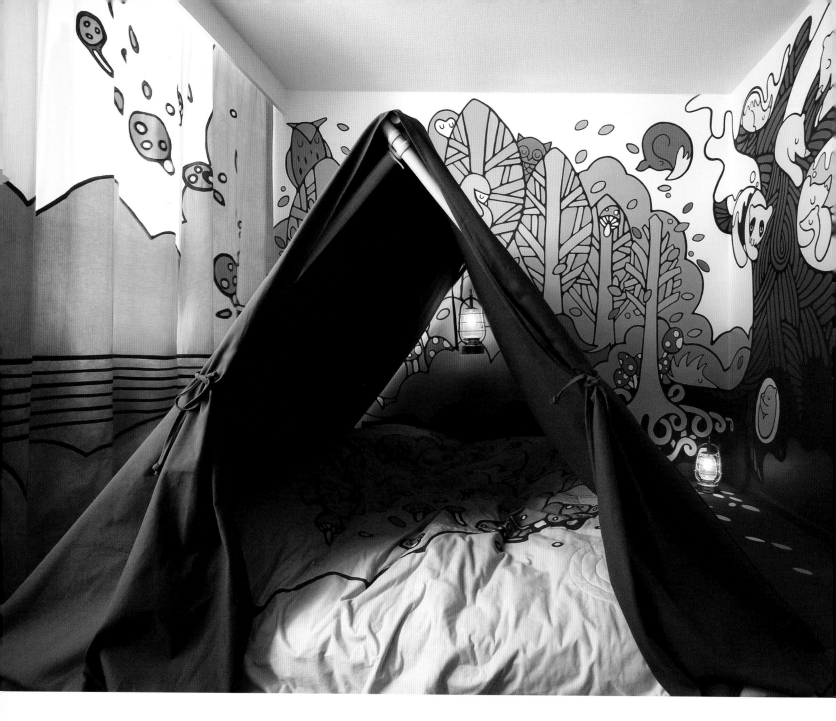

STUDIO / DESIGN FIRM / ARTIST Rinzen (Sydney / Brisbane / Berlin)
WORKS / YEAR Hotel Fox - Sleep Seasons Room / 2005
DESIGN, ILLUSTRATION Rinzen
CLIENT VW
PHOTOGRAPHY diephotodesigner.de
DESCRIPTION Hotel room, hand-painted walls (acrylic paint), bedspread and quilt hand dyed and appliqued.

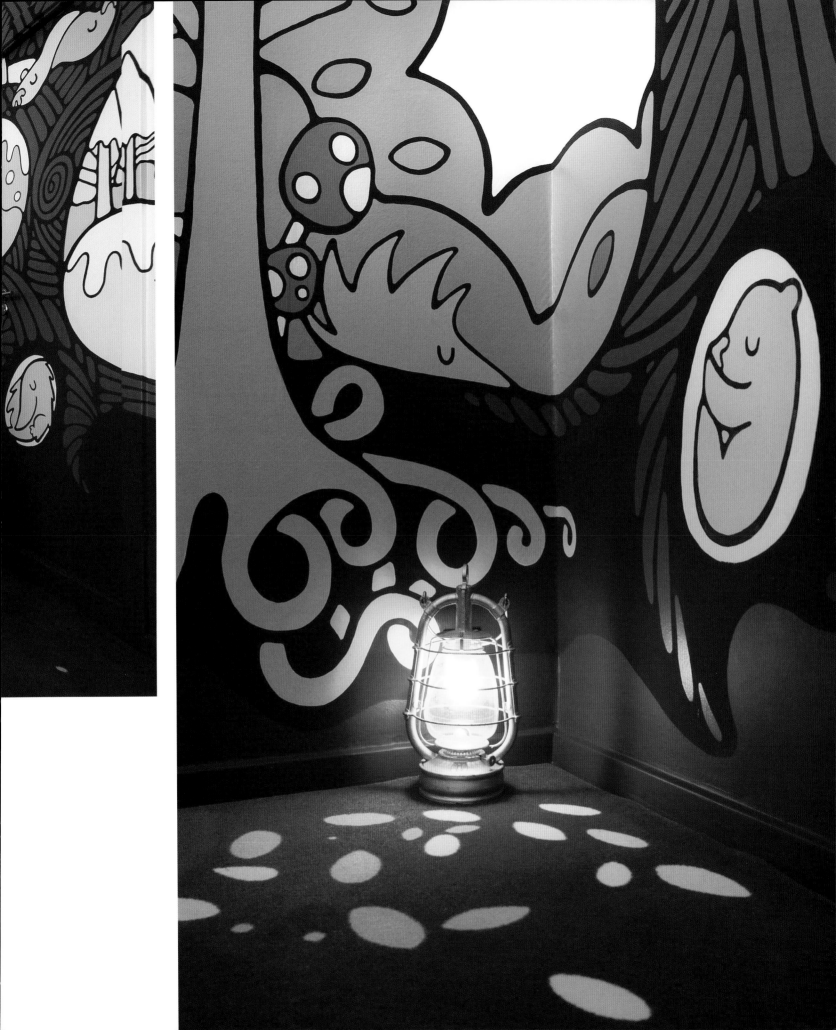

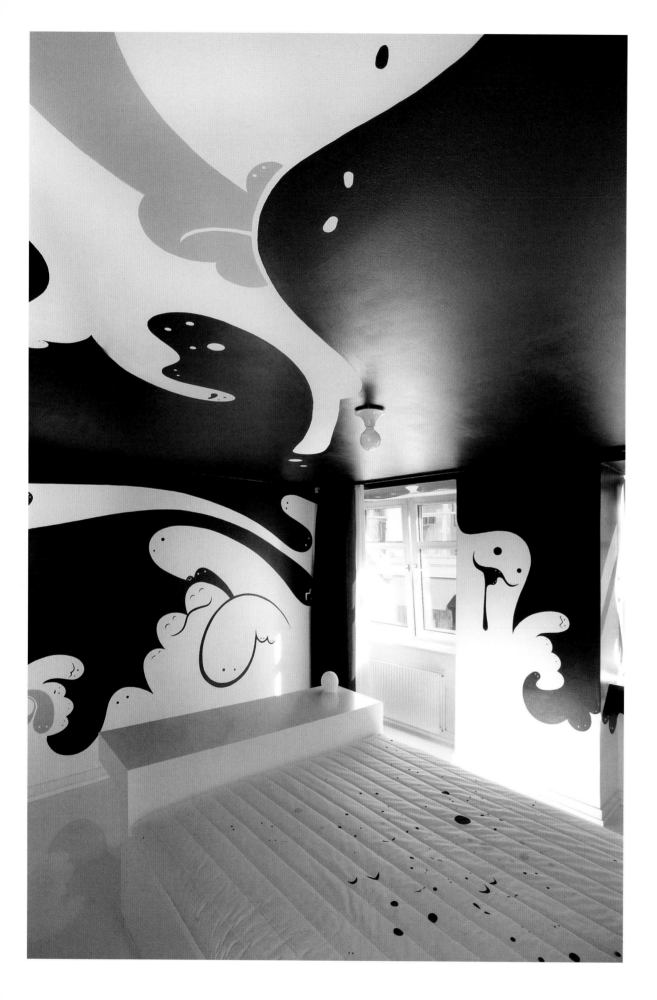

STUDIO / ARTIST Rinzen (Sydney / Brisbane / Berlin)
WORKS / YEAR Hotel Fox - Good Spirits Room / 2005
DESIGN, ILLUSTRATION Rinzen
CLIENT VW
PHOTOGRAPHY diephotodesigner.de
DESCRIPTION Hotel room, hand-painted walls
(acrylic paint).

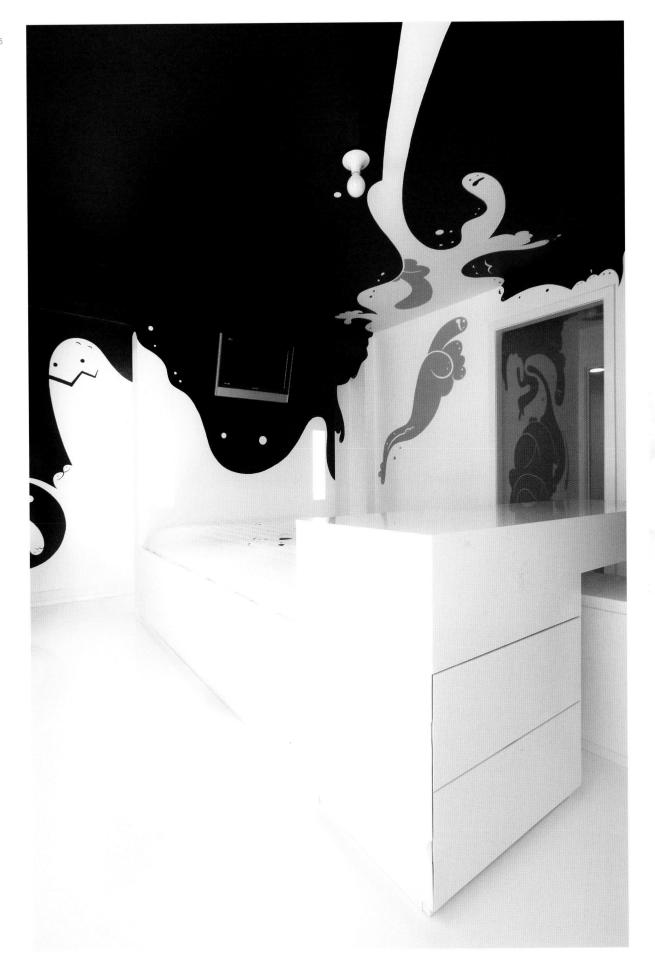

STUDIO / DESIGN FIRM Matthieu Appriou / Telmolindo (Paris, France)
WORK / YEAR Illustrations / 2003
ARTIST Matthieu Appriou
ILLUSTRATION Matthieu Appriou
CLIENT www.show-me-dq.com

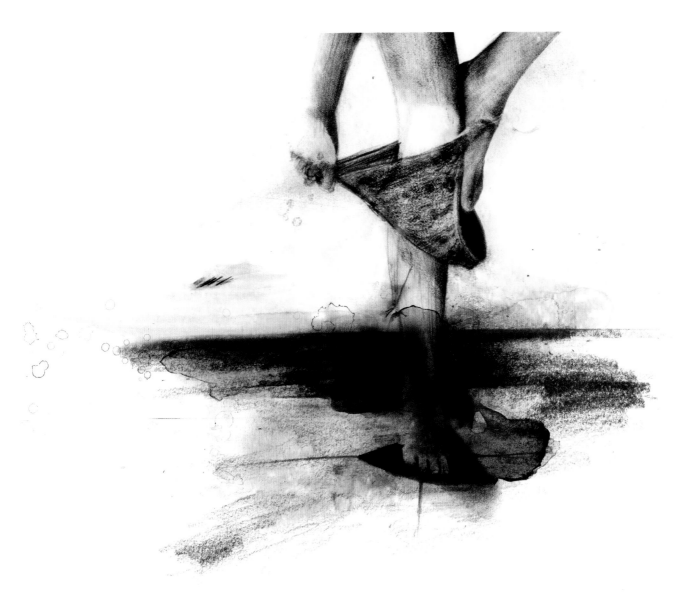

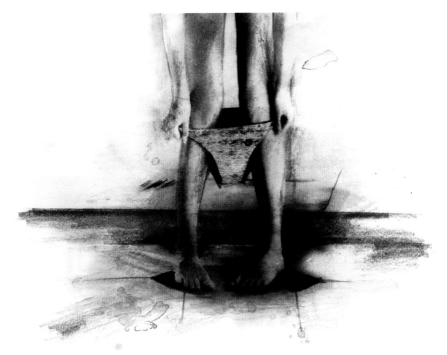

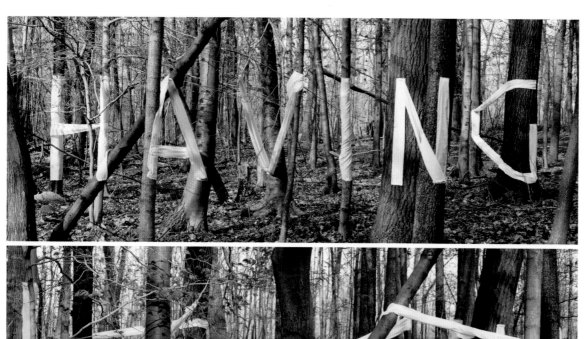

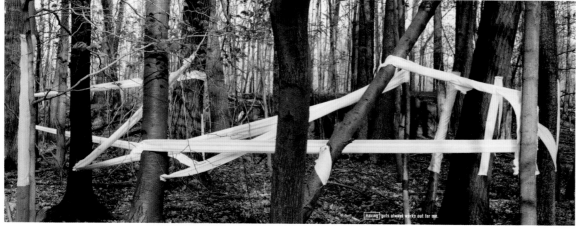

Having [guts] always works out for me.

Having [guts] always works out for me.

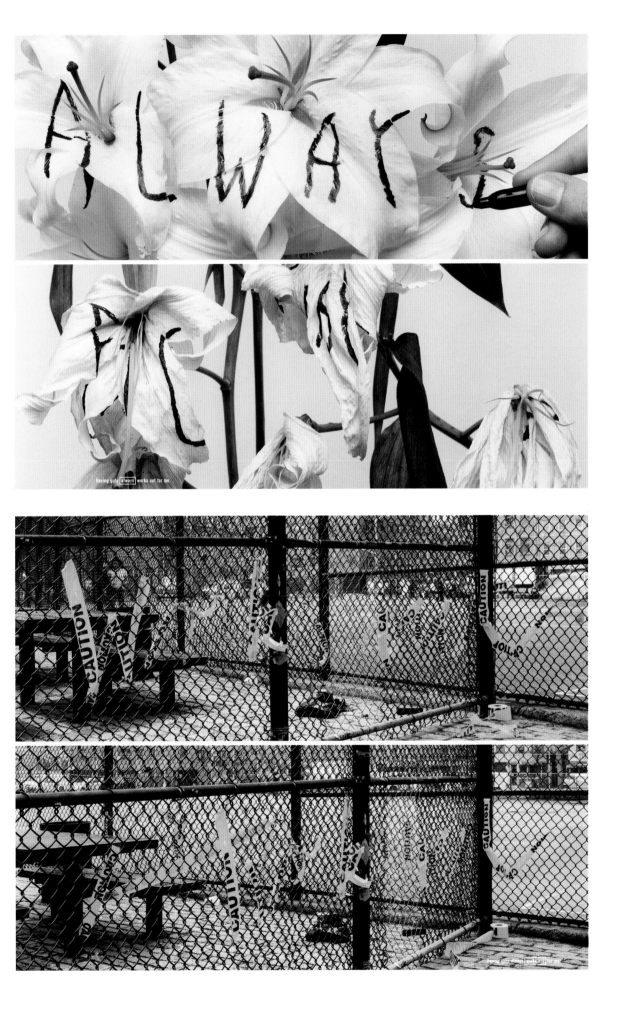

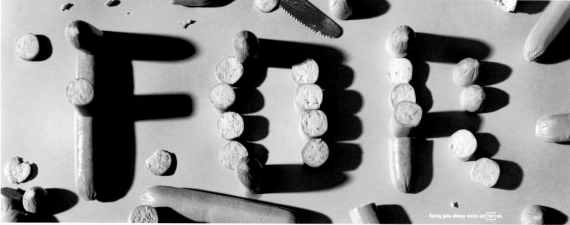

P. 128, 129, 130

STUDIO / DESIGN FIRM Sagmeister Inc. / Bela Borsodi (NY, USA)
WORK / YEAR Having guts always works out for me / 2003
ART DIRECTION Stefan Sagmeister
DESIGN Matthias Ernstberger, Miao Wang,
Stefan Sagmeister
PHOTO Bela Borsodi
CLIENT .copy magazine (Austria)
DESCRIPTION Six newly commisioned double page
spreads for the Austrian Magazine
.copy.
Together they read: Having / guts /
always / works out / for / me.
These are dividing spaces, each
opening a new chapter in the magazine.
Each month the magazine commissions
another studio/artist with the design.

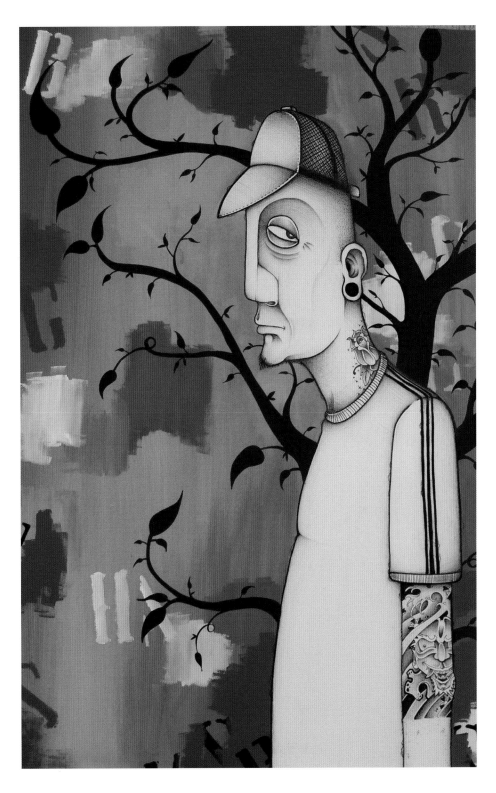

STUDIO / DESIGN FIRM Seacreative (Varese, Italy)
WORK / YEAR Acrylic and ink on canvas / 2005
ARTIST Seacreative
ILLUSTRATION Seacreative

STUDIO / DESIGN FIRM Seacreative (Varese, Italy)
WORK / YEAR Sketchs on paper / 2005
ARTIST Seacreative
ILLUSTRATION Seacreative

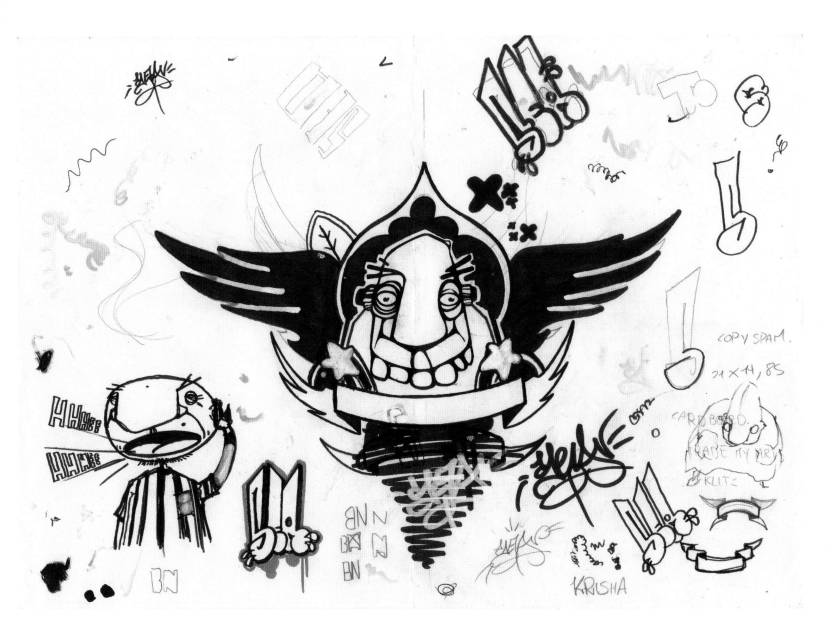

STUDIO / DESIGN FIRM Seacreative (Varese, Italy)
WORK / YEAR Sketch on paper / 2005
ARTIST Seacreative
ILLUSTRATION Seacreative

THE HUMAN BODY

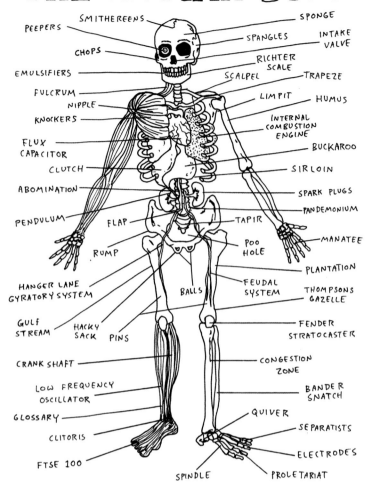

- PEEPERS
- SMITHEREENS
- CHOPS
- EMULSIFIERS
- FULCRUM
- NIPPLE
- KNOCKERS
- FLUX CAPACITOR
- CLUTCH
- ABOMINATION
- PENDULUM
- FLAP
- RUMP
- HANGER LANE GYRATORY SYSTEM
- BALLS
- GULF STREAM
- HACKY SACK
- PINS
- CRANK SHAFT
- LOW FREQUENCY OSCILLATOR
- GLOSSARY
- CLITORIS
- FTSE 100
- SPINDLE
- SPONGE
- SPANGLES
- INTAKE VALVE
- RICHTER SCALE
- SCALPEL
- TRAPEZE
- LIMPIT
- HUMUS
- INTERNAL COMBUSTION ENGINE
- BUCKAROO
- SIRLOIN
- SPARK PLUGS
- PANDEMONIUM
- TAPIR
- POO HOLE
- MANATEE
- PLANTATION
- FEUDAL SYSTEM
- THOMPSONS GAZELLE
- FENDER STRATOCASTER
- CONGESTION ZONE
- BANDER SNATCH
- QUIVER
- SEPARATISTS
- ELECTRODES
- PROLETARIAT

PLANS FOR A ROBOT FRIEND
MADE FROM HOUSEHOLD OBJECTS

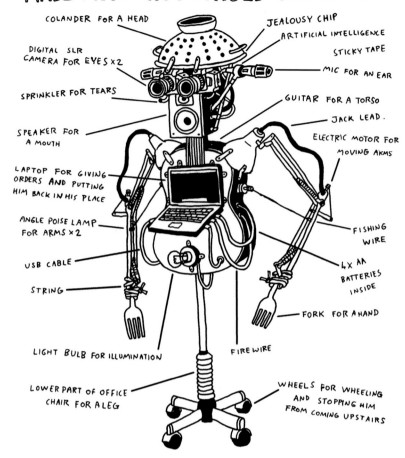

- COLANDER FOR A HEAD
- DIGITAL SLR CAMERA FOR EYES x2
- SPRINKLER FOR TEARS
- SPEAKER FOR A MOUTH
- LAPTOP FOR GIVING ORDERS AND PUTTING HIM BACK IN HIS PLACE
- ANGLE POISE LAMP FOR ARMS x2
- USB CABLE
- STRING
- LIGHT BULB FOR ILLUMINATION
- LOWER PART OF OFFICE CHAIR FOR A LEG
- JEALOUSY CHIP
- ARTIFICIAL INTELLIGENCE
- STICKY TAPE
- MIC FOR AN EAR
- GUITAR FOR A TORSO
- JACK LEAD
- ELECTRIC MOTOR FOR MOVING ARMS
- FISHING WIRE
- 4 x AA BATTERIES INSIDE
- FORK FOR A HAND
- FIREWIRE
- WHEELS FOR WHEELING AND STOPPING HIM FROM COMING UPSTAIRS

STUDIO / DESIGN FIRM Andrew Rae (London, UK)
WORK / YEAR The Human Body / 2005
WORK / YEAR Plans to build a Robot friend / 2004
ARTIST Andrew Rae
CLIENT Personal works
DESCRIPTION Illustration drawn as a wedding present for a friend who is training to be doctor.
DESCRIPTION Illustration produced for an exhibition entitled "Humans vs the Robots".

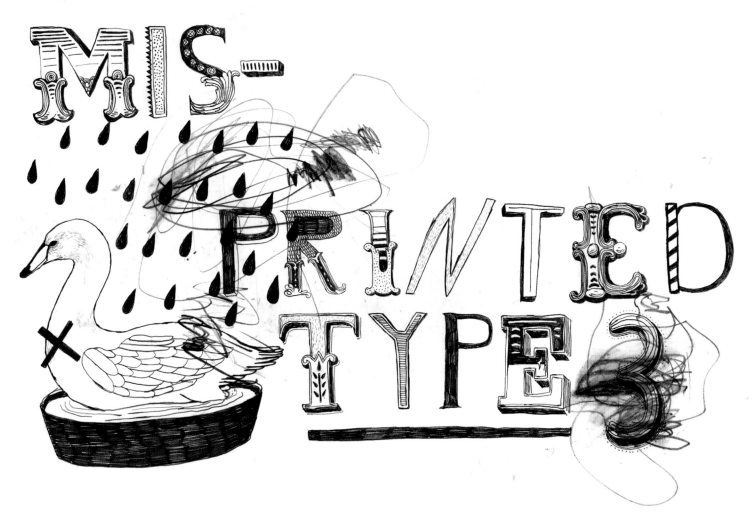

STUDIO / DESIGN FIRM / ARTIST Eduardo Recife / Misprinted Type (Belo Horizonte, Brazil)
WORK / YEAR Misprinted Type 3 / 2004
CREATIVE DIRECTION Eduardo Recife
ART DIRECTION, DESIGN Eduardo Recife
ILLUSTRATION Eduardo Recife
DESCRIPTION Personal Project.

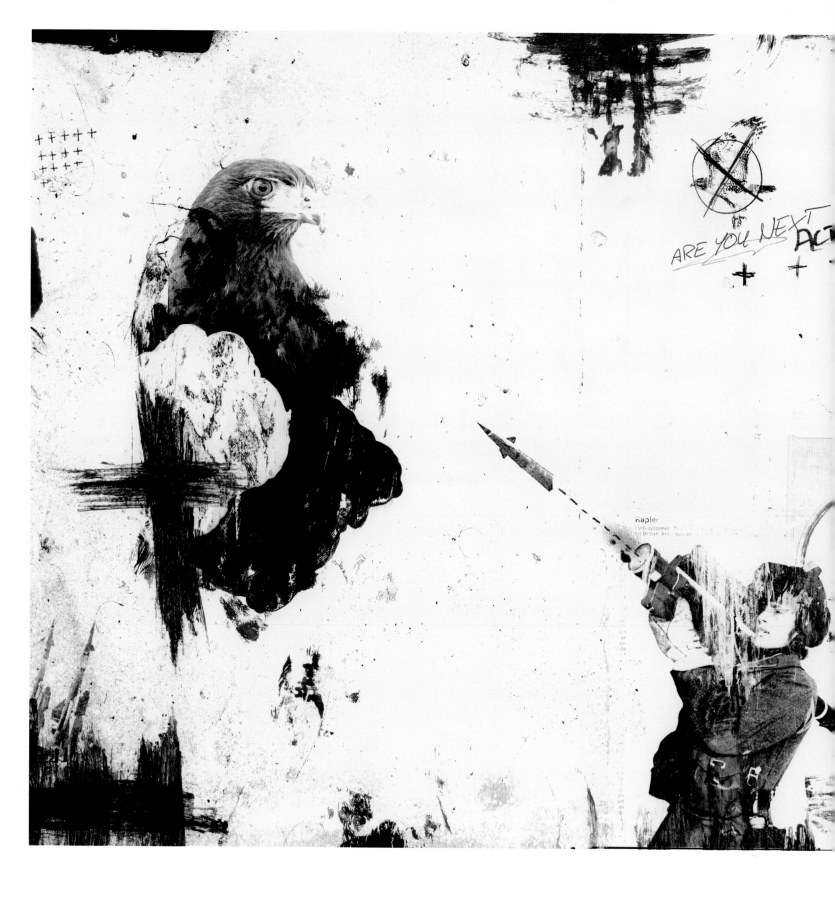

STUDIO / DESIGN FIRM Taobot (Mainz, Germany)
WORK / YEAR Black Day To Freedom / 2005
ARTIST Danny Franzreb
CREATIVE DIRECTION, ART DIRECTION, DESIGN Danny Franzreb
ILLUSTRATION Danny Franzreb
PHOTOGRAPHY, COPY Danny Franzreb
CLIENT Beyond

STUDIO / DESIGN FIRM Peter Hermann (Odense, Denmark)
WORK / YEAR God owes us an apology / 2004
ARTIST Peter Hermann
ART DIRECTION, DESIGN Peter Hermann
ILLUSTRATION Peter Hermann
CLIENT The Progressive
DESCRIPTION Editorial illustration.

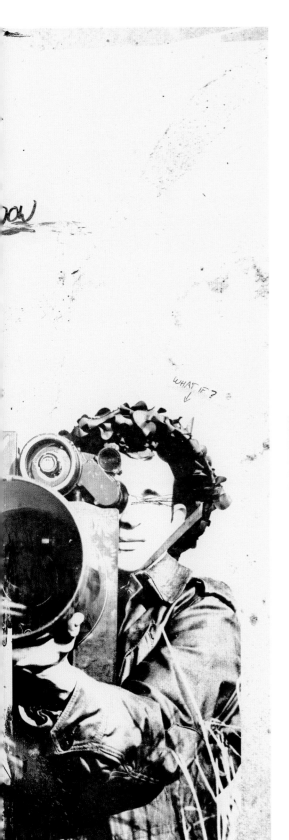

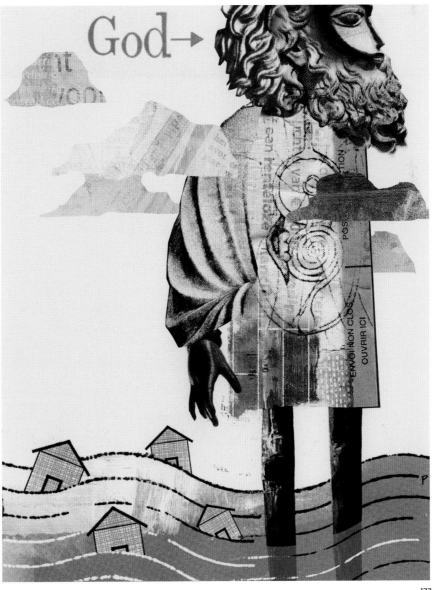

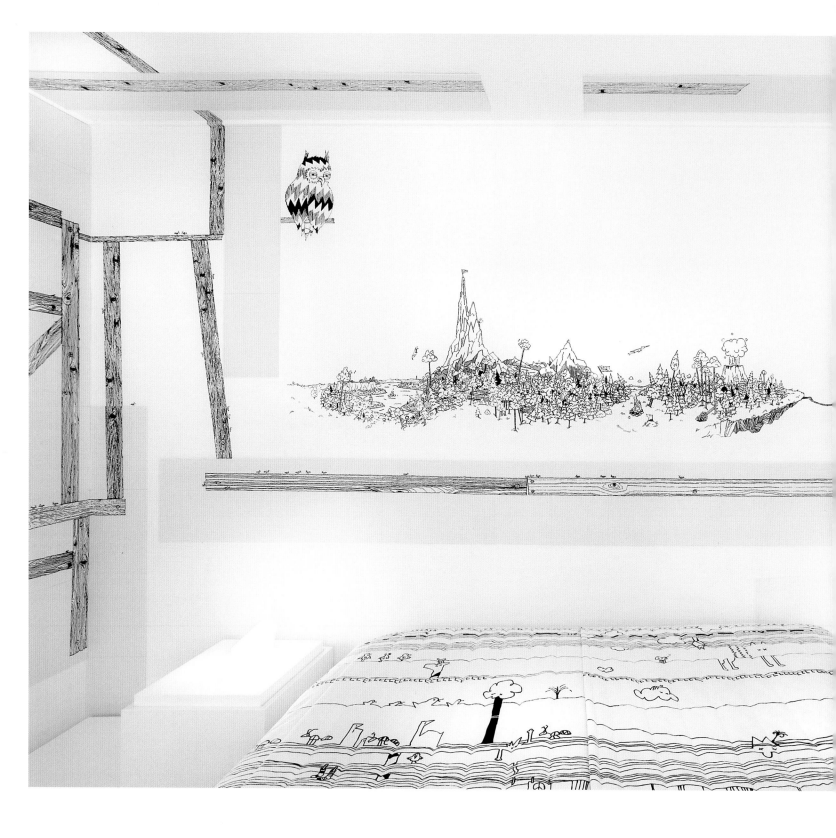

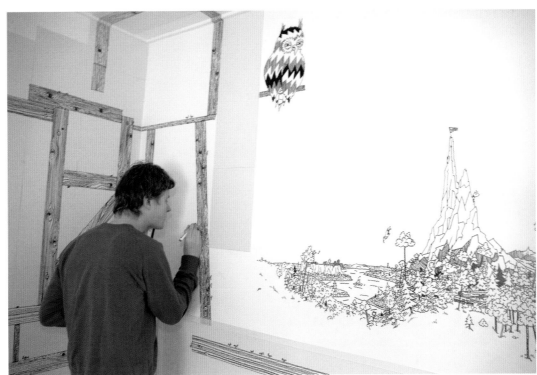

STUDIO / DESIGN FIRM Viagrafik (Wiesbaden, Germany)
WORK / YEAR Skew But You / 2005
ARTIST bstrkt/boe, Leo Volland
CREATIVE DIRECTION bstrkt/boe, Leo Volland
ART DIRECTION bstrkt/boe, Leo Volland
PHOTO diephotodesigner.de / André Nossek
CLIENT Volkswagen AG
DESCRIPTION Wall painting.

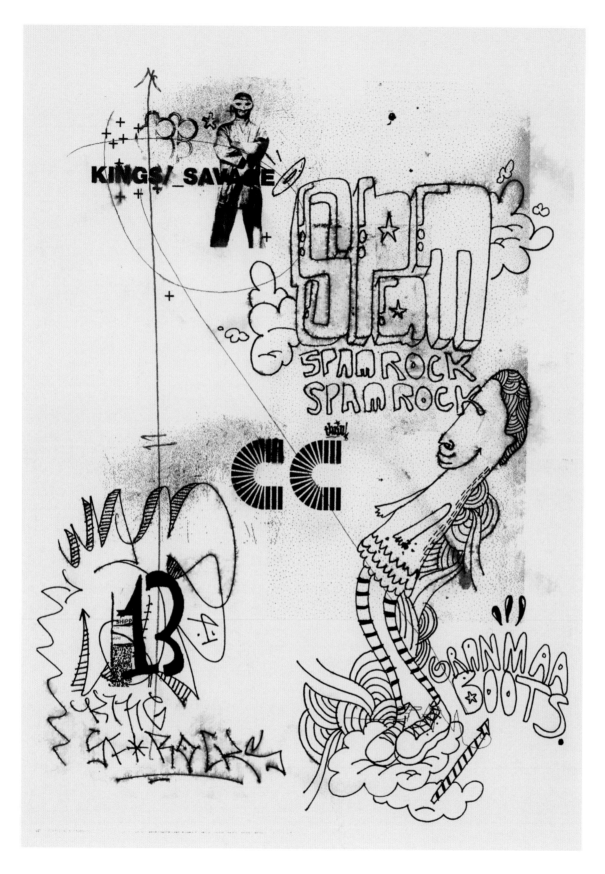

STUDIO / DESIGN FIRM / ARTIST SFaustina (Oakland, USA)
WORK / YEAR Illustration / 2004
CLIENT Spam magazine

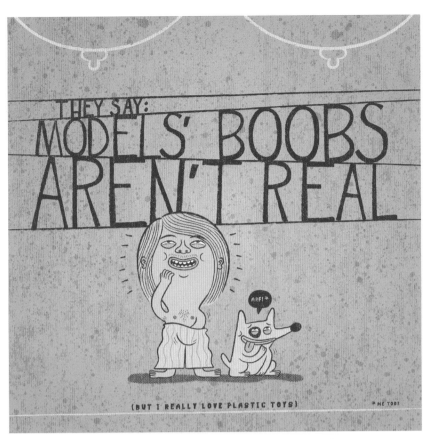

STUDIO / DESIGN FIRM TheBrainbox (Milan, Italy)
WORK / YEAR (Top) Toys / 2005
WORK / YEAR (Bottom) Advices / 2005
ARTIST Mauro Gatti
ART DIRECTION, DESIGN Mauro Gatti
ILLUSTRATION Mauro Gatti
DESCRIPTION Posters personal propaganda.

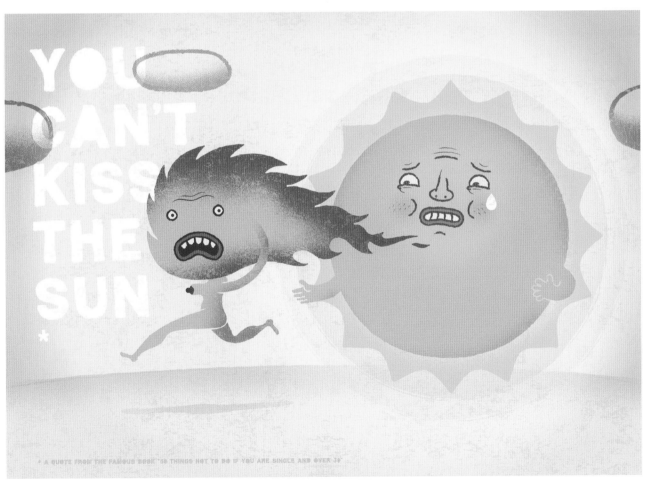

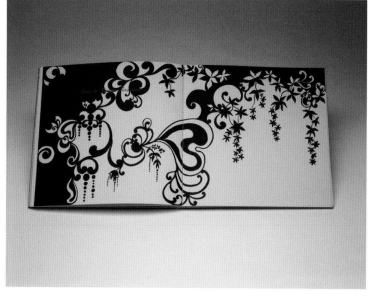

STUDIO / DESIGN FIRM Pablo A. Medina / Cubanica (New York, USA)
WORK / YEAR "Coisa Linda" / 2002
ARTIST AND ILLUSTRATOR Beatriz Milhazes
DESIGNER Pablo A. Medina
CLIENT Museum of Modern Art, NY
EDITOR May Castleberry
PRINTMAKER Jean Paul Russel
BINDER Claudia Cohen
TYPEFACES USED Vitrina, designed by Pablo A. Medina and Clarendon, by Hermann Eidenbenz
DESCRIPTION All artwork for Coisa Linda was custom made for the book by Beatriz Milhazes. Along with Milhazes' work, Pablo A. Medina designed pages of typeset lyrics of familiar Brazilian songs and poems in Portuguese and English translations. The book was hand-bound, hand-screen-printed and hand-constructed. It was an edition of 175 copies with 25 artist's copies. It utilized 45 colors including three metallics. The book also includes hand cut collages, hand dye-cuts, printing on acetate and a cloth bound slip case. It utilizes the familiar 12" x 12" x 1" dimensions of a Long Play disc box set.

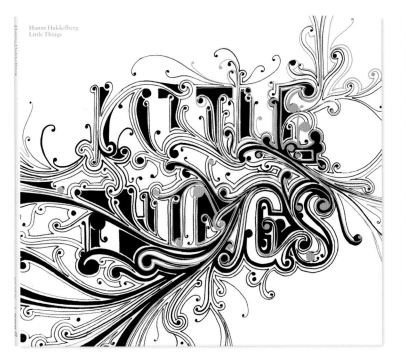

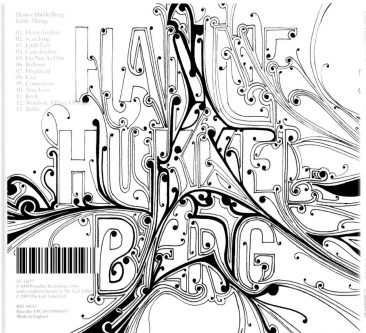

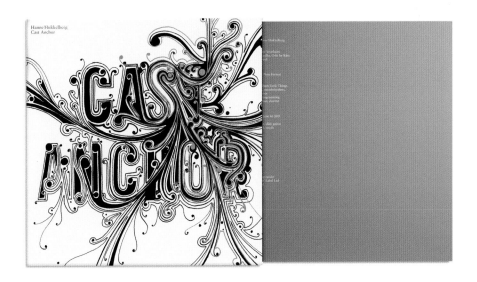

STUDIO / DESIGN FIRM Non-Format (London, UK)
WORK / YEAR Hanne Hukkelberg - Little Things / 2005
WORK / YEAR Hanne Hukkelberg - Cast Anchor / 2005
ART DIRECTION, DESIGN Kjell Ekhorn, Jon Forss
TYPOGRAPHIC ILLUSTRATION Si Scott
CLIENT The Leaf Label
DESCRIPTION CD album packaging, CD single packaging.

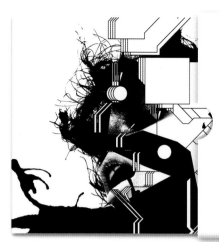

Lo Editions

1.2.3.

Electric Sheep
Synthetic Pleasures
Bug Powder

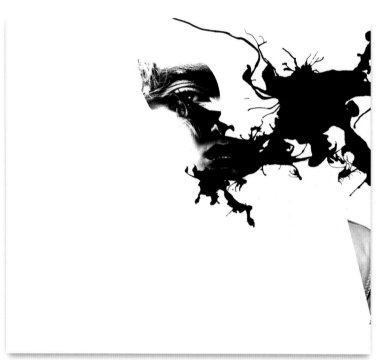

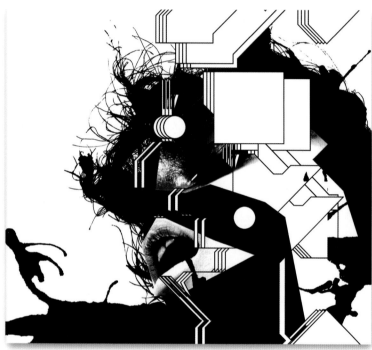

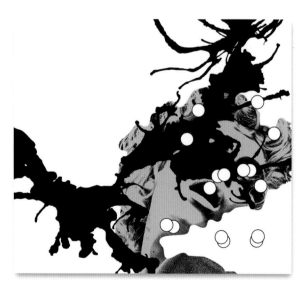

STUDIO / DESIGN FIRM Non-Format (London, UK)
WORK / YEAR Lo Editions 1.2.3. / 2004
ART DIRECTION, DESIGN Kjell Ekhorn, Jon Forss
ILLUSTRATION Kjell Ekhorn, Jon Forss
CLIENT BMG Zomba
DESCRIPTION Packaging for production music 3 CD box set.

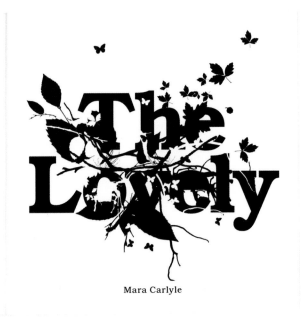

Mara Carlyle

STUDIO / DESIGN FIRM Non-Format (London, UK)
WORK / YEAR Mara Carlyle - The Lovely / 2004
ART DIRECTION, DESIGN Kjell Ekhorn, Jon Forss
TYPOGRAPHIC ILLUSTRATION Kjell Ekhorn, Jon Forss
CLIENT Accidental Records
DESCRIPTION CD album packaging.

STUDIO / DESIGN FIRM Non-Format (London, UK)
WORK / YEAR Théodore - A Summer She Has Never Been, A Winter She Fears / 2004
ART DIRECTION, DESIGN Kjell Ekhorn, Jon Forss
TYPOGRAPHIC ILLUSTRATION Kristian Hammerstad
CLIENT Lo Recordings
DESCRIPTION CD album packaging.

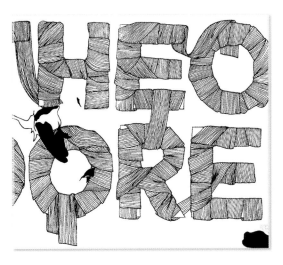

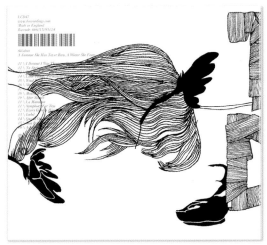

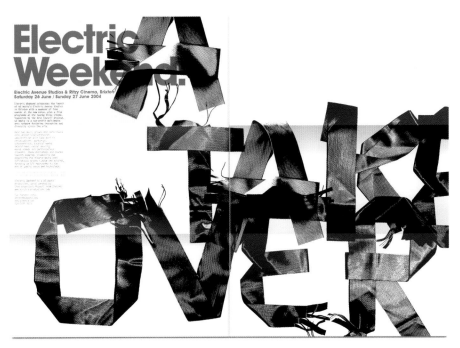

STUDIO / DESIGN FIRM Non-Format (London, UK)
WORK / YEAR Electric Weekend: A Takeover / 2004
ART DIRECTION, DESIGN Kjell Ekhorn, Jon Forss
CUSTOM MADE TYPOGRAPHY Kjell Ekhorn, Jon Forss
CLIENT b3 Media
DESCRIPTION Flyer/poster.

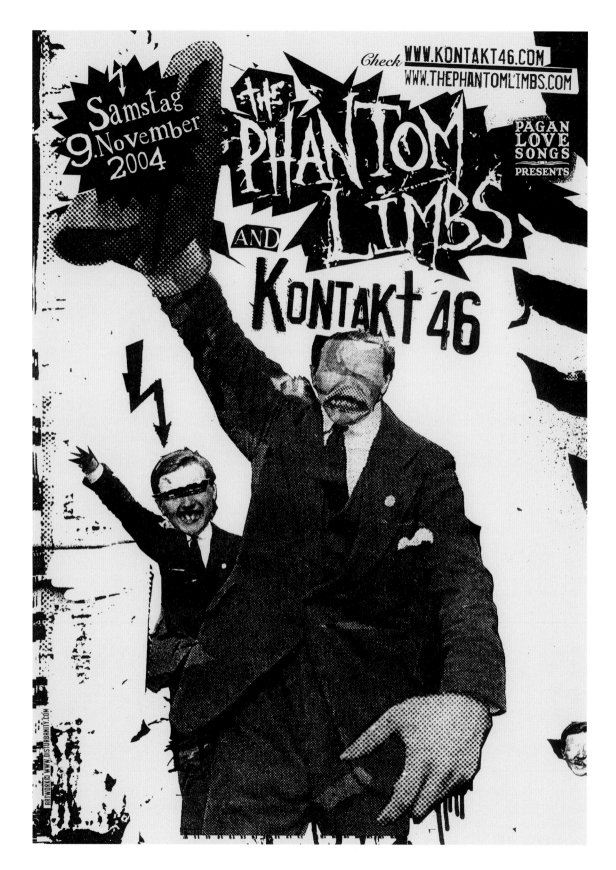

STUDIO / DESIGN FIRM Disturbanity (Dortmund, Germany)
WORK / YEAR Pagan Love Songs presents: the Phantom Limbs and Kontakt46 / 2004
ARTIST Matthias Gephart
TECHNIQUES Multiple collage, sketchbook+mac,
 rank xerox enhanced copy format.
DESCRIPTION Illustration poster for german punk/hc band
 Kontakt46 and california deathrockers
 Phantom Limbs.

STUDIO / DESIGN FIRM Fawn Gehweiler / No Candy (Los Angeles, USA)
WORK / YEAR "It's a mod, mod world" / 2005
ARTIST Fawn Gehweiler
DESCRIPTION Product design illustration for Nook, Australia,
 collage, digital.

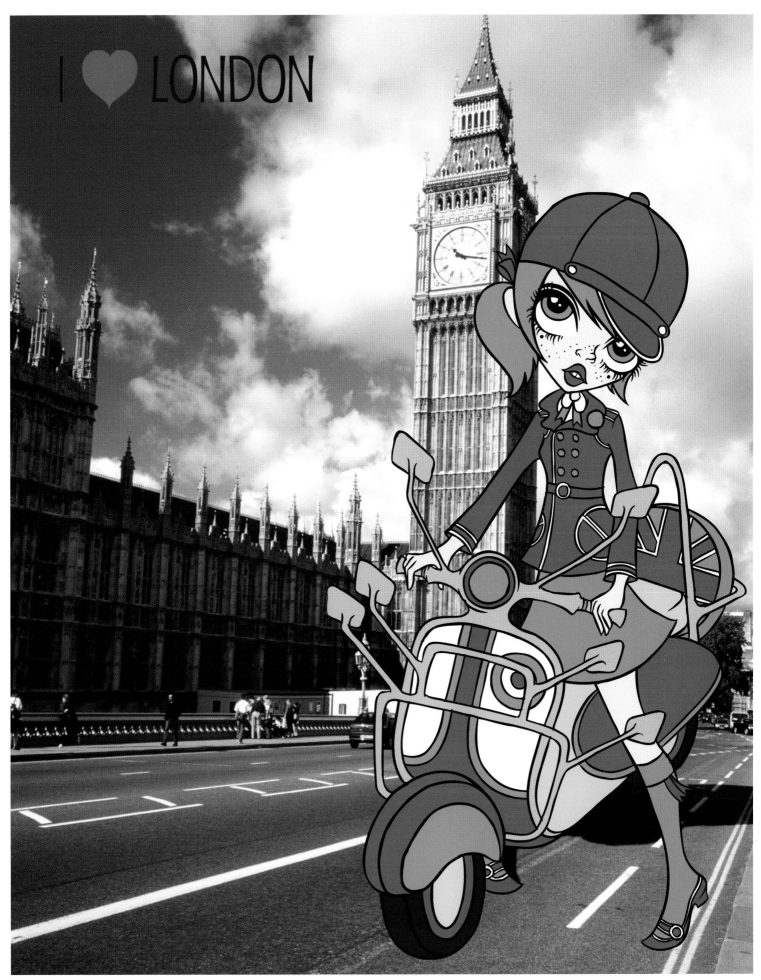

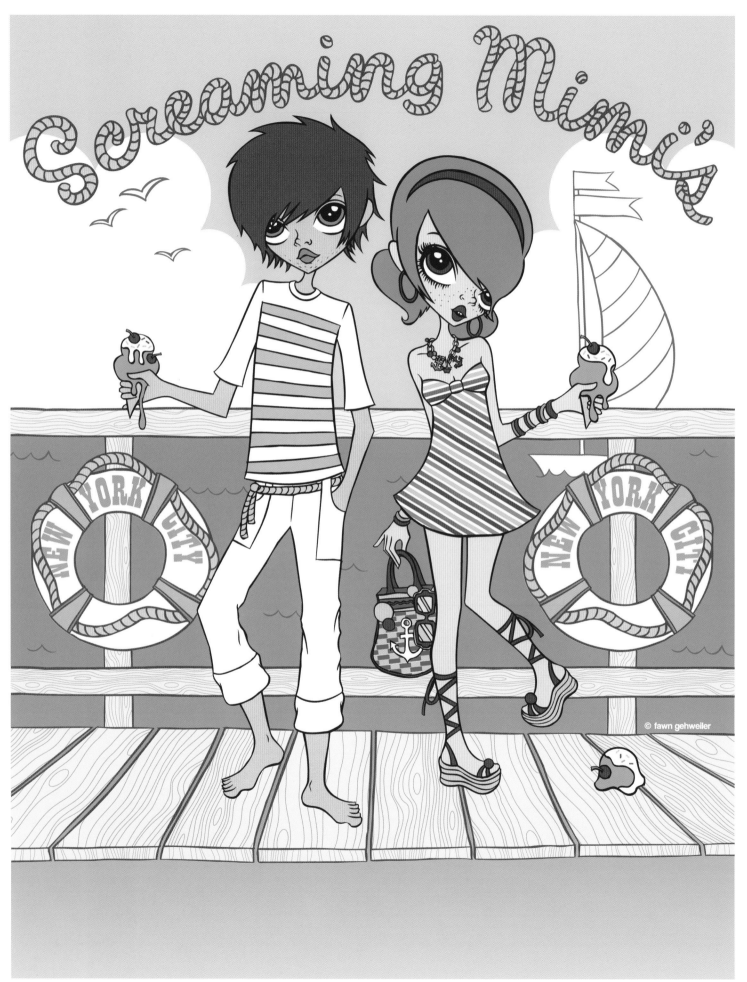

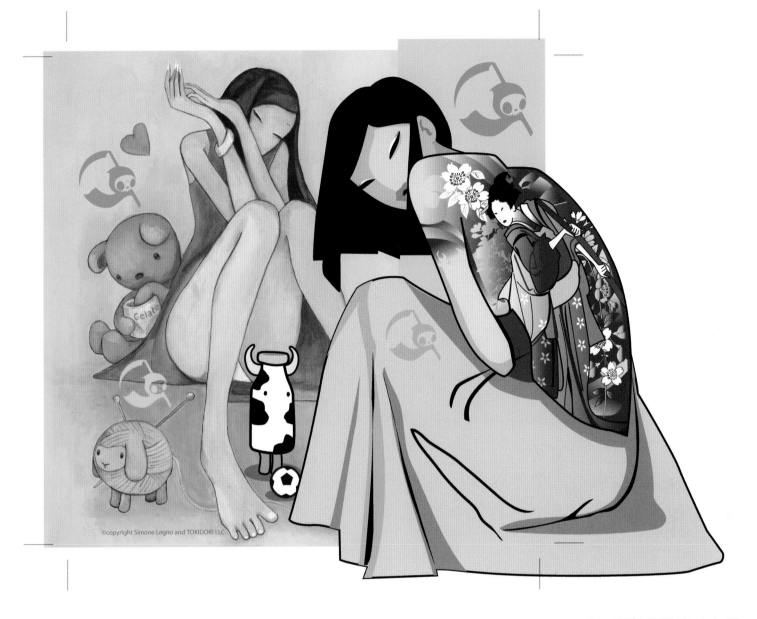

STUDIO / DESIGN FIRM TOKIDOKI LLC (Los Angeles, USA)
WORK / YEAR Mamma, I want to be a soccer player / 2003
ARTIST Simone Legno
ILLUSTRATION Simone Legno

STUDIO / DESIGN FIRM Fawn Gehweiler / No Candy (Los Angeles, USA)
YEAR 2005
ARTIST Fawn Gehweiler
DESCRIPTION Summer Ad campaign for Screaming Mimi's Boutique,
NYC and Tokyo.

Left
STUDIO / DESIGN FIRM Reza Abedini Studio (Tehran, Iran)
WORK / YEAR Illustration of an unsuccessful suicide / 2001
ARTIST Reza Abedini
CREATIVE DIRECTION, ART DIRECTION, DESIGN Reza Abedini
ILLUSTRATION Reza Abedini
COPY Salim Sefid Bakht
PHOTO AmirAli Ghasemi
CLIENT Salim Sefid Bakht
DESCRIPTION Installation Exhibition Poster.

STUDIO / DESIGN FIRM Reza Abedini Studio (Tehran, Iran)
WORK / YEAR Ahmad Amin Nazar / 2004
ARTIST Reza Abedini
CREATIVE DIRECTION, ART DIRECTION, DESIGN Reza Abedini
ILLUSTRATION Ahmad Amin Nazar
COPY Reza Abedini
PHOTO AmirAli Ghasemi
CLIENT Sayhoon Gallery
DESCRIPTION Painting Exhibition Poster.

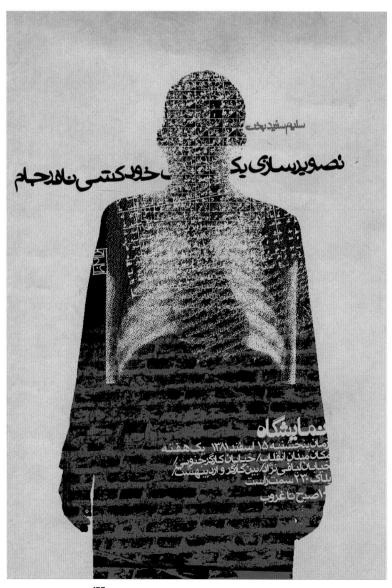

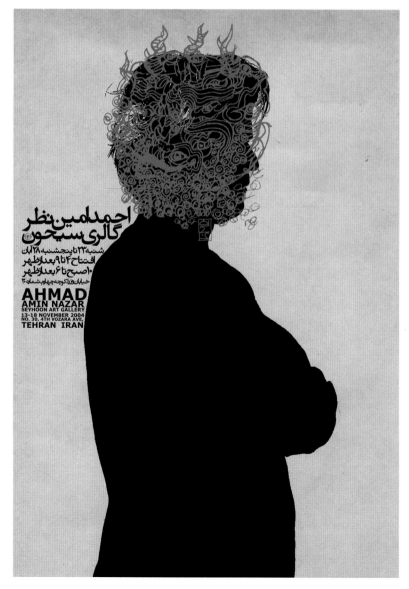

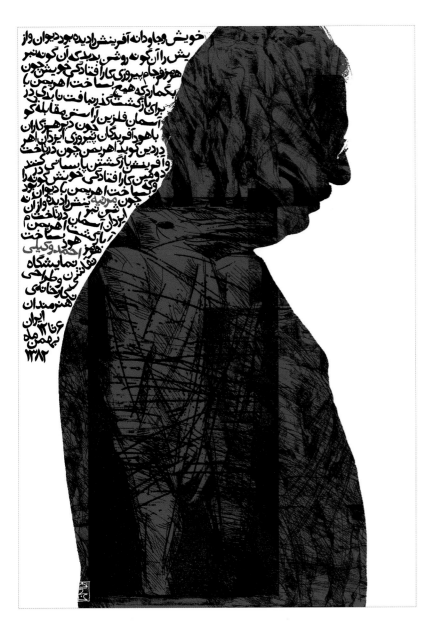

STUDIO / DESIGN FIRM Reza Abedini Studio (Tehran, Iran)
WORK / YEAR Elegy / 2004
ARTIST Reza Abedini
CREATIVE DIRECTION, ART DIRECTION, DESIGN Reza Abedini
ILLUSTRATION Ahmad Vakili
COPY Ahmad Vakili - R. Abedini
PHOTO Reza abedini
CLIENT Iranian Artists House
DESCRIPTION Painting Exhibition Poster.

STUDIO / DESIGN FIRM Peter Hermann (Odense, Denmark)
WORK / YEAR The world in one click / 2005
ARTIST Peter Hermann
ART DIRECTION, DESIGN Peter Hermann
ILLUSTRATION Peter Hermann
CLIENT Kristeligt Dagblad
DESCRIPTION Editorial illustration.

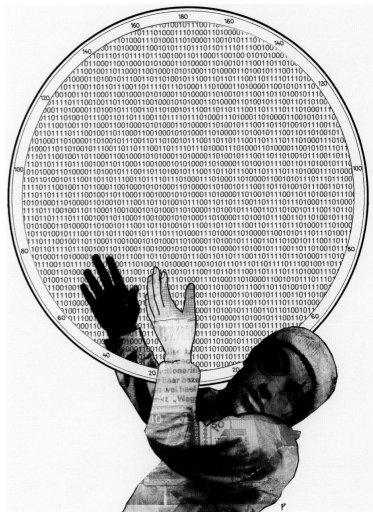

STUDIO / DESIGN FIRM Peter Hermann (Odense, Denmark)
WORK / YEAR Russian short stories / 2005
ARTIST Peter Hermann
ART DIRECTION, DESIGN Peter Hermann
ILLUSTRATION Peter Hermann
CLIENT Financial Times Magazine
DESCRIPTION Illustration for book review.

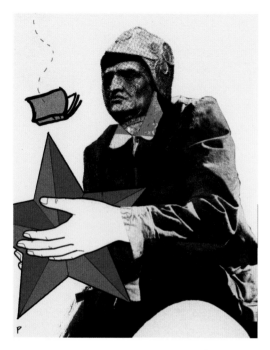

STUDIO / DESIGN FIRM Peter Hermann (Odense, Denmark)
WORK / YEAR Accused of being a pedophiliac / 2005
ARTIST Peter Hermann
ART DIRECTION, DESIGN Peter Hermann
ILLUSTRATION Peter Hermann
CLIENT BUPL
DESCRIPTION Editorial illustration.

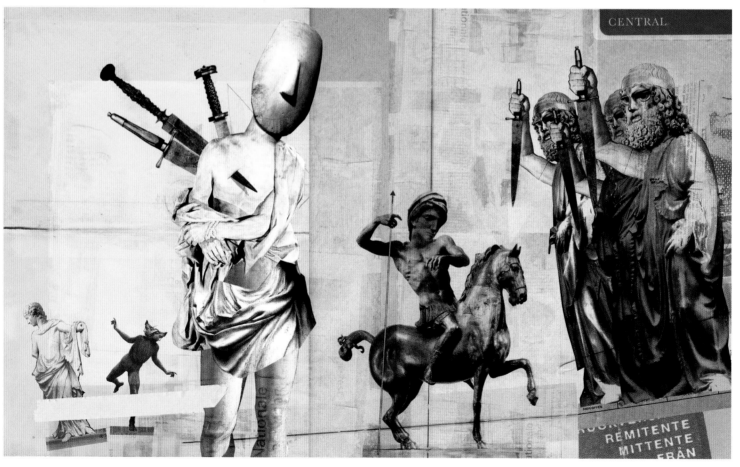

STUDIO / DESIGN FIRM vo6 (Rio de Janeiro, Brazil / Rotterdam, The Netherlands / Barcelona, Spain)
WORK / YEAR My dad / 2004
ARTIST Yomar Augusto
CREATIVE DIRECTION David Quiles / Marc Mascort
DESIGN Yomar Augusto
ILLUSTRATION Yomar Augusto
PHOTOGRAPHY Yomar Augusto
CLIENT Rojo Magazine / Indian Jeans
DESCRIPTION Illustration for Fashion Brand.

STUDIO / DESIGN FIRM / ARTIST SFaustina (Oakland, USA)
WORK / YEAR Mixed Media Collage / 2004
CLIENT Personal
PHOTOGRAPHY Unknown

STUDIO / DESIGN FIRM Niko Stumpo / The Hanazuki Company
 (Amsterdam, The Netherlands)
WORK / YEAR Print Work for AiKO / 2004
CREATIVE DIRECTION Niko Stumpo
ART DIRECTION, DESIGN Niko Stumpo
DESCRIPTION Print work for t-shirts, magazines and books.

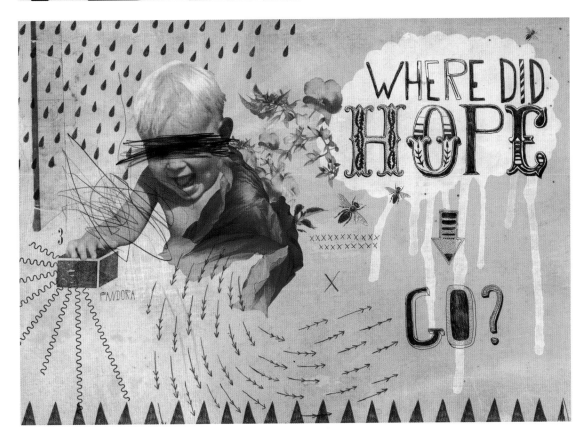

STUDIO / DESIGN FIRM / ARTIST Eduardo Recife / Misprinted Type (Belo Horizonte, Brazil)
WORK / YEAR Misprinted Type 3 / 2005
CREATIVE DIRECTION Eduardo Recife
ART DIRECTION, DESIGN Eduardo Recife
ILLUSTRATION Eduardo Recife
DESCRIPTION Personal Project.

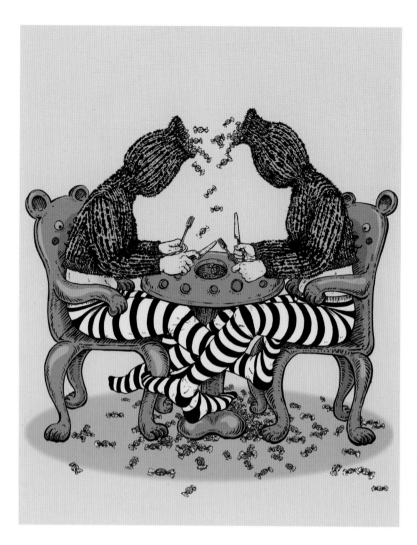

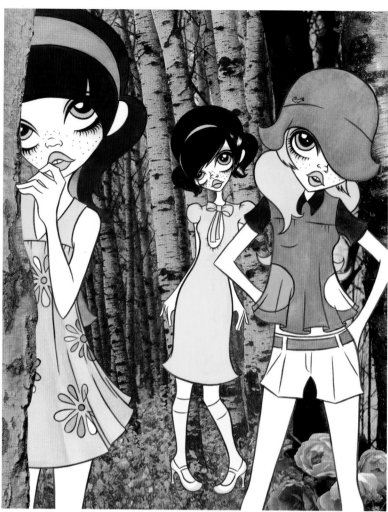

STUDIO / DESIGN FIRM Fawn Gehweiler / No Candy (Los Angeles, USA)
WORK / YEAR "Garden Party" / 2005
ARTIST Fawn Gehweiler
DESCRIPTION Fashion story for Anthem magazine, Los Angeles
EDITORIAL DETAILS Millie wears dress by Alexandre Herchcovitch,
scarf by Hermes.
Lucy wears dress by Kitkitdodge, socks by
Miss Dater, shoes by Marc Jacobs.
Anne-Marie wears hat and shorts by Lacoste,
shirt by Alexandre.
Herchcovitch all wear golden tangerine
eyeshadow by Benefit.

STUDIO / DESIGN FIRM Yuko Shimizu (New York, USA)
WORK / YEAR Candy fight / 2003
ARTIST Yuko Shimizu
ILLUSTRATION Yuko Shimizu
CLIENT Personal piece.

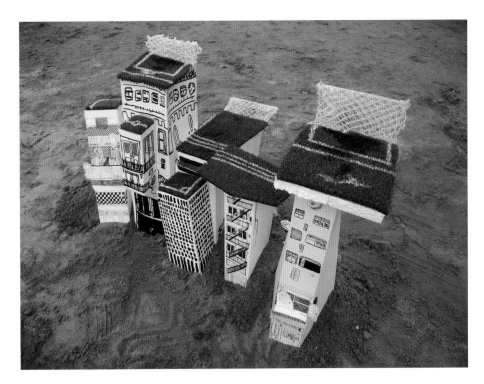

STUDIO / DESIGN FIRM No-Domain (Barcelona, Spain)
WORK / YEAR Autogoal / 2005
ARTIST No-Domain
CREATIVE DIRECTION No-Domain
ART DIRECTION No-Domain
CLIENT Rojo / Adidas
DESCRIPTION Artwork.

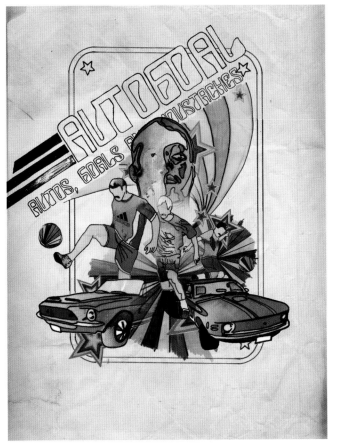

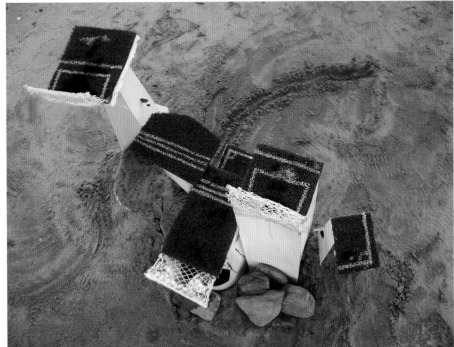

STUDIO / DESIGN FIRM Neasden Control Centre (Manchester, UK)
WORK / YEAR "Love Football" / 2005
ARTIST Steve Smith
PHOTO Anna Fernandez De Paco (www.carredelsgats.com)
CLIENT Adidas illustration commissioned through Rojo Magazine
in Barcelona for a "Love Football" campaign.

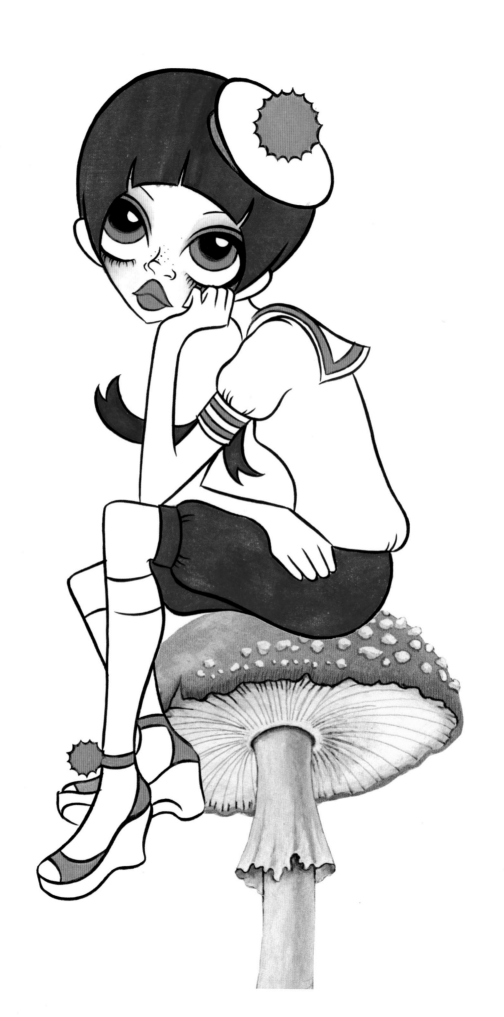

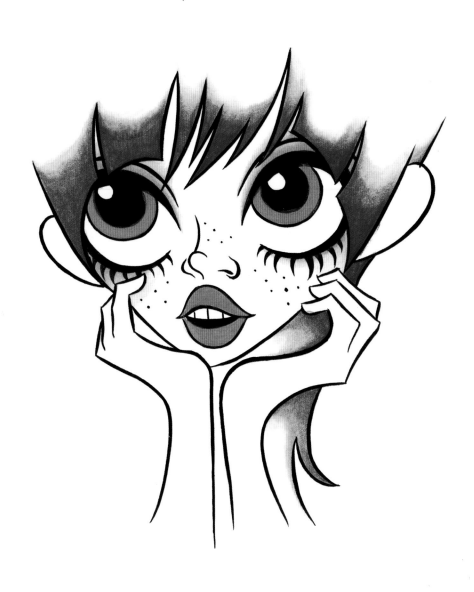

STUDIO / DESIGN FIRM Fawn Gehweiler / No Candy (Los Angeles, USA)
WORK / YEAR (P 158) "Biba Baby" / 2004
WORK / YEAR (This Page) "Shelley Duvall" / 2004
ARTIST Fawn Gehweiler
DESCRIPTION Personal works, watercolor and collage.

STUDIO / DESIGN FIRM / ARTIST Institut Drahomira / Julien Pacaud (Paris, France)
WORK / YEAR Néons Blancs et Asphaltine / 2004
ARTIST Julien Pacaud
ART DIRECTION. DESIGN Julien Pacaud
CLIENT Bizarrre-K7 (label), Arman Mélies (musician)
DESCRIPTION CD Packaging.

STUDIO / DESIGN FIRM Antigirl (Phoenix, Arizona USA)
WORK / YEAR My give way
ARTIST Tiphanie Boroke
ART DIRECTION Arik B.
CLIENT Personal / Fine Art
DESCRIPTION Mixed Media Collage

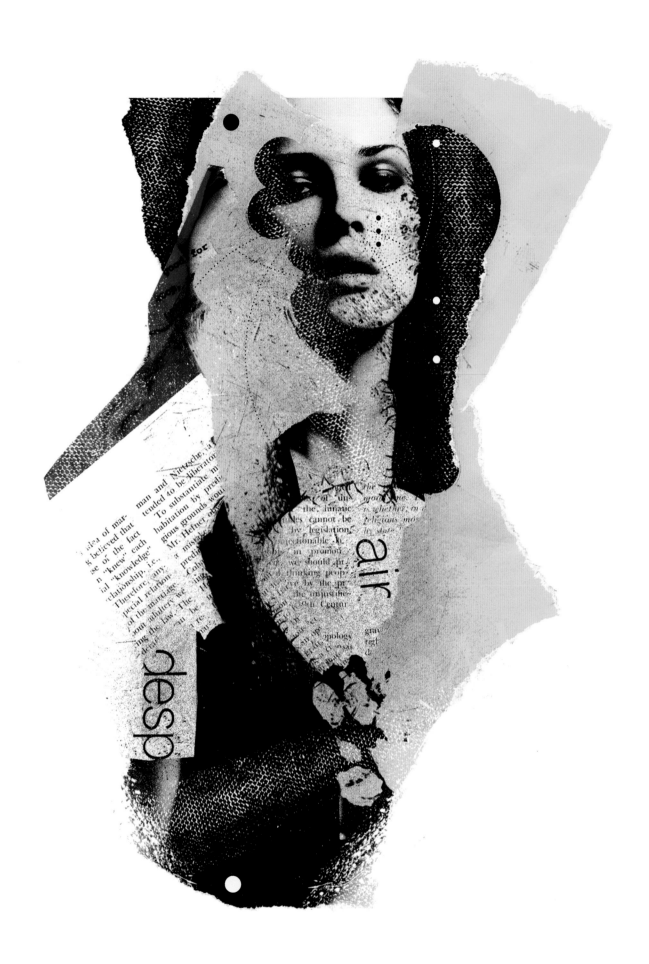

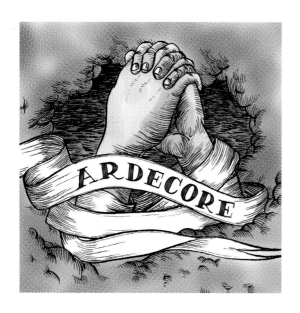

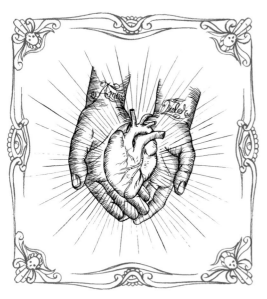

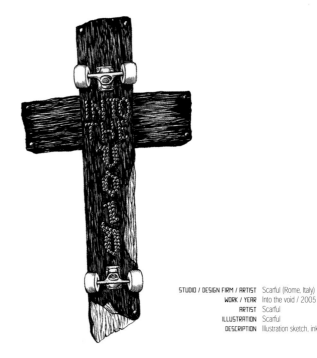

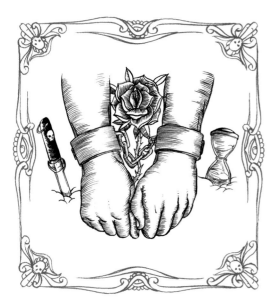

STUDIO / DESIGN FIRM / ARTIST Scarful (Rome, Italy)
WORK / YEAR Into the void / 2005
ARTIST Scarful
ILLUSTRATION Scarful
DESCRIPTION Illustration sketch, ink on paper, 21x30cm.

STUDIO / DESIGN FIRM / ARTIST Scarful (Rome, Italy)
WORK / YEAR Ardecore digipack cover / 2005
WORK / YEAR "L'eco der core'", booklet illustration / 2005
WORK / YEAR "Come te posso ama'", booklet illustration / 2005
WORK / YEAR "Lupo de fiume'", booklet illustration / 2005
ARTIST Scarful
ART DIRECTION, DESIGN Scarful
ILLUSTRATION Scarful
CLIENT Il Manifesto CD, Rome.
DESCRIPTION CD packaging, illustrations.

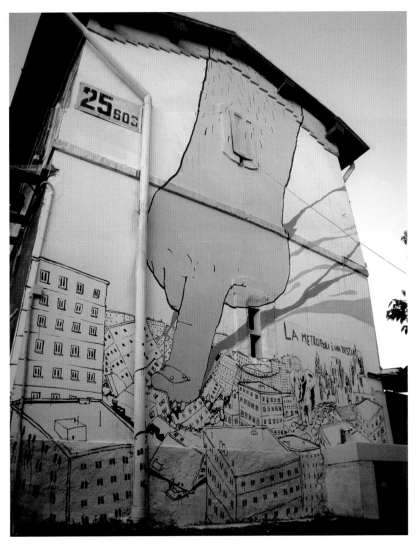

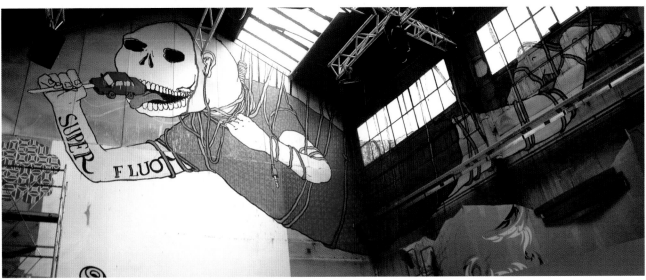

STUDIO / DESIGN FIRM / ARTIST blu (Bologna, Italy)
WORK / YEAR no title / 2005
DESCRIPTION Wall paintings (murals).

P. 164

STUDIO / DESIGN FIRM Yuko Shimizu (New York, USA)
WORK / YEAR Second Wind / 2004
ARTIST Yuko Shimizu
ILLUSTRATION Yuko Shimizu
ART DIRECTION SooJin Buzelli
CLIENT Global Custodian Magazine (USA)
DESCRIPTION For article on mutual fund scandal.

STUDIO / DESIGN FIRM Yuko Shimizu (New York, USA)
WORK / YEAR Portrait of Bjork / 2005
ARTIST Yuko Shimizu
ILLUSTRATION Yuko Shimizu
ART DIRECTION, DESIGN Kaz Iwai
CLIENT New York Walker Magazine (USA)
DESCRIPTION Portrait of Bjork created for magazine cover.

Top
STUDIO / DESIGN FIRM Fawn Gehweiler / No Candy (Los Angeles, USA)
WORK / YEAR "Garden Party" / 2005
ARTIST Fawn Gehweiler
DESCRIPTION Fashion story for Anthem magazine, Los Angeles
EDITORIAL DETAILS Marie A. wears shirt, tie and skirt by
Alexander McQueen, socks by Miss
Dater, shoes by D-Havz.
Marie B. wears shirt, tie, skirt and jacket
by Alexander McQueen, socks by Miss
Dater, shoes by D-Havz, croquet set
by Jacques America.
Both wear electric blue metallic eyecolor
by Anna Sui.

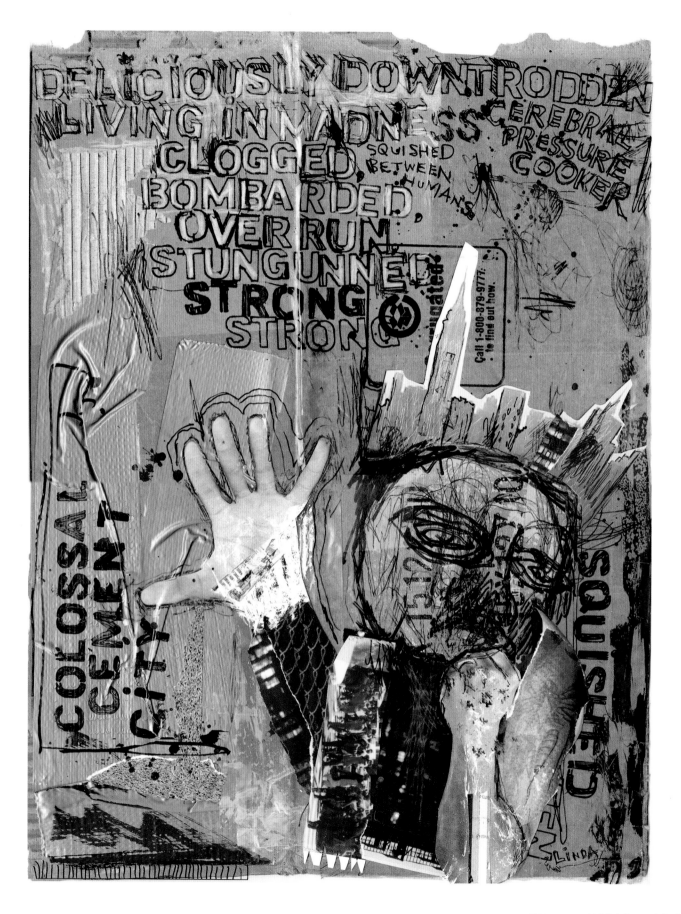

STUDIO / DESIGN FIRM LindA Zacks, Extra-oomph (New York, USA)
WORK / YEAR Colossal Cement City / 2004
ARTIST LindA Zacks
CLIENT Beautiful/Decay Magazine
DESCRIPTION Mixed-Up Media. Interpretation of the theme "New York City".

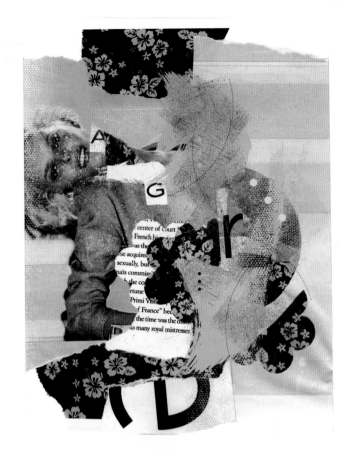

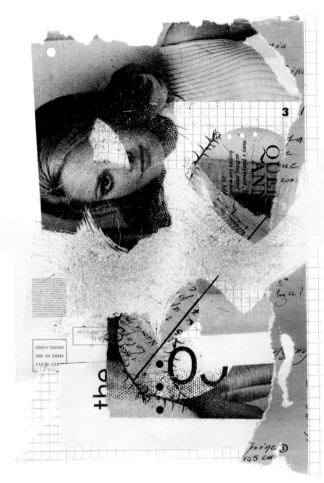

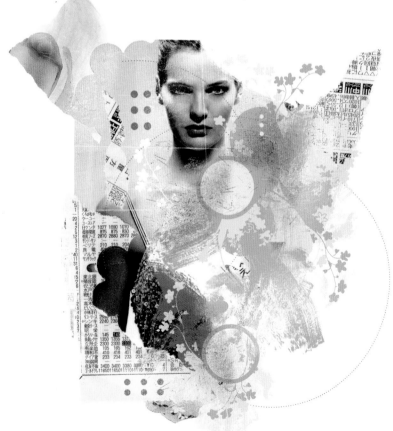

STUDIO / DESIGN FIRM Antigirl (Phoenix, Arizona USA)
WORK / YEAR (Top Left) Fine Form / 2004
WORK / YEAR (Top Right) Recoil Grace / 2004
WORK / YEAR (Left) Road Rage / 2005
ARTIST Tiphanie Boroke
ART DIRECTION Arik B.
CLIENT Personal / Fine Art
DESCRIPTION Mixed Media Collages.

STUDIO / DESIGN FIRM / ARTIST Kev Speck (London, UK)
WORK / YEAR Clarabella / 2005
ART DIRECTION, DESIGN Kev Speck
ILLUSTRATION Kev Speck
DESCRIPTION Illustration.

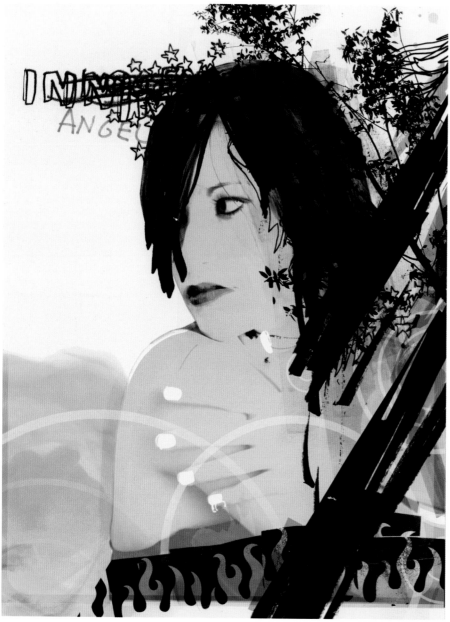

STUDIO / DESIGN FIRM Neuarmy (Philadelphia, USA)
ARTIST Ryan Katrina
WORK / YEAR "Untitled" / 2005
CREATIVE / ART DIRECTION Ryan Katrina
DESIGN / ILLUSTRATION Ryan Katrina
CLIENT Andrea Lugli / Handmade
DESCRIPTION Print/Mixed media.

STUDIO / DESIGN FIRM Neuarmy (Philadelphia, USA)
ARTIST Ryan Katrina
WORK / YEAR "Untitled" / 2005
CREATIVE / ART DIRECTION Ryan Katrina
DESIGN / ILLUSTRATION Ryan Katrina
CLIENT Andrea Lugli / Handmade
DESCRIPTION Print/Mixed media.

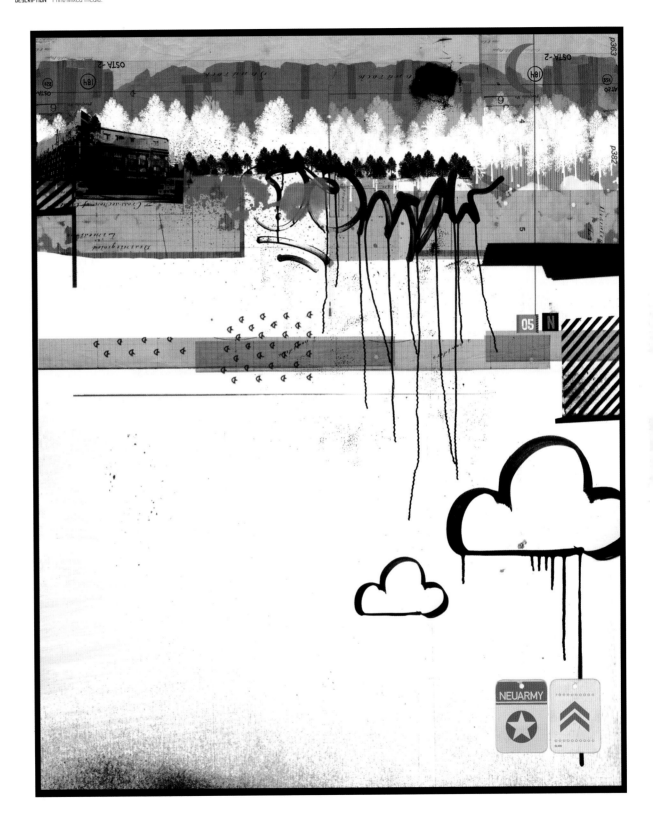

ARTISTS David Shields and Mark Todd (San Marcos, USA)
WORK / YEAR Ashe Motors / 2001
ART DIRECTION David Shields and Mark Todd
DESIGN David Shields and Mark Todd
WRITING Mark Todd
DESCRIPTION Artists book, published in 500 copies.

STUDIO / DESIGN FIRM Sagmeister Inc. (New York, USA)
WORK / YEAR Punctuation Poster / 2004
ART DIRECTION Stefan Sagmeister
DESIGN Matthias Ernstberger
ILLUSTRATION Matthias Ernstberger
CLIENT Neenah Paper
DESCRIPTION A paper company commissioned
a number of New York designers
to design a poster using one single
punctuation symbol, in our case
the apostrophe.
Our apostrophe is in the letter
elimination business.

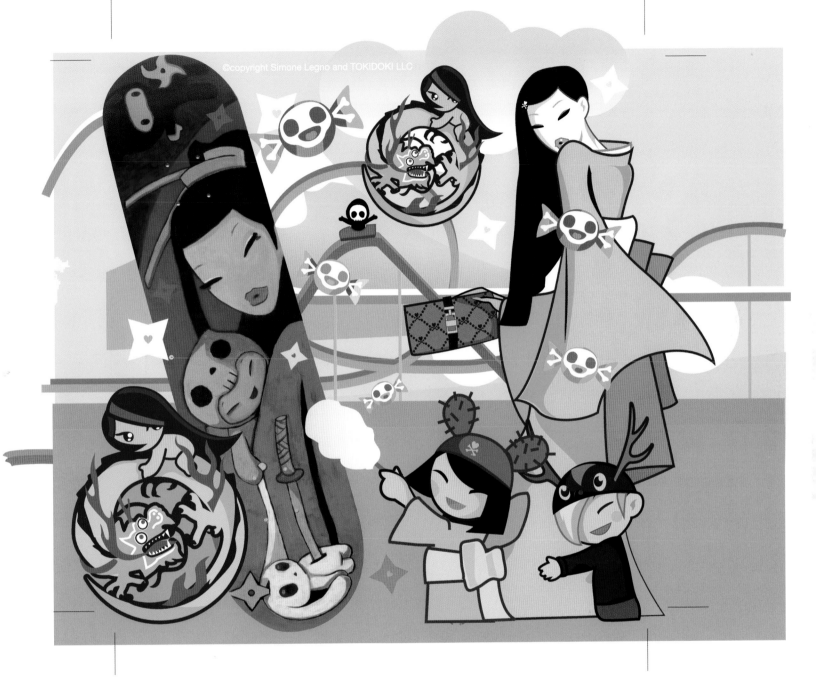

©copyright Simone Legno and TOKIDOKI LLC

STUDIO / DESIGN FIRM TOKIDOKI LLC (Los Angeles, USA)
WORK / YEAR Lunapark fujisan / 2004
ARTIST Simone Legno
ILLUSTRATION Simone Legno

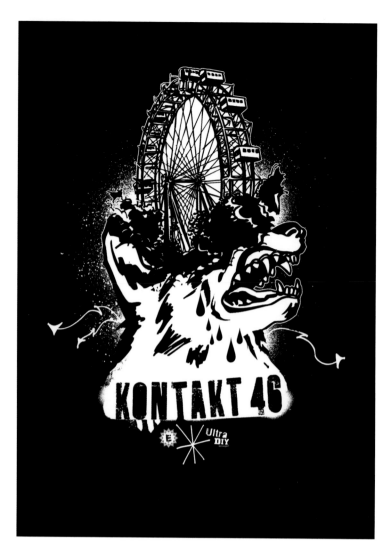

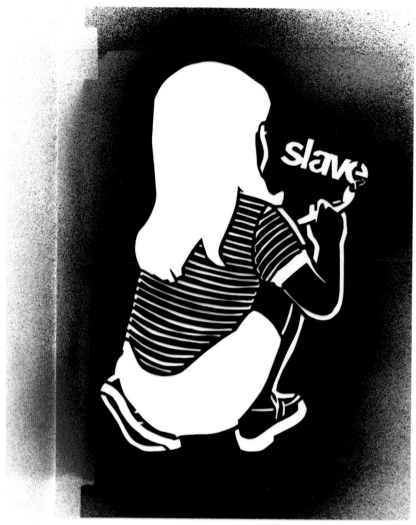

STUDIO / DESIGN FIRM Disturbanity (Dortmund, Germany)
WORK / YEAR K46 Violent Entertainment / 2005
ARTIST Matthias Gephart
TECHNIQUES Vector collage, drawing, spraypaint, screenprint.
DESCRIPTION Illustration t-shirt motiv for punk/hc band, Kontakt46.

STUDIO / DESIGN FIRM Viagrafik (Wiesbaden, Germany)
WORK / YEAR Slavegirl / 2003
ARTIST mnwrks/slave, André Nossek
CREATIVE DIRECTION mnwrks/slave, André Nossek
ART DIRECTION mnwrks/slave, André Nossek
PHOTO André Nossek
CLIENT Self
DESCRIPTION Stencil.

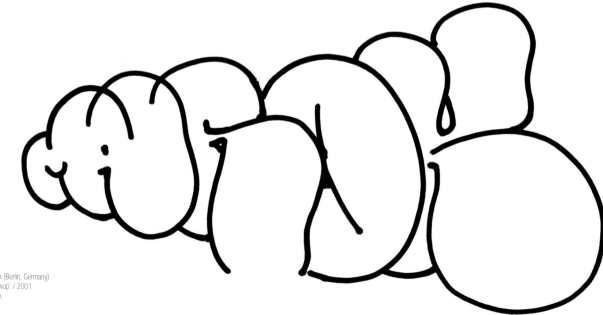

STUDIO / DESIGN FIRM / ARTIST Marok (Berlin, Germany)
WORK / YEAR 'Throwup' / 2001
ARTIST Marok

STUDIO / DESIGN FIRM Disturbanity (Dortmund, Germany)
WORK / YEAR Education Lost: the face of Ultra DIY / 2005
ARTIST Matthias Gephart
TECHNIQUES Mind distortion, photography, drawing,
scan and vectorrism.
DESCRIPTION Artwork for DIY-Label Education Lost.

STUDIO / DESIGN FIRM You Are Beautiful (London, UK)
WORK / YEAR Snickers/Nfl / 2004/5
ARTIST Kerry Roper
ART DIRECTION, COPY Aaron Adler / Ari Weiss / Steve McElligott / Kerry Roper
DESIGN Matt Even / Kerry Roper
CLIENT Snickers / BBDO NYC
DESCRIPTION Advertising

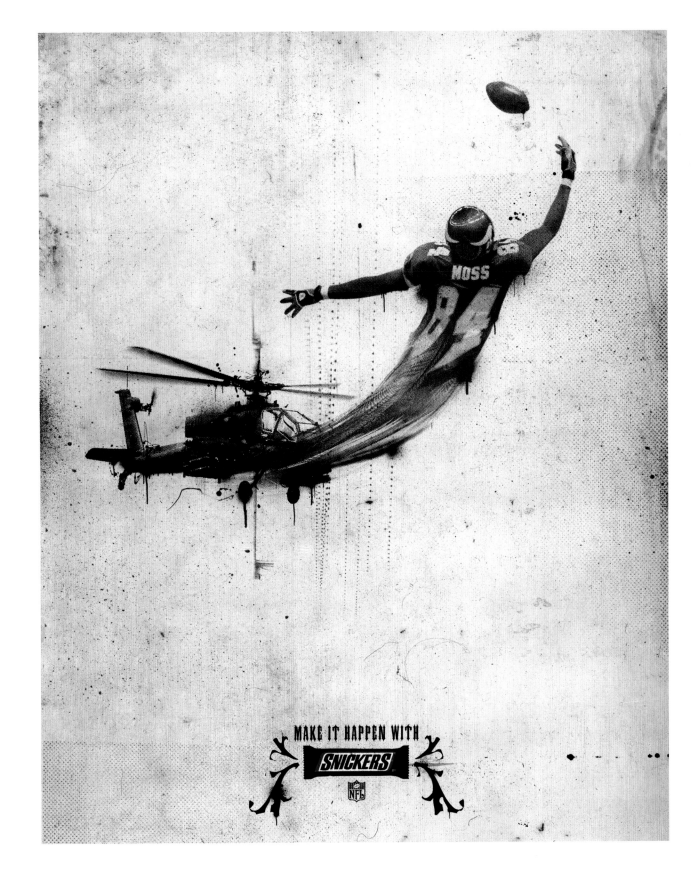

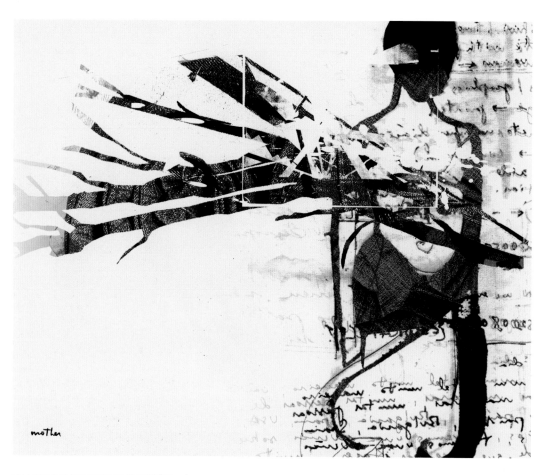

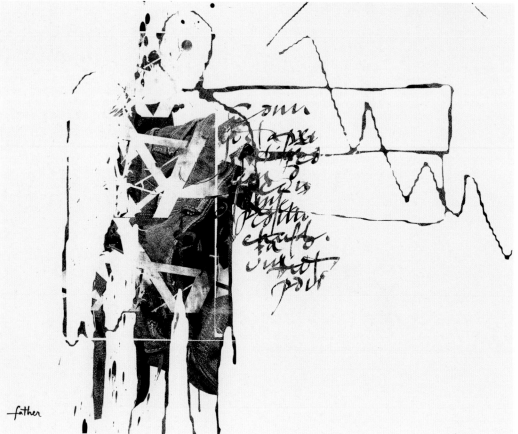

STUDIO / DESIGN FIRM vo6 (Rio de Janeiro, Brazil
/ Rotterdam, The Netherlands / Barcelona, Spain)
WORK / YEAR (Top - Bottom) Mother Jeans / 2004 - Father jeans / 2004
ARTIST Yomar Augusto
CREATIVE DIRECTION David Quiles / Marc Mascort
DESIGN Yomar Augusto
ILLUSTRATION Yomar Augusto
PHOTOGRAPHY Milena Valnarova
CLIENT Rojo Magazine / Indian Jeans
DESCRIPTION Illustration for Fashion Brand.

P. 177
STUDIO / DESIGN FIRM Yuko Shimizu (New York, USA)
WORK / YEAR Fujiyama Geisha Rio De Janeiro / 2004
ARTIST Yuko Shimizu
ILLUSTRATION Yuko Shimizu
CLIENT Self
DESCRIPTION A personal piece created for Design Is Kinky (Sydney,
Australia)'s Semi-Permanent Design conference.

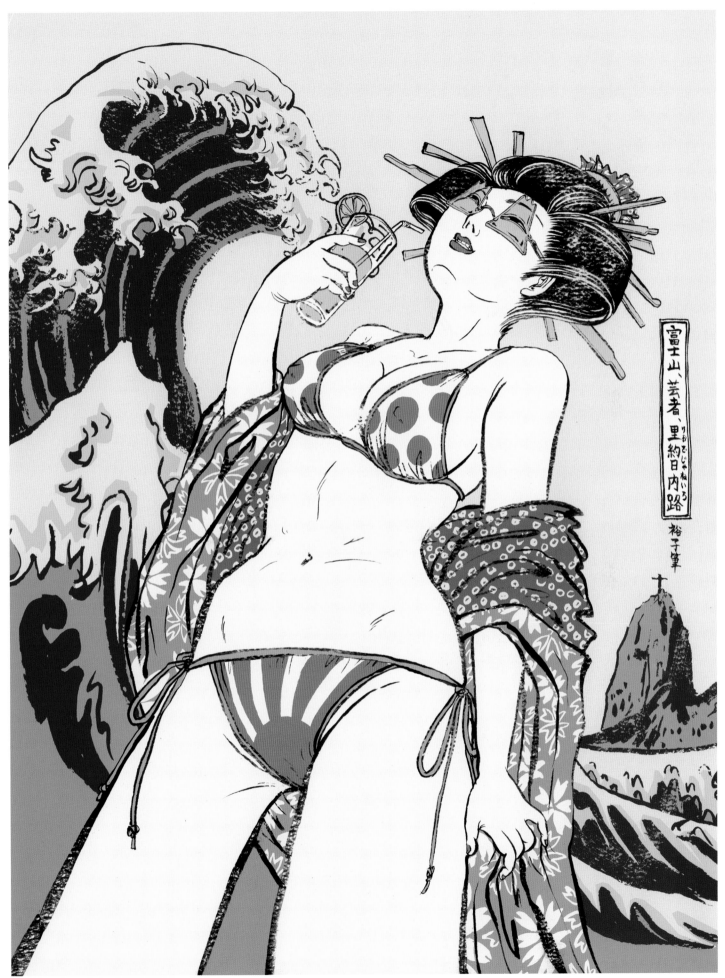

富士山、芸者、里約日内路
りおでじゃねいろ
裕子筆

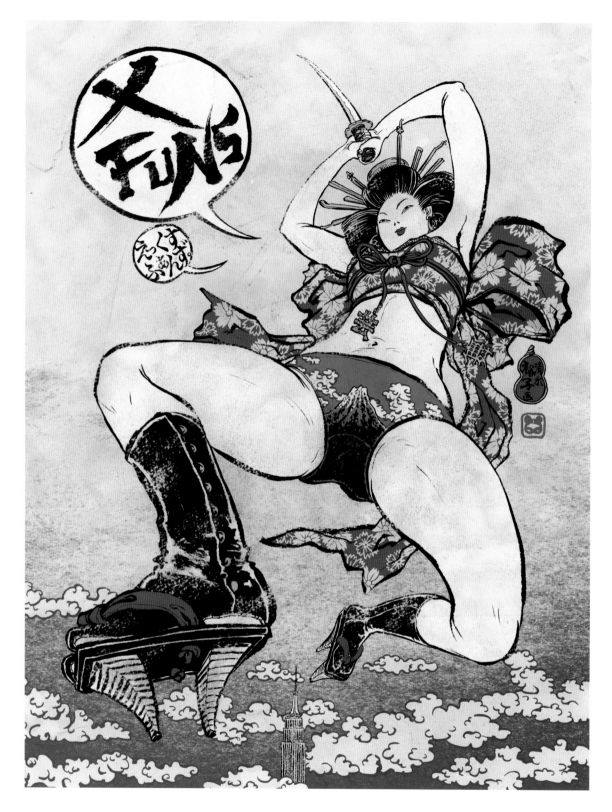

STUDIO / DESIGN FIRM Yuko Shimizu (New York, USA)
WORK / YEAR Revenge of the Geisha Girl / 2005
ARTIST Yuko Shimizu
ILLUSTRATION Yuko Shimizu
CLIENT X FUNS (Taiwan)
DESCRIPTION A personal piece created to be a cover of a design magazine.

STUDIO / DESIGN FIRM You Are Beautiful (London, UK)
WORK / YEAR Beautiful America / 2005
ARTIST Kerry Roper
ART DIRECTION, COPY Kerry Roper
DESIGN Kerry Roper
CLIENT Adrenalin magazine
DESCRIPTION Editorial illustration, cover concept.

STUDIO / DESIGN FIRM You Are Beautiful (London, UK)
WORK / YEAR I Love Cake / 2004 - Yum Yum / 2005
ARTIST Kerry Roper
ART DIRECTION, COPY Kerry Roper
DESIGN Kerry Roper
CLIENT The Big Issue magazine
DESCRIPTION Editorial illustrations.

adre-nalin

adrenalin
023

adre-nalin

adrenalin
023

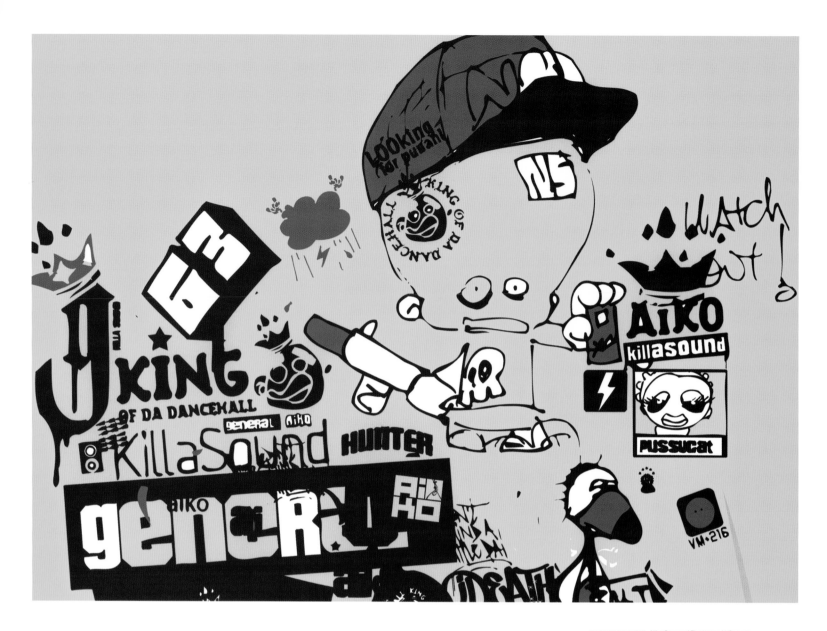

STUDIO / DESIGN FIRM Niko Stumpo / The Hanazuki Company
(Amsterdam, The Netherlands)
WORK / YEAR Print Work for AiKO / 2004
CREATIVE DIRECTION Niko Stumpo
ART DIRECTION, DESIGN Niko Stumpo
DESCRIPTION Print work for t-shirts, magazines and books.

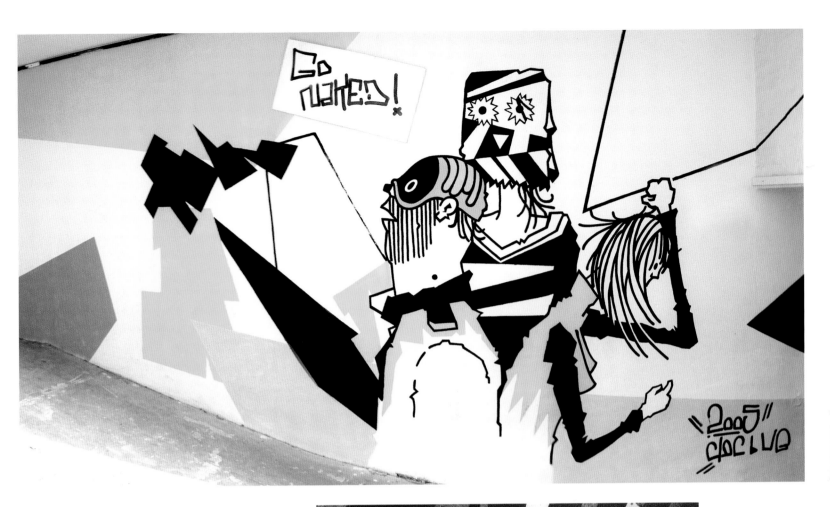

STUDIO / DESIGN FIRM Viagrafik (Wiesbaden, Germany)
WORK / YEAR Kill Boredom / 2005
ARTIST bstrkt/boe, Leo Volland
CREATIVE DIRECTION bstrkt/boe, Leo Volland
ART DIRECTION bstrkt/boe, Leo Volland
PHOTO André Nossek
CLIENT Superkronik Club
DESCRIPTION Wall painting.

STUDIO / DESIGN FIRM Disturbanity (Dortmund, Germany)
WORK / YEAR Kore Disketch / 2005
ARTIST Matthias Gephart
TECHNIQUES Adult fun in disorder, spraypaint + copy collage
on paper, intense crewname tagging, scan.
DESCRIPTION Free illustration, overworked sketchbook piece,
disturbo poster artwork.

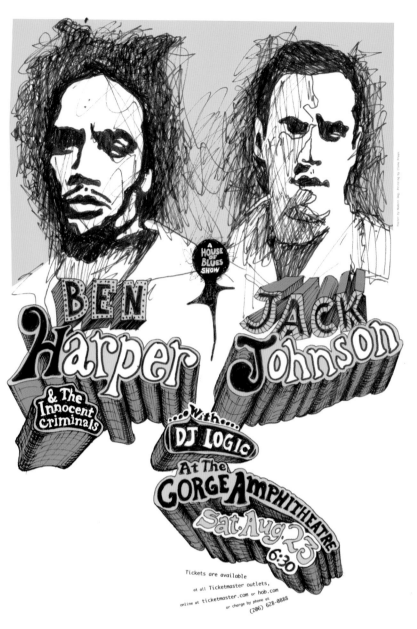

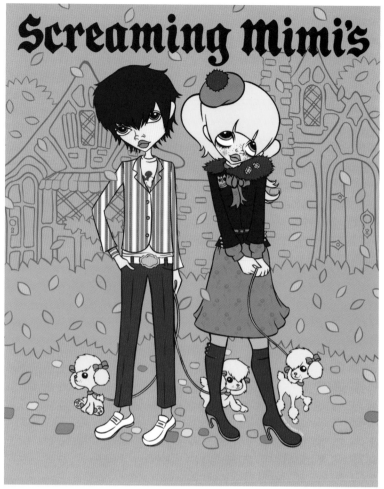

STUDIO / DESIGN FIRM Fawn Gehweiler / No Candy (Los Angeles, USA)
YEAR 2004
ARTIST Fawn Gehweiler
DESCRIPTION Fall Ad campaign for Screaming Mimi's Boutique, NYC and Tokyo.

STUDIO / DESIGN FIRM Modern Dog Design Co. (Seattle, USA)
WORK / YEAR Illustration / 2005
ART DIRECTION Michael Strassburger
DESIGN Michael Strassburger
ILLUSTRATION Michael Strassburger
CLIENT House of Blues

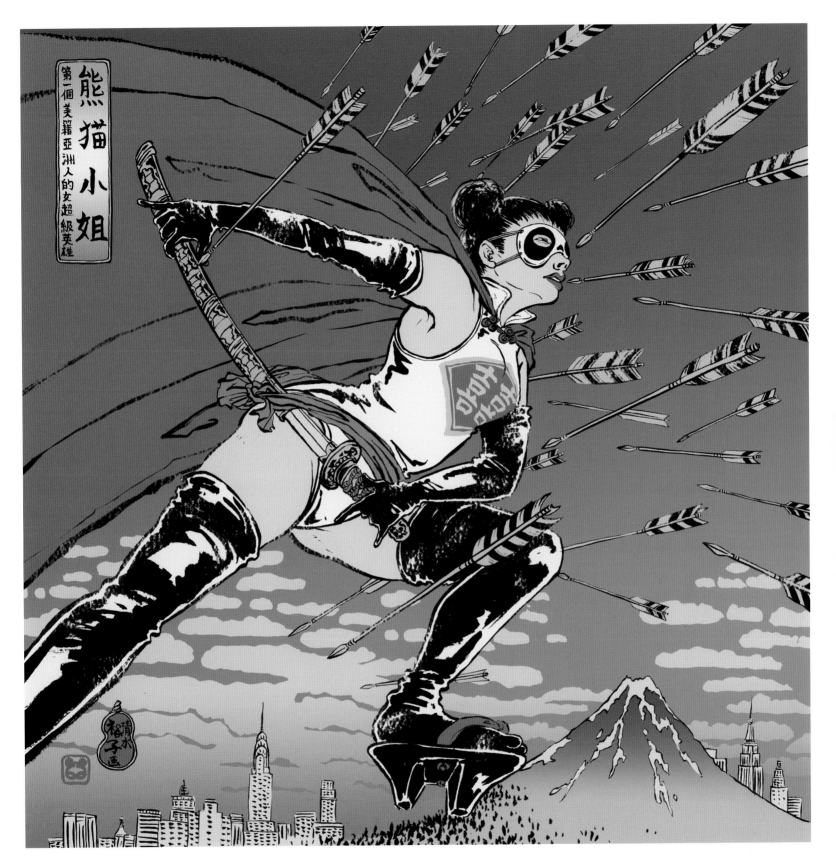

STUDIO / DESIGN FIRM Yuko Shimizu (New York, USA)
WORK / YEAR Panda Girl, the First Asian-American Superheroine / 2005
ARTIST Yuko Shimizu
ILLUSTRATION Yuko Shimizu
ART DIRECTION Mark Murphy
DESCRIPTION Personal piece created for "Artistic Utopia" artist calendar book 2005
designed by Murphy Design, Berkley, CA USA.

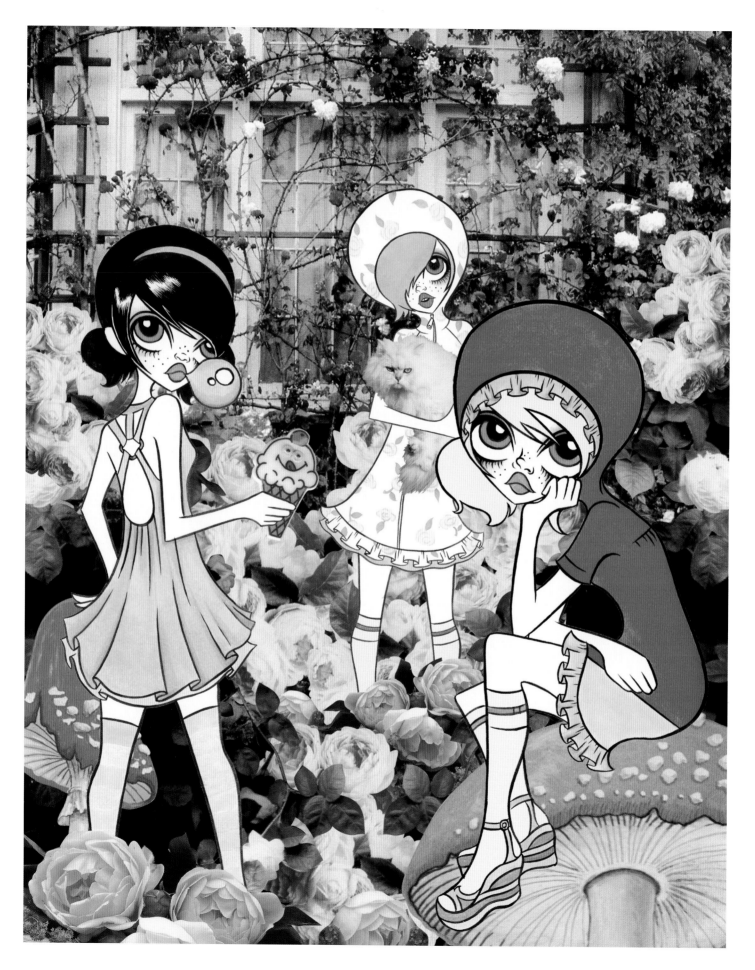

P. 184

STUDIO / DESIGN FIRM Fawn Gehweiler / No Candy (Los Angeles, USA)
WORK / YEAR "Garden Party" / 2005
ARTIST Fawn Gehweiler
DESCRIPTION Fashion story for Anthem magazine, Los Angeles
EDITORIAL DETAILS Zoe wears dress by Alexandre Herchcovitch,
rugby socks by Dosty.
Pippa wears dress by Alexandre Herchcovitch,
socks and sock garters by Miss Dater.
Anastasia wears dress by Alexandre
Herchcovitch, socks and garters by Miss Dater,
shoes by Terry De Havilland.
All wear pixie eyeshadow quartet by Hard Candy.

STUDIO / DESIGN FIRM You Are Beautiful (London, UK)
WORK / YEAR 2004 Native Weapon Exhibition / 2004
ARTIST Kerry Roper
ART DIRECTION, COPY Kerry Roper
DESIGN Kerry Roper
CLIENT Adrenalin magazine
DESCRIPTION Exhibition.

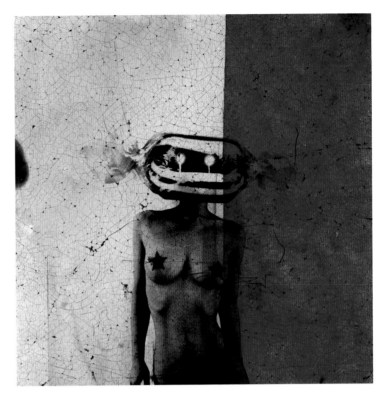

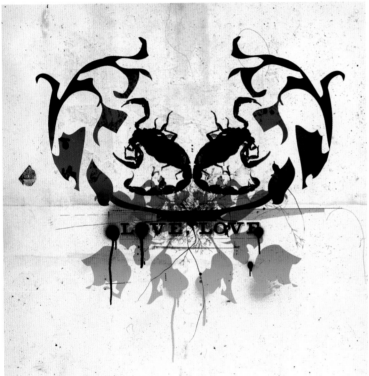

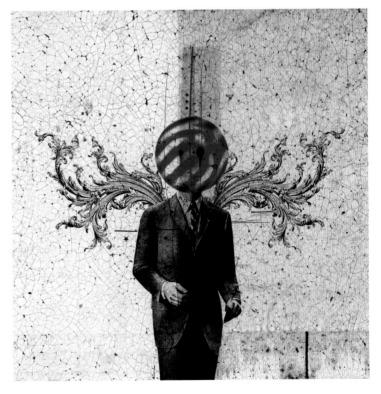

STUDIO / DESIGN FIRM You Are Beautiful (London, UK)
WORK / YEAR A girl called candy / 2005
ARTIST Kerry Roper
ART DIRECTION, COPY Kerry Roper
DESIGN Kerry Roper
CLIENT You Are Beautiful
DESCRIPTION Exhibition.

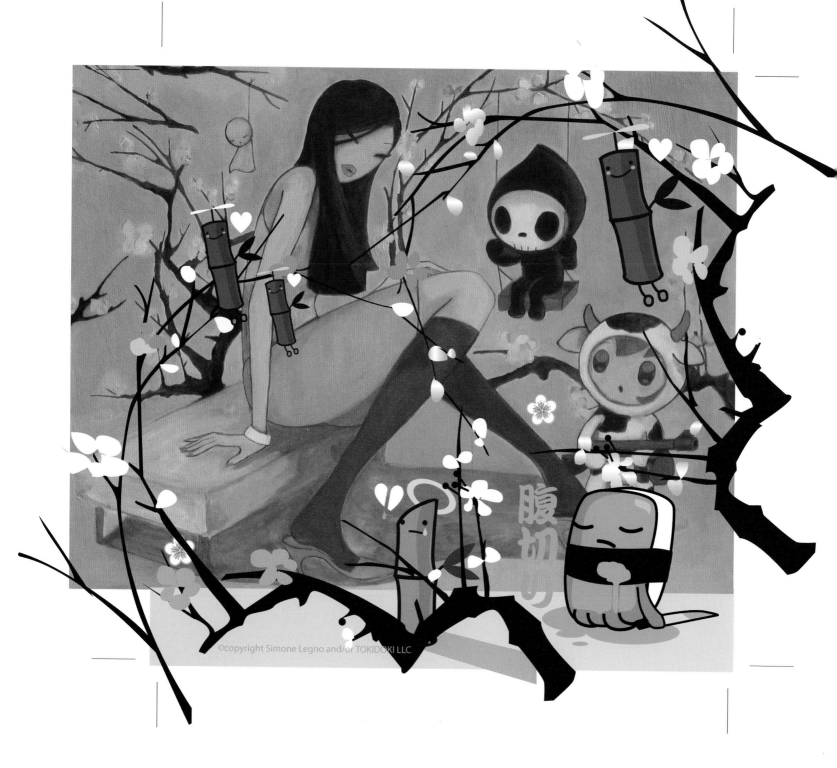

©copyright Simone Legno and/or TOKIDOKI LLC

STUDIO / DESIGN FIRM TOKIDOKI LLC (Los Angeles, USA)
WORK / YEAR Secret meeting / 2004
ARTIST Simone Legno
ILLUSTRATION Simone Legno

STUDIO / DESIGN FIRM Vault49 (New York, USA)
WORK / YEAR Renaissance: Mix Collection / 2004
ART DIRECTION, DESIGN Vault49
CLIENT Renaissance
DESCRIPTION CD Packaging.

STUDIO / DESIGN FIRM Vault49 (New York, USA)
WORK / YEAR Renaissance: Mix Collection / 2004
ART DIRECTION, DESIGN Vault49
CLIENT Renaissance
DESCRIPTION CD Packaging.

STUDIO / DESIGN FIRM Automatic Art and Design (New York, USA)
WORK / YEAR Illustration / 2004
ARTIST Charles Wilkin
ART DIRECTION Paul Meany
DESIGN / ILLUSTRATION Charles Wilkin
CLIENT Vogue Australia
DESCRIPTION Editorial Illustration.

STUDIO / DESIGN FIRM Mike Giant (Albuquerque, NM USA)
WORK / YEAR Passive Moles / 2005
ARTIST Mike Giant
CLIENT Upper Playground
DESCRIPTION Illustration for t-shirt.

STUDIO / DESIGN FIRM Mike Giant (Albuquerque, NM USA)
WORK / YEAR Annabel Lee / 2004
ARTIST Mike Giant
CLIENT Rebel8
DESCRIPTION Illustration for t-shirt.

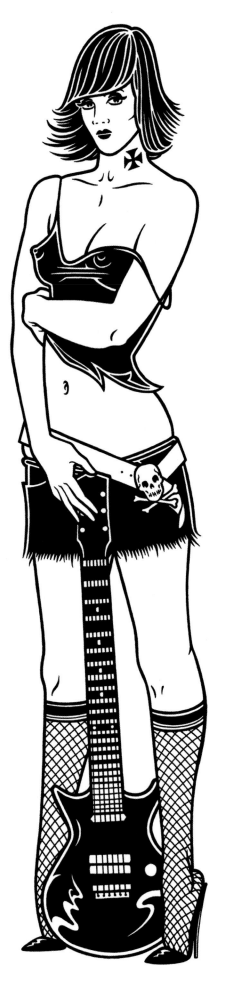

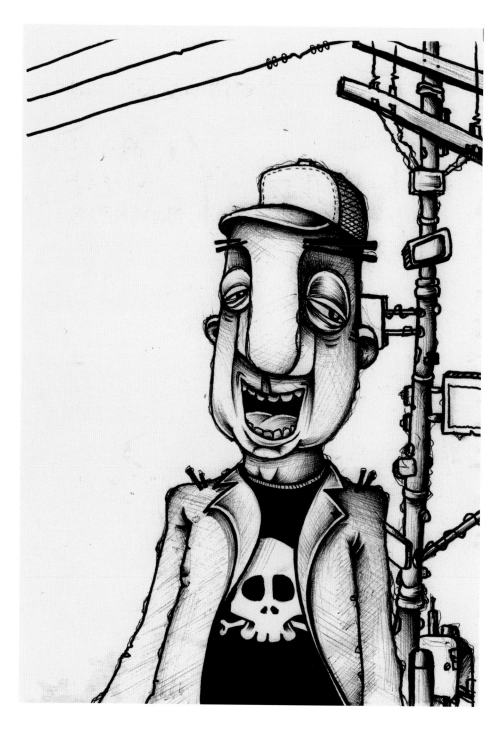

STUDIO / DESIGN FIRM Seacreative (Varese, Italy)
WORK / YEAR Sketch on paper / 2005
ARTIST Seacreative
ILLUSTRATION Seacreative

Left
STUDIO / DESIGN FIRM Mike Giant (Albuquerque, NM USA)
WORK / YEAR Rocker Girl / 2004
ARTIST Mike Giant
CLIENT Rebel8
DESCRIPTION Illustration for t-shirt.

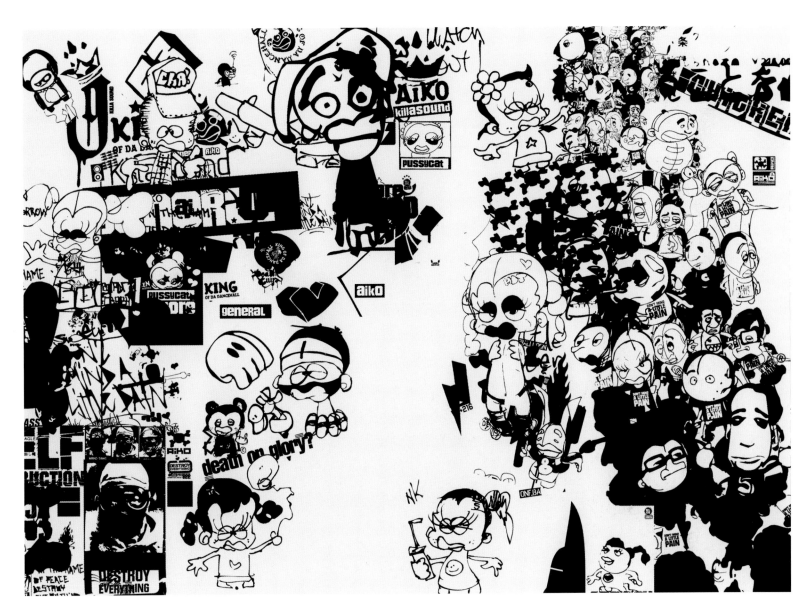

STUDIO / DESIGN FIRM Niko Stumpo / The Hanazuki Company
(Amsterdam, The Netherlands)
WORK / YEAR Print Work for AiKO / 2004
CREATIVE DIRECTION Niko Stumpo
ART DIRECTION. DESIGN Niko Stumpo
DESCRIPTION Print work for t-shirts, magazines and books.

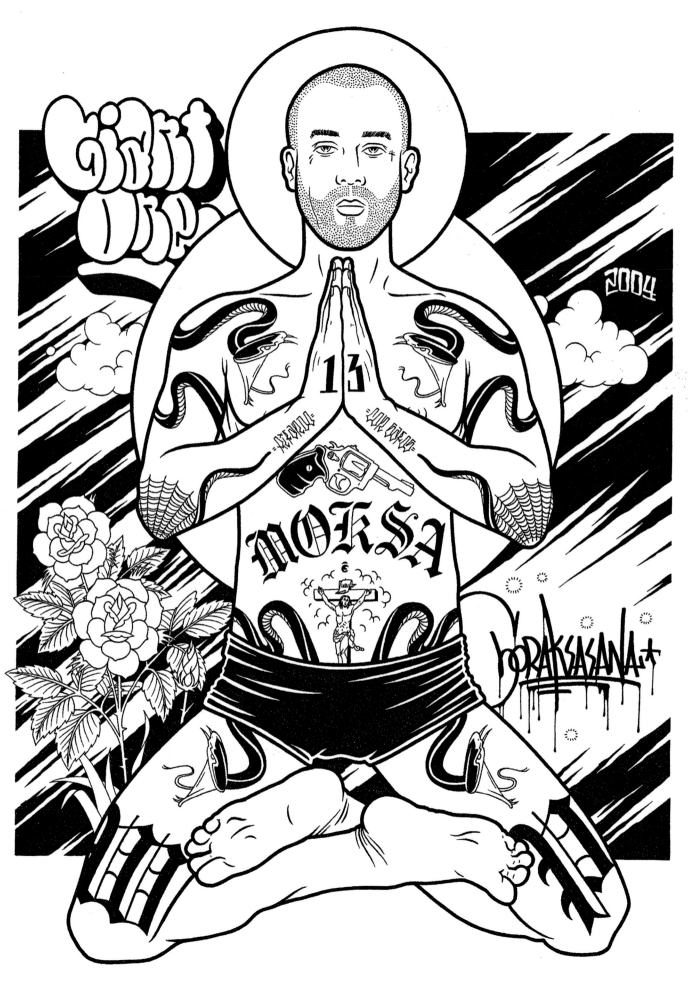

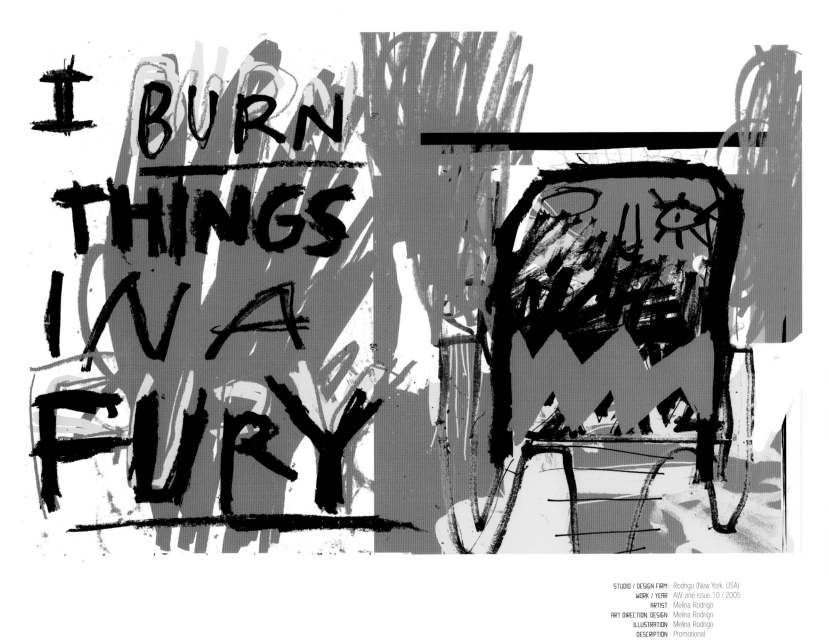

STUDIO / DESIGN FIRM Rodrigo (New York, USA)
WORK / YEAR AW zine issue 10 / 2005
ARTIST Melina Rodrigo
ART DIRECTION, DESIGN Melina Rodrigo
ILLUSTRATION Melina Rodrigo
DESCRIPTION Promotional.

STUDIO / DESIGN FIRM Mike Giant (Albuquerque, NM USA)
WORK / YEAR Moksa – from the Kundalini series / 2004
ARTIST Mike Giant
CLIENT Personal work
DESCRIPTION Illustration for gallery show.

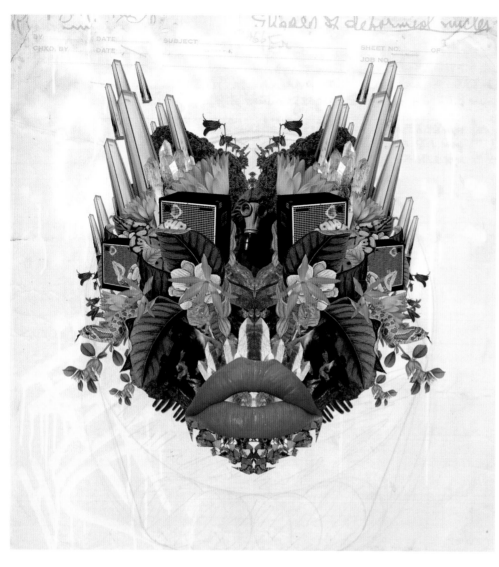

STUDIO / DESIGN FIRM Insect (London, UK)
WORK / YEAR Mish Mash London 2004 / 2004
ARTIST Paul Insect
CREATIVE DIRECTION Paul Insect
ART DIRECTION. DESIGN. ILLUSTRATION Paul Insect
CLIENT Mish Mash Clubs
DESCRIPTION Illustration for Mish Mash Club, Cargo London.

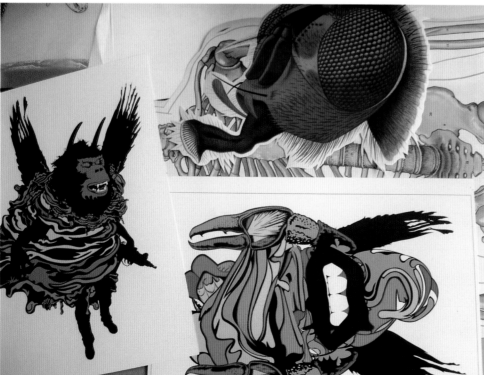

P. 197.
STUDIO / DESIGN FIRM Insect (London, UK)
WORK / YEAR Grafuckingsect / 2005
ARTIST Paul Insect
CREATIVE DIRECTION Paul Insect
ART DIRECTION. DESIGN. ILLUSTRATION Paul Insect
CLIENT Peter Vattanatham / www.grafuck.com
DESCRIPTION Illustration for Grafuck book.

STUDIO / DESIGN FIRM Insect (London, UK)
WORK / YEAR Lipwires, Ltd edition prints / 2005
ARTIST Paul Insect / Luke Insect
CREATIVE DIRECTION Paul Insect / Luke Insect
ART DIRECTION. DESIGN. ILLUSTRATION Paul Insect / Luke Insect
CLIENT The Outside Institute London / POW
DESCRIPTION Personal / ltd Screenprint.

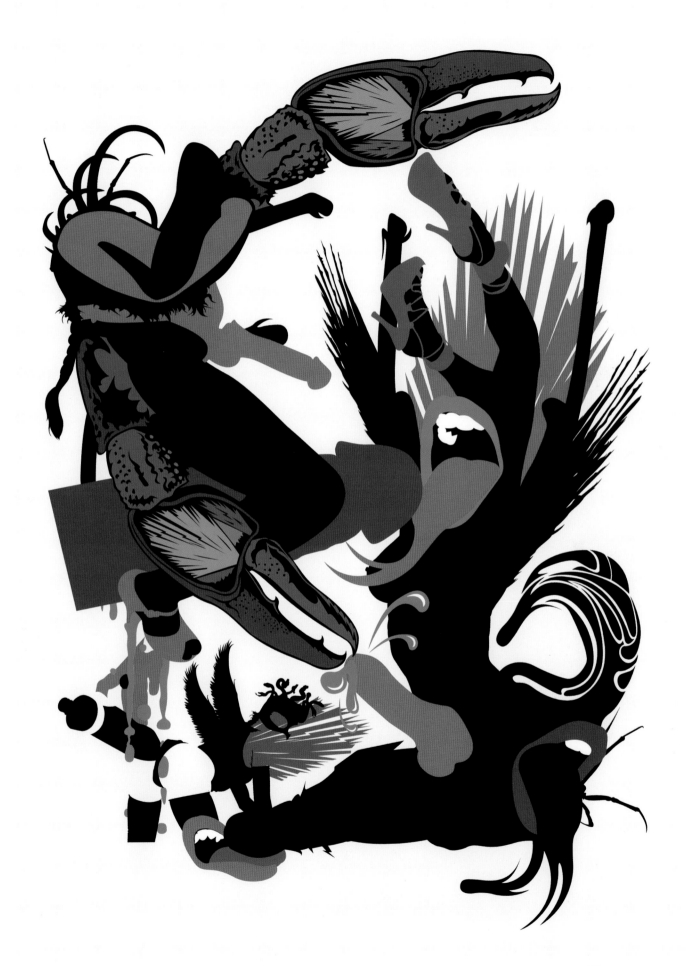

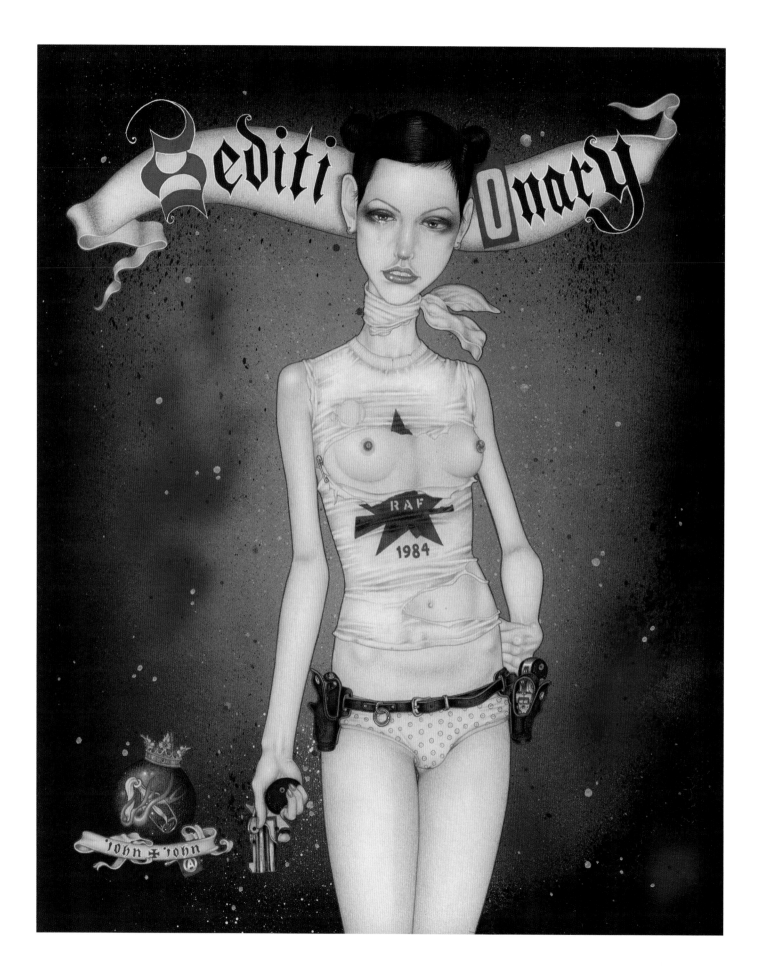

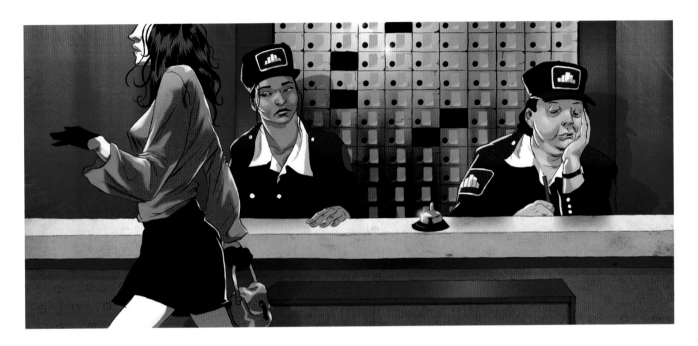

STUDIO / DESIGN FIRM Tomer Hanuka (London, UK)
WORK / YEAR The Franklin Abraham / 2004
ILLUSTRATOR Tomer Hanuka
ART DIRECTOR Gibb Slife
DESCRIPTION Editorial illustration for the New Yorker Magazine about
the movie The Franklin Abraham.

STUDIO / DESIGN FIRM John John Jesse (New York, USA)
WORK / YEAR Seditionary / 2004
DESCRIPTION 16" x 20" Graphite, Color Pencils, Color Inks, Gouache,
Enamels, India Ink on Board.
© John John Jesse, photo courtesy, ArtatLarge.com

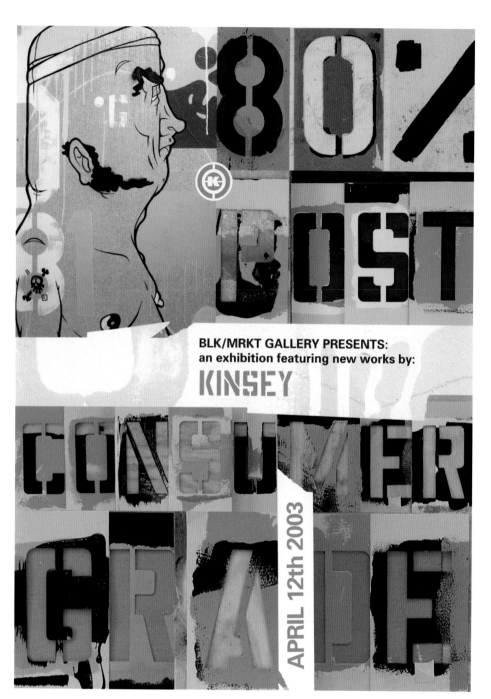

BLK/MRKT GALLERY PRESENTS:
an exhibition featuring new works by:

KINSEY

APRIL 12th 2003

STUDIO / DESIGN FIRM BLK/MRKT Gallery (Los Angeles, CA USA)
WORK / YEAR Exhibition "80% Post-Consumer Grade" postcard invite for Kinsey solo / 2003
ARTIST Kinsey
CREATIVE DIRECTION Kinsey

Top to Bottom
STUDIO / DESIGN FIRM Kinseyvisual (Los Angeles, CA USA)
WORK / YEAR (Top) Supervision / 2004
WORK / YEAR (Centre) Withdrawn / 2003
WORK / YEAR (Bottom) Algorithms / 2003
ARTIST Kinsey
MEDIUM Acrylic, tape & screen printing.
KIND OF WORK Fine Art

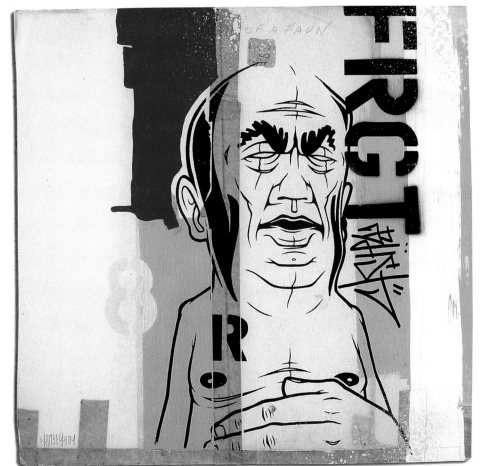

STUDIO / DESIGN FIRM Automatic Art and Design (New York, USA)
WORK / YEAR Illustration / 2003
ARTIST Charles Wilkin
DESIGN / ILLUSTRATION Charles Wilkin
CLIENT Émigré
DESCRIPTION Editorial Illustration.

STUDIO / DESIGN FIRM Kinseyvisual (Los Angeles, CA USA)
WORK / YEAR FRGT / 2004
ARTIST Kinsey
MEDIUM Acrylic, tape, spray paint & screen printing.
KIND OF WORK Fine Art.

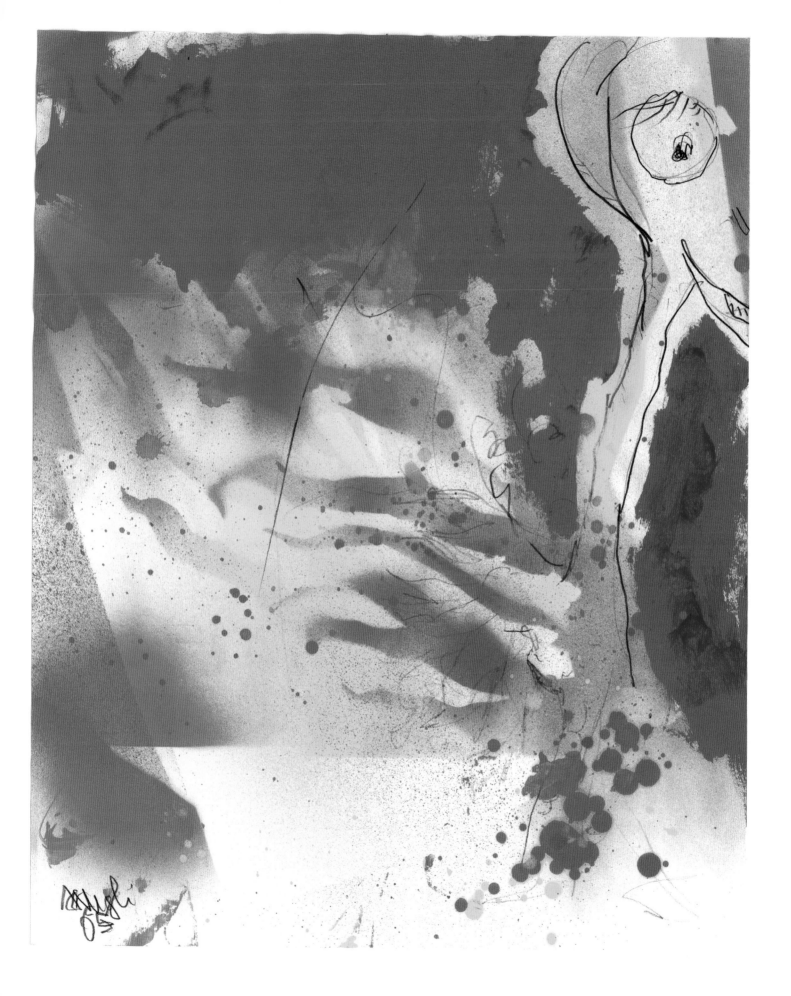

Left & P. 202
STUDIO / DESIGN FIRM Andrea Lugli Design (Modena, Italy)
WORK / YEAR Lil' Struthio / 2005
ARTIST Andrea Lugli
ART DIRECTION, DESIGN, ILLUSTRATION Andrea Lugli
CLIENT Self

STUDIO / DESIGN FIRM Andrea Lugli Design (Modena, Italy)
WORK / YEAR "Roma 2004" / 2005
ARTIST Andrea Lugli
ART DIRECTION, DESIGN, ILLUSTRATION Andrea Lugli
PHOTO Andrea Lugli
CLIENT Crucix-Shop
DESCRIPTION Adv Illustration.

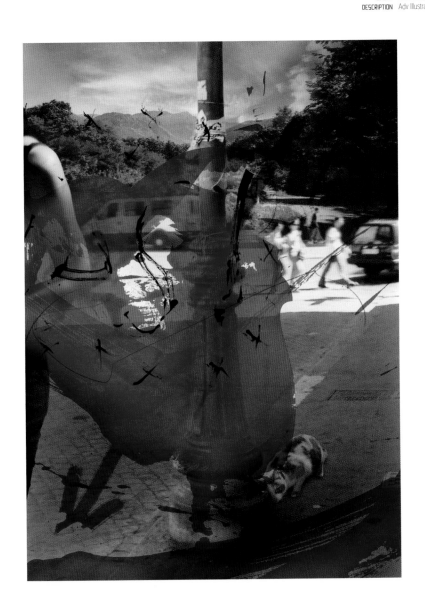

GIRLS ROCK!
the movie

GET INVOLVED!
Girls Rock Productions - 588 Guerrero Street
San Francisco CA 94110 - tel: 415-517-1979
arne@girlsrockmovie.com -
www.girlsrockmovie.com

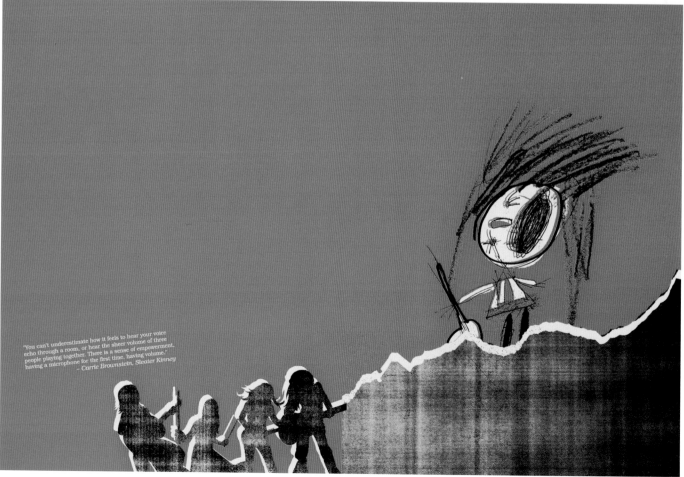

"You can't underestimate how it feels to hear your voice
echo through a room, or hear the sheer volume of three
people playing together. There is a sense of empowerment,
having a microphone for the first time, having volume."
– Carrie Brownstein, Sleater Kinney

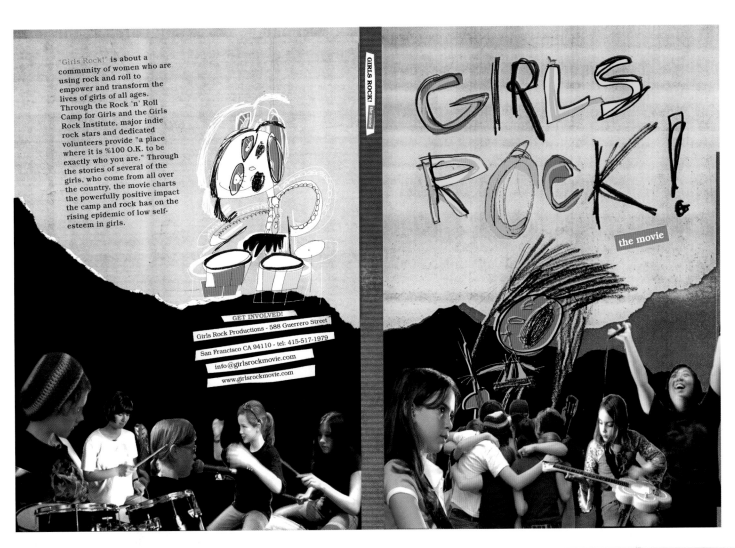

"Girls Rock!" is about a community of women who are using rock and roll to empower and transform the lives of girls of all ages. Through the Rock 'n' Roll Camp for Girls and the Girls Rock Institute, major indie rock stars and dedicated volunteers provide "a place where it is %100 O.K. to be exactly who you are." Through the stories of several of the girls, who come from all over the country, the movie charts the powerfully positive impact the camp and rock has on the rising epidemic of low self-esteem in girls.

GET INVOLVED!
Girls Rock Productions - 588 Guerrero Street
San Francisco CA 94110 - tel: 415-517-1979
info@girlsrockmovie.com
www.girlsrockmovie.com

GIRLS ROCK! the movie

GIRLS ROCK! the movie

Shane King - Producer/ Cinematographer
Girls Rock Productions - 588 Guerrero Street
San Francisco CA 94110 - tel: 415-298-6597
shane@girlsrockmovie.com
www.girlsrockmovie.com

STUDIO / DESIGN FIRM Joshua Berger Creative (Portland, USA)
WORK / YEAR "Girls Rock!" / 2005
ART DIRECTOR Joshua Berger
DESIGNER Yasmeen Ayyashi
ILLUSTRATOR Melina Rodrigo
CLIENT Girls Rock Productions
DESCRIPTION Brand identity and packaging for a documentary
film about the Rock and Roll Camp for Girls.

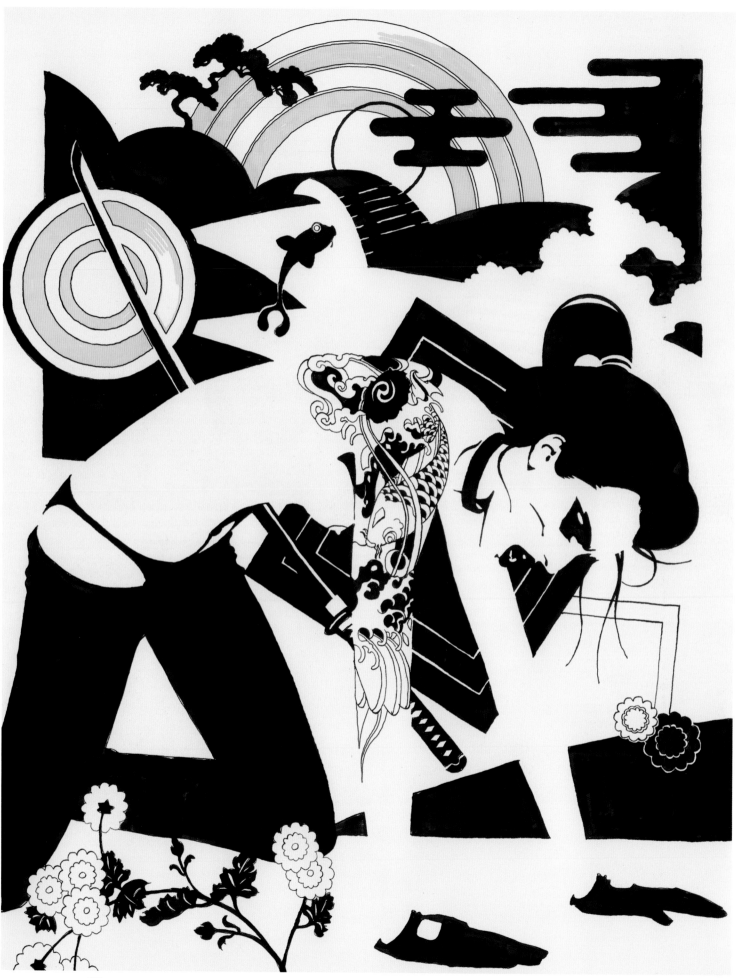

STUDIO / DESIGN FIRM Jasper Goodall (Brighton, UK)
WORK / YEAR Leaping Carp / 2005
ARTIST Jasper Goodall
ART DIRECTION, DESIGN, ILLUSTRATION Jasper Goodall
CLIENT Self
DESCRIPTION Unpublished Illustration.

STUDIO / DESIGN FIRM Jasper Goodall (Brighton, UK)
WORK / YEAR Go Go / 2005
ARTIST Jasper Goodall
ART DIRECTION, DESIGN, ILLUSTRATION Jasper Goodall
CLIENT Self
DESCRIPTION Unpublished Illustration.

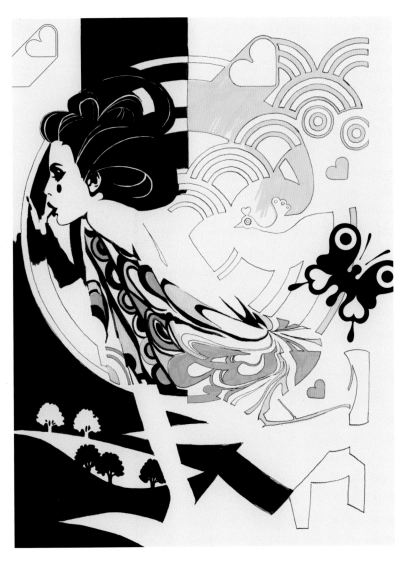

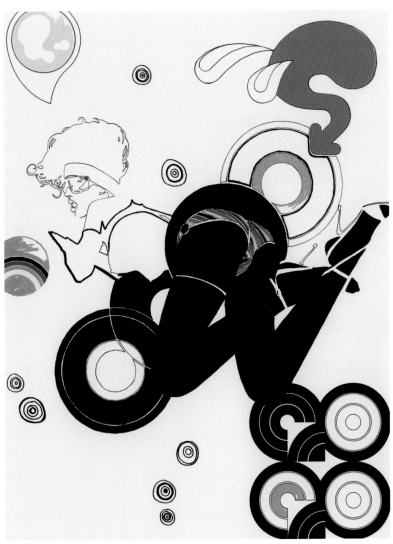

STUDIO / DESIGN FIRM Jasper Goodall (Brighton, UK)
WORK / YEAR Peacock / 2004
ARTIST Jasper Goodall
ART DIRECTION, DESIGN, ILLUSTRATION Jasper Goodall
CLIENT Self
DESCRIPTION Unpublished Illustration.

CONTACT / INDEX